Elemental Magic

Elemental Magic

Volume II

The Technique of Special Effects Animation

Joseph Gilland

With a Foreword by Wayne Kimbell

Routledge
Taylor & Francis Group

LONDON AND NEW YORK

First published 2012 by Focal Press

Published 2022 Routledge
2 Park Square, Milton Park, Abingdon, Oxon OX14 4RN
605 Third Avenue, New York, NY 10017

Routledge is an imprint of the Taylor & Francis Group, an informa business

Library of Congress Cataloging-in-Publication Data
Gilland, Joseph.
 Elemental magic: the technique of special effects animation / Joseph Gilland.
 p.cm.
 Includes index.
 ISBN 978-0-240-81479-7 (pbk. : alk. Paper) 1. Animated films—Technique.
2. Drawing—Technique. I. Title.
 NC1765.G49 2011
 741.5′8—dc22 2008046558
British Library Cataloguing-in-Publication Data
A catalogue record for this book is available from the British Library

ISBN 13: 978-0-240-81479-7 (pbk)

To my dear Sister Kathy with love . . .

Table of Contents

Foreword by Wayne Kimbell ix

Preface: The Art of Animating Special Effects xiii

A Message from Cyberspace xxxiii

Acknowledgements xxxix

Chapter 1. Introduction to the Elements 1

Chapter 2. The Wave 21

Chapter 3. The Splash 57

Chapter 4. Lighting a Fire 165

Chapter 5. Blowing It Up 243

Chapter 6. Magic: The Art of Animating Pixie Dust 279

Index 307

Foreword

by Wayne Kimbell

In 1981 I moved to Montreal from Hollywood to work on the special effects for the animated feature film *Heavy Metal*. I was hired to do the backlight effects—the flares that run the length of magical swords, the ebbs and glows of a volcano about to explode—and to add flash to explosions and magic dust and sparkle wherever needed. As I began, the movie's release date was moved up three months. No panic—I asked for help. A director and a production manager suggested Joe Gilland, a rookie animator in the in-between department. They said Joe had loads of talent and lots of promise. Hmm, he'd be a gofer in Hollywood. I was stuck with a rookie and an impossible deadline. It's the biz.

As it turned out, Joe did have the skills I needed. He had good instincts—an artist/animator's intuition, an intuition based on keen observation of life's little things, the details. Most artists can see the big picture and put a frame around it. Special effects artists have to notice the details, especially the details.

How does a reflected shape change as it moves across a windshield? How does light flare then zip down a strip of chrome? How does water spill from a bucket, and how does light flicker on it as it spills?

It's this kind of observation, seeing the details, that's key to animating magic and making it believable. You need to know which details matter, how to simplify them (even cut), and what to emphasize. Knowing how to render nature gives an artist/animator insight into the magical, the preposterous, and whatever dreams one might have, and then, make them real. Render them, save to disc.

When I met Joe he was just starting out, but as we worked it was clear he had these instincts. He was, I could see, a natural observer. He would stop and smell the flowers. Literally. Our first meeting (outside the office) was on a church lawn under a tree watching spring clouds morph as they drifted by in a crisp Canadian blue sky.

When the film was done, nine weeks later, I felt as if I had discovered a new talent—a talent I would soon recommend to others. And Joe had discovered a new direction for his skills. These skills he has since taken around the world and—through "the magic of movies"—delighted (unknowing) millions with them.

Thirty years later, as I sit here in Santa Barbara, it is good to think that I was there, in the beginning, at the start of Joe's journey—from apprentice to master—in the art of special effects animation. Enjoy this book. Learn from it. It is Joe's life's work laid bare, clearly for the taking . . . it's Joe's torch. Take it if you really want to.

Preface

The Art of Animating Special Effects

Animation is a sublime art form. Many who make it their life's work will tell you it is like a modern form of alchemy. From inanimate objects, we create life. From wood, minerals, and plastic, we create seemingly conscious, living things. From these same inanimate tools we can create a compelling interpretation of the elements as we know them: Earth, Air, Fire, and Water. And then there are the elements that are born in our fertile imaginations. Wonderful, mystical, magical elements like pixie dust and magic potions, spiritual entities, ghosts, and portals into other dimensions.

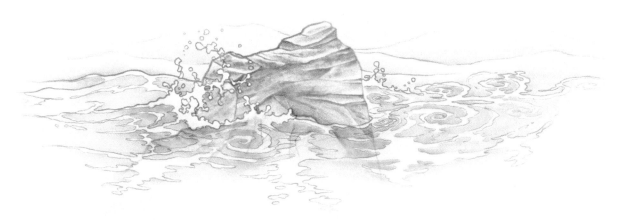

In my previous book, *Elemental Magic: The Art of Special Effects Animation,* I brought my life's experience of animating the elements to the printed page. In that book, for the first time in the history of the art of animation, I gave a detailed account of how we, the special effects animators of the world, have learned how to understand the energy underlying all natural phenomena in our world. With pencil and paper and whatever technology we have at our disposal, we can create from scratch, living, flowing, exploding, exciting, and we hope very convincing approximations of the world of the elements. And in doing this, we breathe additional life into the animated characters and settings that fill the universe of animated films.

The elements themselves are only a part of the story. It is *energy* that
we animate when we create special effects. H_2O molecules alone do
not create splashes and waves. Left alone, water is static to the naked
eye, although its molecular structure we understand to be a buzzing,
whirling universe of particles, thanks to the insights that physics has
given us. Observe a glass of water that sits undisturbed, or a lake, dead
calm in the early morning stillness. Water is absolutely still when it is
left alone to its own devices. The splashes, ripples, and waves that we
see in our everyday lives and recognize as *water* would not come into
being without outside forces coming into play. A body of water must
be touched, pushed, dragged, or moved in some way, with the help of
gravity and an infinite number of possible external interruptions—be
it a boat moving through the water, a dog swimming through it, or a
rock being skipped across its surface. It is these interactions between
water and its environment that make it come to life. Pure energy brings
any element to life, and then that energy takes on the characteristics of
that specific element, as it follows through on its energetic path of least
resistance.

For instance, a rock thrown into a still pool of water creates a very fluid and perfectly "waterlike" splash. That same rock thrown into a bowl of oatmeal will create a splash as well, but a splash held together by the specific molecular behavior of oatmeal. It will be extremely globular and thick, with far fewer individual shapes and drops breaking off from the main body of the splash. And that reaction can vary a great deal, depending on how watery or how thick the oatmeal is. So what we have in any splash, regardless of the type of fluid, is a combination of the initial driving energy and the molecular characteristics of the fluid working together.

A body of fluid, with no external forces acting upon it, is completely static.

In the first *Elemental Magic* it was this energy that I focused on more
than anything else. I repeated the message again and again, driving
home the fact that as special effects animators, we do not animate
things, we animate *energy.* All too often I have seen novice animation
artists attempting to animate shapes and lines, rather than the underlying
energy that drives an element to movement and form. This is a common
mistake for character animators as well. When animating a character
one must also be acutely aware of the driving forces behind a character's
movement, such as intent and emotion, or a character's defining physical
attributes. Without an awareness of the energy driving a character,
an animator's performance can seem lifeless and uninspired, or even
awkward and decidedly weird!

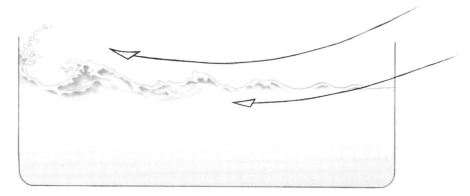

Add some wind, and the liquid surface becomes animated, alive with motion.

So a character animator must understand what makes his or her character tick, and my premise for organically animating special effects elements to their fullest potential is that an effects animator must understand what makes his or her elements tick as well! Almost like method actors who will throw themselves into the mindset of a character they must portray, effects animators should actually be able to ask themselves, "What would I do if I were a still, calm pool of water, and someone threw a medium-sized flat piece of slate rock into me? How would I react?" or "What would I do if I were a massive chunk of rock cliff-face breaking off and crashing into a valley below?"

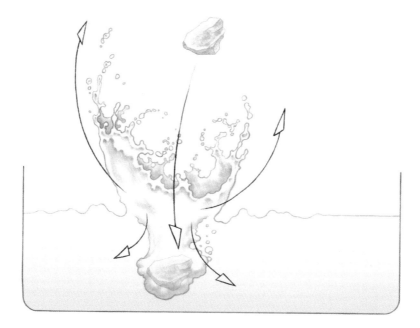

Throw in a rock on a slight angle, and a unique, asymmetrical splash springs to life!

In the website that accompanies this book (www.elementalmagicbook. com), *Elemental Magic, Volume II: The Technique of Special Effects Animation,* I will add another dimension to illustrating animation principles for the reader, filming the actual dynamic interaction of artist and medium that goes into creating special effects animation. While drawing, animating, and explaining the process, I will bring the reader/ viewer into a world where the artist becomes one with the element as much as possible. Starting with a blank sheet of paper, we will experience together the step-by-step technique of animating a special effects scene. This includes imagining and even voicing the sound effects that would accompany the effect being animated, to better mimic and put oneself into the environment in which the effect takes place.

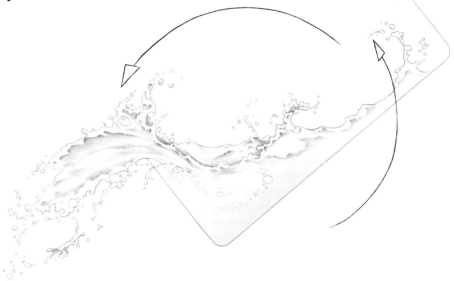

Tip a container of fluid on its side and gravity takes over, causing the liquid to surge and spill earthward.

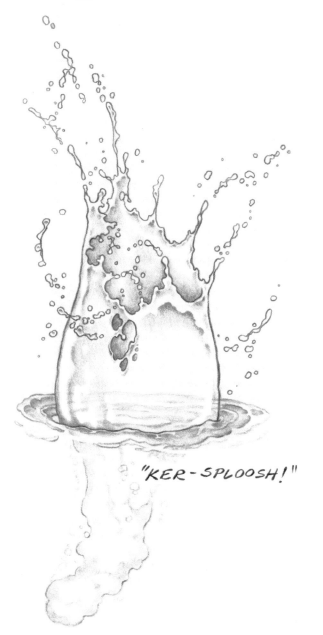

"KER-SPLOOSH!"

As I draw, and put myself into the environment and the element, I find myself emoting and reacting much as the element itself would. Making splashing sounds, crashing sounds, explosive sounds, and even twinkling magic sounds as I draw are all part and parcel of my creative special effects process. Strange as this may seem to some, to me it simply reflects a sort of "method acting" technique, wherein actors throw themselves into the role wholeheartedly, actually becoming the characters they are portraying.

Another important aspect of my writing about and demonstration of my special effects technique is that as much as possible, I try to keep my language simple. I find it very frustrating that an academic approach to understanding the physics of special effects elements almost invariably ends up sounding overly complex and can alienate someone attempting to grasp the concepts of matter and energy interacting. Much of the language of physics is a kind of "academic speak," with terminology unknown to the average artist or layperson. However, it need not be rocket science, and the principles of physics can be easily explained in simple, good old-fashioned English. Scientists love to dream up new, complicated, intellectual-sounding words to describe what are actually very simple events to understand, without a degree in physics.

This is all well and good for the inner circles of scientific academia, but it is out of place in the artist's world, and I hope to present the ideas and techniques in this book in a warm, simple, friendly way that everybody can easily wrap their heads around.

Complexity of knowledge does not necessarily lead to the full understanding of an element's true nature!

In the world of computer generated imagery, or the "CGI" world of animation, which has become the standard means of expression in the animation medium today, much of the academic language of physics has carried through into the animation software that has been developed in the last two decades. This phenomenon occurred for the simple reason that the initial designers and creators of this software were indeed scientists, not animators or artists. Unfortunately for all involved, there was a disconnect between the two disciplines, as the majority of software developers seemed to be unaware of the fact that animation had already been evolving a language of its own for the past 60 to 70 years. Thus, software packages emerged in which, although they were supposedly designed to "animate" special effects elements, attempting to use them felt more like falling into the deep end of a pool of physics and mathematical academic terminology. Baffling, complex, and obtuse, apparently little if any effort was made to make these software packages user-friendly, or at the very least to adopt some of the already existing language of animation that had been around for several decades.

At this stage, I would like to pay my respect to the men and women who have, for as long as we have studied animation, devoted themselves to understanding physics, and to developing computer hardware and software designed to mimic and understand elemental dynamics of various kinds. This work was often funded by the aerospace industry, in order to explore aerodynamics as well as fluid dynamics. These computer scientists were true pioneers, and they developed complex

computer languages and systems to closely mimic how air and fluids react to shapes moving through them. This research influenced the design of modern aviation a great deal, as well as laid the groundwork for the dynamic particle animation systems that we now use and take for granted.

The development of modern-day particle dynamic systems, often driven financially by the military, represents an extremely exciting, creative, and innovative period in humankind's understanding of the elements. However, this exploratory research was approached from an extremely academic and scientific point of view, and I doubt that any of these pioneers in the development of dynamic physics ever dreamed that their research would be fueling a blockbuster movie industry, chockfull of special effects driven by their very own particle dynamics systems. I understand, and also respect, that these physicists and scientists had developed a very concise and descriptive language to describe the various phenomena that they were attempting to describe. However, it is a language that the average Joe cannot wrap his head around. If anything, I have found it frustrating to have to learn a whole new technical vocabulary in order to navigate some of the high-end dynamic effects software programs commonly in use today.

The natural dynamics of special effects are infused in our DNA! It is just a matter of knowing it, finding it, and then tapping into this infinite wellspring of information.

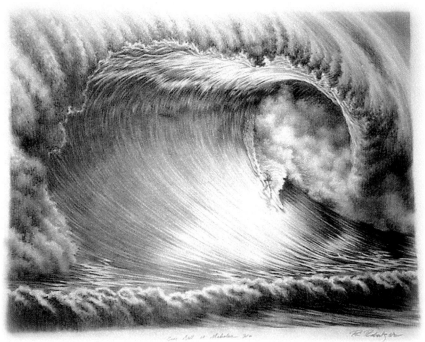

And so I try to approach the subject in a language that every artist can speak, and conversely, any scientist or mathematician can easily understand as well. It is best, I believe, to erase the lines between artist and scientist, and speak in a language that is immediately accessible to us all. Of course there are animation artists who are extremely comfortable with the more technical and scientific approach to creating visual effects. But in simplifying the language, I feel that I can speak to them as well as the professional or novice animation artist, the layperson, or even the old-school analog dinosaur who is alienated by the digital and scientific complexity of it all.

The real beauty of understanding and animating the elements is that it really is accessible to everyone, and it need not be an overly complex undertaking with a steep and daunting learning curve. I believe that a great deal of the understanding of how it all works can be grasped intuitively, with the imagination, rather than the intellect. As Einstein was famously quoted as saying, "Imagination is more important than knowledge." Well, that wonderful quote applies perfectly to the world of animating the elements. Far from needing to understand complex sets of mathematical principles and scientific formulae, what a special effects animator really needs to be able to do is to *feel* and *imagine* how the elements work. And a great deal of that information is already within us, hard-wired into our DNA and reinforced by a lifetime of observing the elements all around us, firsthand.

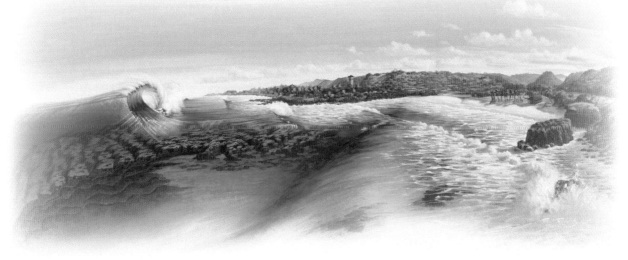

Surfing and fishing cultures that have developed with a close relationship to the ocean have a natural understanding of how tides, waves, and currents work. We can access that level of understanding if we make understanding the elements an integral part of our lives!

Every time we brush our teeth and watch the water swirl down the drain, every time we unplug a boiling kettle spewing steam, or every time we sit around the campfire telling stories, we have a front row seat to the most perfect demonstration of how special effects elements work. And subliminally, we have been absorbing that information our entire lives. Our memories and imaginations are full of it, especially if we pay attention.

This photo, taken by a student in her backyard, is an excellent example of the kinds of incredible effects we see in our everyday lives, but miss out on if we are not paying close attention!

It is my hope that this book will do much to demystify a discipline
that has always been considered highly complex and far too difficult
for the average mortal to understand, never mind to master. To me,
animating the elements is like embracing life itself. It is "moving into"
the phenomena that surround us every day for our entire lives. The wind
that caresses our face as we walk down a beach is the same wind that
has created the waves lapping up against the sand, and the same wind
that moves the water that forms every grain of sand on the beach under
our feet.

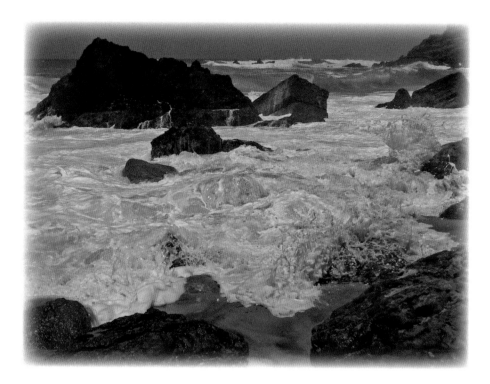

Whether creating a mountain range, a heaving ocean surface, a volcano, a forest fire, or a single drop of rain, the energy that surrounds us is an integral part of what we are made of ourselves. There is no disconnect when the elements can be experienced in this all-inclusive way. And there certainly is no need for a degree in advanced physics, or an understanding of the strange jargon that often goes with it.

So rather than thinking of animating the elements as tackling a difficult task that is outside of your realm of experience, begin this journey with the wonderful realization that the elements are the most natural thing we could possibly imagine. The blueprint, all the information and energy, is in our DNA. We *are* the elements. We are part and parcel of the same wonderful package that is our natural life. Embrace the elements thus, and the journey is a smooth ride on the waves of life, deep into a magical realm that is our birthright. Like a sparkling raindrop in the sunlight, falling from a new spring leaf into a cool deep well of life-giving sustenance, the journey into the elements is as natural as is the sun rising to greet us every morning.

A child playing in the backyard is a great source of elemental effects reference. Better yet, get out there and play yourself!

A Message from Cyberspace

Throughout much of my *Elemental Magic* books and workshops,
I emphasize the importance of self-reliance when seeking reference
material to learn about special effects. The message of my work is
to connect the reader with his or her naturally occurring organic and
genetic knowledge of the elements, as well as his or her creative
intuition and ingenuity in finding ways to learn about the elements. And
this approach generally means avoiding using the computer as a tool
until one has truly delved as deeply as possible into one's own creative
research, independent of the Internet or any software assistance.

However, it's extremely important for me to make it abundantly clear that using the Internet as a research tool is by no means taboo in my book. I spend a great deal of time online from day to day, and how far the Internet has come as far as the breadth of information available is simply staggering. One could educate oneself in virtually any discipline using only the Internet as a library and teaching tool. Esoteric information about once rarified academic fields of study like quantum physics, hydro- and aerodynamics, or brain chemistry, are now available to anyone with an Internet connection. Mathematics is extremely well covered, and I know more than a few people who have given themselves a top-notch math education online.

Since the rise of the Internet in the early 1990s, almost every single academic paper written on any subject you can imagine has been posted online in some shape or form. To find these documents can require delving a little deeper into the Internet than the average half-hearted web search, but the volume of pure unadulterated top-notch information of all kinds available online is incredible. And happily, much of this incredible wealth of information is making its way into the mainstream highways of this enormous worldwide digital database, and deep-search engines with creative and emotional links to actual content (rather than simply searching keywords and symbols) are being created to help us better find whatever it is we think we're looking for—and maybe even what we don't know we're looking for.

I have learned a great deal about special effects of all kinds online since I began using the Internet daily, which for me was in 1994. That was when I got my first computer workstation consisting of two big Silicon Graphics monitors hooked up to a monstrous SGI tower, and a full-bore high-speed Internet connection, which was very rare to the average user at that time. This was when I first started working for Walt Disney Feature Animation, and they went to great lengths to be at the cutting edge of computer technology. Since that time, I have learned dozens of software programs, for 2D, 2.5D, and 3D, and have spent at least half of my time working as an animator on a computer of one kind or another, and always hooked up to the Internet. So to say that digital tools have had an influence on my work over the last 17 years would almost be an understatement. Almost everything creative that I do has been profoundly affected by the advent of the Internet during the latter half of my career.

Be that as it may, the most important elements in my creative toolbox have nothing to do with computer software or Internet access. Regardless of the sophisticated nature of the Internet, and the fact that it becomes more sophisticated every day, I still contend that the real supercomputer that we need to be looking into is the one we are born with, and we need to learn how to reconnect our natural computer with the surrounding energy matrix of our natural world and the universe around us. The powerful digital fluid-dynamic simulations that were created in the last few decades represent the end result of a lot of humans sitting and watching a lot of fluid dynamics flow by for millennia. We simply used computers to run the numbers we discovered that generate dynamic, working, almost living models of how molecules of all kinds react to movement, flow, or obstruction of any kind. Computers enabled us to see these dynamic models in action, since looking into the mind of a physicist and seeing them is not possible. But the possibility of creating code that can mimic hydrodynamics began there, in the creative and organizational center of the physicist's brain, or knowledge field. Every molecule in the physicist's brain is connected to all the energy in the universe, and that is where the inspiration came from.

And that is where all the really good stuff comes from: from the roots of the organic world that gave birth to us. When we stand with our bare feet in a river, this is not a trivial interaction with nature. It is a real connection to our lifeblood, our source of life, our very being. When we experience the heat of a flame on our face, whether from the sun or a manmade source, we are touching the sun's energy, and we are brushing with pure energy—energy that would actually devour us were we to stand too close. And when we feel smoke in our eyes or lungs, we are actually becoming a part of the cycle of natural events that created the smoke in the first place.

Physicists and mathematicians did not spend endless hours in front of a computer trying to figure this stuff out. They spend their time observing real dynamic behaviors and creating experimental setups to mimic certain hydro- and aerodynamic situations.

When we are actively present in a real-time elemental event, we are an integral part of that event, and it becomes an integral part of our internal knowledge database. Thinking about an event and experiencing an event are two extremely different proposals. And what we spend most of our time doing online is thinking about things. All good and well, and possibly with enormous benefits, but a far cry from organic interactions of the "first kind."

So I propose that to learn as much as possible about elemental effects, we need to focus on the real-time organic experiences at our fingertips and create our own internal information databases, long before we begin to scour the Internet for the information. And as I point out repeatedly in this and my previous volume, most of us already have. Day-to-day interactions with the elements in mundane and common activities have given us a lifetime of firsthand experience with almost every conceivable elemental event. We have all been observing the stuff our whole lives, but how much have we been paying attention to what we've seen? We've all seen thousands of splashes, but when's the last time you tried to describe one, either with words or by drawing it?

So, all the power in the world to the Internet and the riches it has to offer. Avail yourself of course to the most vast and readily available database of information in the history of humankind. It will be sitting there patiently awaiting your return from the fantastic voyage of hands-on interactive exploration into the magnificent, infinitely unfolding world of organic elemental effects that will feed your imagination and enrich your eventual input into the digital database.

Acknowledgements

Since the release of the first volume of *Elemental Magic: The Art of Special Effects Animation,* the number of people who have encouraged me to write a second book as a follow-up has been almost overwhelming. I finally did succumb to the pressure and, unbelievably, managed to pull it all together despite many roadblocks and unexpected twists and turns in the road. But not without a great deal of help, support, and love, from many wonderful friends and colleagues.

Without my Sister Kathy's love and support, this would never have been possible, period. Kathy, you are the greatest Sister I ever, and this one's for you. May all of your hopes and dreams come true, and may I have a part in making them happen for you. To my Mother, Tommy, thanks for always being there. And to all the family, Ben, Logan, and of course Cally and Jack. And all of you back East in Ontario too. You all mean more to me than you know! Thank you Marilyn for always reflecting love and believing in me. To you Jara, words cannot express my gratitude and love. And thanks to my two very patient and loving cats, Franky and Tommy, for your constant companionship and affection.

Big thanks to my gracious landlords and their whole family—Brian, Julie, Kailan, Finley, and their pets, Buddha, Yoshimi, and Gordie—for making me feel so at home in my creative space, and getting me to go for walks too!

To my family of Soberiders, my deepest debt of gratitude for your love and support through the most difficult times of my life, and the very best times as well. You all know who you are, and I love you with all my heart.

Special thanks too to Sean and Sheila at Vancouver Island Tattoo for their huge support. And to my Burning Man family, and to every Burner who attended Burning Man for the last two years, you've all helped this dream come true.

To Michel Gagne, Phil Roberts, Dave Lemieux, Jenn Brisson, Zoe Evamy, Jazno Francoeur, Keith Ingham, Wayne Kimbell, Rita Street, Jennifer Claire Pearson, Jay Schuh, Dorse Lanpher, Anne Denman, Dean Dublois, Don Hahn, Chris Sanders, Ed Hooks, Milt Grey, Myriam Casper, Tina Price and everyone at the Creative Talent Network, Dave Tidgewell, Michael Duhaschek, Jack Thornton, Sean Ramirez, Dave Nicholson, Sari Gennis, the whole gang at Monterrey Tec, and oh so many more amazing people in my life who ceaselessly inspire me, tolerate me, love me, and push me to do my very best. I only hope that if you have been there for me in any way, that I have expressed my gratitude to you adequately. I wish I could fill these pages with your names. I am profoundly blessed with an overwhelming amount of love and support, and I thank you all!

And finally to my support team at Focal Press, headed by Anais Wheeler, thanks for putting up with my creative quirks, and my agent, Carole Jelen, thanks for getting this magical ball rolling in the first place.

Joseph Gilland

Chapter 1

Introduction to the Elements

For the last two years, since writing my first book, *Elemental Magic: The Art of Special Effects Animation,* I have been traveling a great deal, conducting special effects workshops based on many of the ideas I put forth in that initial volume. I have been bowled over by the warm reception that my first book has received, and I am deeply grateful to know that it has been inspirational to many animation artists, students, and fans around the world. I would like to especially thank you, the readers of my first book, who have made it a great success. I wrote it for you. Thank you for embracing it so wholeheartedly!

However, it frequently comes up in the conversations I have about the first book that the subject matter is so vast, that it was virtually impossible for me to cover everything in the kind of detail that I really would have liked to offer.

To really delve deeply into each specific type of effects animation in minute detail would have taken a book of a thousand pages or more. An entire encyclopedia could be written about special effects animation. Entire books could be written just on animating a splash, or a house on fire. Whenever I look closely at my first book, I always find myself wishing there was more. More specifics on how to actually animate effects, starting with a blank sheet of paper. More of the *real stuff* or the *nitty-gritty,* as it were, to borrow from John Canemaker's generous endorsement of my first book. I decided to take a cue from John, and from my actual teaching experiences in the past. The more I have tried to teach special effects animation by talking and showing students still images, diagrams, and whatever reference material I could find, the more I have realized how important it is to teach by example. After conducting only a few classes, I felt like I was wasting my breath, babbling for hours about something that takes action to actually *do*.

So I decided to animate "live" in front of my effects classes, starting with a blank sheet of paper and walking the class through the process as I drew. This was somewhat daunting at first, because I was putting myself on the spot, forcing myself to animate from a cold start, with a group of expectant, enthusiastic students staring at my every move, and every line I put down was open to scrutiny. It was nerve-wracking, but ultimately it worked out fabulously, as I was able to dig deep and draw on three decades of experience and spill it out on the pages.

As I took on animating a simple water splash, I limited the amount of time I had to one hour, to complete all of the drawings and then capture them digitally for playback. This way I was forced to draw fast, and with energy, demonstrating the very principles that I put down in my first book and was constantly emphasizing in my lectures: to always animate drawing fast, sketching roughly with energy and abandon, and not worry about making every line perfect but just going for it. From pages full of seemingly messy scribbles, the students would see a piece of flowing special effects animation emerge. Not flawless by any stretch of the imagination, but animating sweetly nonetheless, with all the timeless animation principles of energy, intent, exaggeration, and dynamics clearly demonstrated in real time.

And so, in this my second book, *Elemental Magic, Volume II: The Technique of Special Effects Animation,* I decided that while I would still try to write a lot more about specific details involved in animating special effects, the real deal is to teach by live demonstration. That is why, if you are reading this, you also have access to the accompanying website www.elementalmagicbook.com, complete with clips of me drawing and animating live. This is where the real magic comes to life.

I didn't animate complex special effects in feature films by talking about it. Where the rubber hits the road is when the animator flips the pages and quickly roughs in his or her next drawing.

I believe that *that* is what anyone who is interested in the technique of special effects animation really wants to see. I sincerely hope that by creating this second volume as such, I will be able to deliver to you an unparalleled and intimate look into how special effects animation evolves and emerges from the imagination of an effects artist to a blank piece of paper, in real time.

At various stages throughout this book, I will go through many of the very same stages of explaining effects animation that I did in the first *Elemental Magic* volume. There is definitely some repetition and overlap, but with every word and page in this book, I have strived to take another, far more in-depth look at a variety of aspects of creating hand-drawn special effects from scratch. There is also a great deal to be said for the repetition of key principles in any advanced learning process. The idea is to truly ingrain the intuitive feelings and detailed knowledge of fluid shapes, design, and animation principles into yourself so that they become natural and flowing, and can spill out of you as naturally as water spills out of a bucket.

Initially, I had set out in this book to try to cover the full range of elemental effects elements that are embodied in the very common "Earth, Wind, Fire, and Water" phrase. However, as this book has evolved, I have narrowed the focus of the material, and the elements I will cover in great detail in this volume are water, fire, smoke, explosions, and certain "magic" elements.

Chapters 2 and 3 cover water waves and water splashes, respectively. The written and illustrated pages in the book will cover for you in extreme detail the creative and practical processes involved in understanding how to approach animating these elements. Then in the accompanying video footage available on the book's website, I will animate and explain more specific and narrowly focused examples of these elements. For the study of wave animation, we will be looking at animating a cross-section of a wavy body of wind-blown water representing something roughly the size of a swimming pool, which is a great way to get a grasp on the most simple and fundamental principles behind animating a wave.

The splash we will study will be a medium-sized splash like one we would see if we dropped something roughly the size of a baseball into a calm body of water. I find this to be a great jumping-off point for someone learning to animate a splash.

Chapters 4 and 5 will deal with animating fire and smoke, and explosions, respectively, which can contain elements not only of fire and wind but also earth and water. In the written and illustrated sections of these chapters, I will delve into great detail on a wide range of variations of fire and smoke: not only with step-by-step examples of the animating process, but also with the underlying creative thought process, as well as the observational and research process that I consider to be the very cornerstone of my success as a special effects animator.

The fire I will use to demonstrate with in the accompanying live footage to be found on the website will be an "average-sized" fire, if there is such a thing, approximately the size of the average campfire. This is an element that most people are familiar with, and it's a great place to start for us to understand what goes into animating a fire. What child is not mesmerized by a campfire, staring for hours into its hypnotic dance of light and pure energy? The smoke we will explore animating, just to be practical and consistent, will be the same kind of smoke we might see coming from such a medium-sized campfire. For an explosion I will animate something relatively small and manageable, roughly the size of a large firecracker exploding.

Only Chapter 6 does not fall readily into the four elemental categories. In Chapter 6 we will play with magic, and I will attempt to cover as much ground as possible. But since magic is such an infinitely broad and by its very nature undefined creative endeavor, I will focus for the most part on some of the thought processes and practical considerations that go into creating the classical "pixie dust" magic featured in so many of our most beloved animated films in the history of the art form. On the book's accompanying website, I'll be animating pixie dust in the classical way, as it appeared in early Disney films, like *Fantasia* (1940) and *Peter Pan* (1953). These types of effects draw their inspiration from the elements, and understanding how smoke, fire, and water behave will help us to create far more dynamic and beautiful magic effects.

It is extremely important to note again here that when thinking about special effects, there is a great deal of crossover from one category to another. The elements are inextricably linked together in many respects.

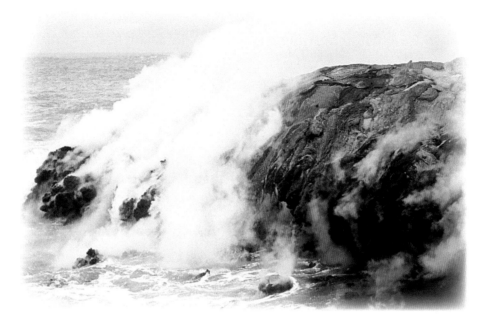

Take wind, for example. Essentially, wind is invisible, and we see it
only when it affects another element. Wind blowing in the trees, waves
on a water surface, dust storms, the reaction of fire and smoke to wind
conditions, all of these are wind elements interacting with other elements
to create an effect. Another good example is a rockslide or avalanche
crashing into trees or tumbling into a body of water. Another even more
exciting and dynamic example is when volcanic lava flows directly into
the ocean, a fantastic phenomenon, and one of the most compelling
natural special effects on our planet, which can be seen on the big island
of Hawaii on a fairly regular basis. This creates an incredible show
of special effects, as the lava splashes hissing into the ocean creating
heaving waves and belching out enormous clouds of billowing steam.

Under the water, bubbles and currents swirl wildly in the waves, with extreme temperature changes creating swirling eddies of activity. As the steam rises and dissipates, it is whipped around by even more swirling vortices of energy, caused by the super-heated lava and the cooler surrounding air.

For the moment, I'll take a preliminary look at the effects elements I will cover in this book, discussing some of their most important attributes, and keeping an eye out for when and where the different elements interact and overlap.

This drawing could be either smoke, or steam, or dust that has somehow been kicked up. In their initial stages, these three effects can look identical. But they are completely different elements, and their molecules will react and resolve differently to the forces acting upon them, and each will resolve in its own unique way.

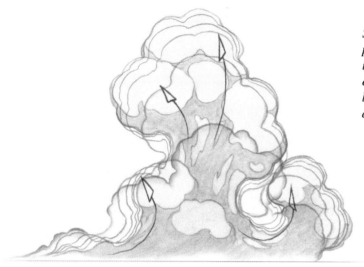

Smoke will usually continue to move upward, unless there is a hard wind that pushes it in another direction. Smoke is still being propelled by heated air, and in fact the particles in the smoke may be extremely hot themselves. Of these three elements, smoke will take the longest to dissipate by far. Smoke can actually linger for hours or even days before it dissipates completely, unlike steam and dust, which have very different ways of dissipating.

Steam will behave somewhat like smoke, because the super-heated water molecules are being propelled, like smoke, by heated air. But unlike smoke particles, the water molecules will be absorbed into the surrounding atmosphere very quickly, becoming invisible to the naked eye. Therefore steam appears to simply vanish before our very eyes.

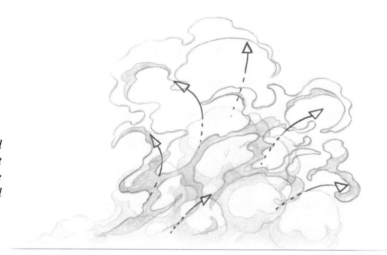

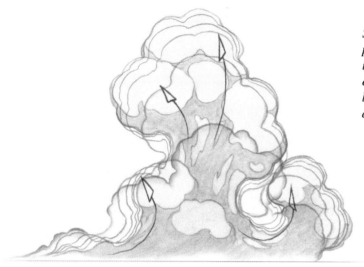

Dust has its own very unique set of physics. Usually, dust is stirred up by wind, an explosion, or by the impact of an object disturbing it in some way. Dust particles tend to be heavier, although not always, and they will usually succumb to gravity and begin to settle back down to earth before long. In some cases in the right atmospheric conditions, dust can be held aloft by windstorms for hours or days, behaving more like smoke, but always eventually returning to earth.

Fire

Fire and its by-products, like smoke and embers, are in my mind the most visceral and intense of all the elements, although as soon as I say that, the visceral intensity of a storm at sea comes to mind, and I realize that water, combined with wind, has its own raw and sometimes terrifying energy. And then there is the fact that, without wind, water is pretty tame, and without wind, fire rarely rages out of control. The energy that makes these elements take on their most ferocious nature is the wind, and its energy in turn is driven by the sun and the rotation of our planet, the ongoing cosmic battle of darkness and light, hot and cold. It is always extremely important to remember that when we are animating fire or smoke, what we are really animating is particles of combusting matter that are flowing and moving in the dynamic air currents caused by the intense heat of an ignited fire interacting with the surrounding cool air.

But fire, I must say, still holds a very special place in my imagination, and in the collective imagination of humankind. Even compared to water, it is impossible to get a grip on fire. You cannot pour yourself a glass of fire and hold it in front of you! As fire puts on its show, it dances and flickers wildly, and it is very difficult even to see it, much less touch it, or hold it. Getting too close to fire quickly becomes

extremely uncomfortable, and it is only with careful control that we can harness it and use it for our own benefit. The impossibility of holding or touching fire, along with its potential for destructiveness, lends it its intensity, its mystery and allure.

There is, of course, a highly scientific side to how fire is created and how it works. Some knowledge of the science behind fire is nice to have, but it does not really come into play at all when we are attempting to animate fire. In Chapter 3, I will briefly discuss the science of fire, but the emphasis, as always in my work, will be on *feeling* and *understanding* how fire works *in the most intuitive way possible.*

Water

Water is the wonderful and exciting element that I usually stress most of all when teaching special effects, primarily because the fluid dynamics at play when water moves are the cornerstone dynamics of all special effects animation, and perhaps the most easily observed. Elements like fire and wind embody many of the same fluid dynamics as water, but these are far more difficult to observe with the naked eye in most situations, whereas water, be it a tiny raindrop splash or an enormous rushing river, gives us a very graphic and visible demonstration of how fluid dynamics work. Adding colored dyes, air bubbles, or any number of other elements to water in movement, gives us an extremely clear view of how fluid dynamics work. And so water is one of the most enjoyable and easy effects elements to research, while remaining possibly the most complex and difficult to visualize graphically and to animate.

"Water, water everywhere, and not a drop to drink!" Looking at our
planet from a distance, it is indeed a watery place, with fully three
quarters of our planet being covered with the stuff! Water is the very stuff
of life, it would seem, and I have been utterly mesmerized by water my
entire life. I never tire of watching a boat's wake, a violent rainstorm, the
seashore, or even a simple water droplet dripping out of a leaky faucet.
Water appears to us in an infinite variety of shapes, events, and forms,
morphing itself endlessly to adapt to its surroundings and conditions.

We will look at water and fluid dynamics in two of the following
chapters: Chapter 2, "The Wave," and Chapter 3, "The Splash."

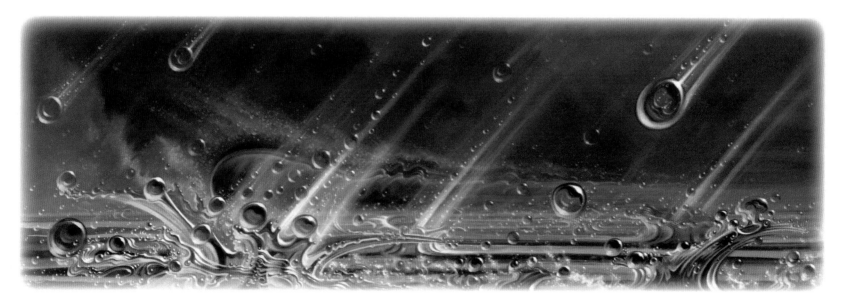

This highly stylized painting by Chris Lundy is a beautiful example of just
how far we can take our own unique interpretation of a water effect.

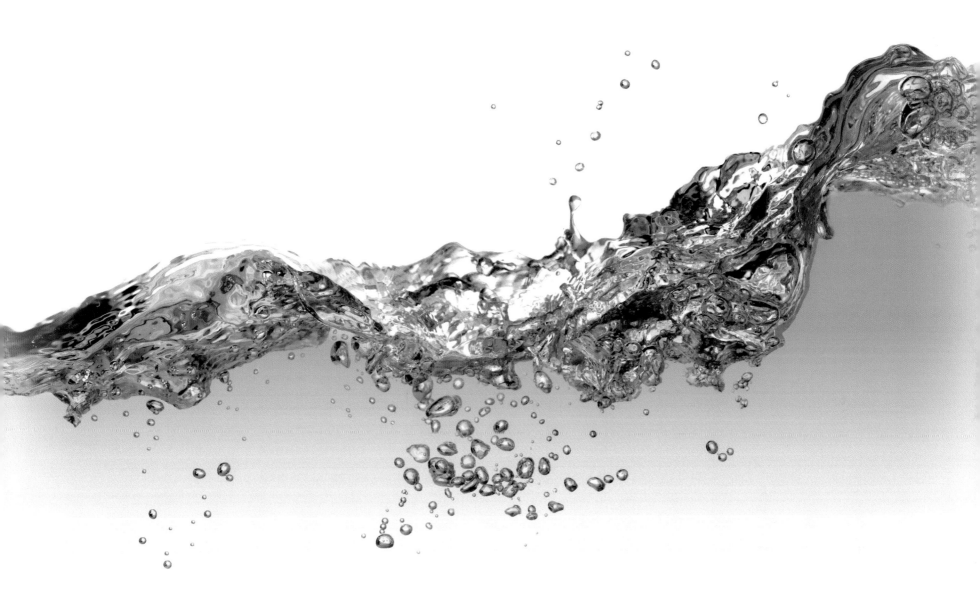

Keep in mind that all of the *principles* of elemental animation that I am presenting here will generally stay the same as a given element increases in scale, the only difference being that larger-scale elements move much more slowly and may contain a great deal more detail. But the driving physics principles remain the same, so what you learn here can be applied in a wide variety of ways to the element you are animating, regardless of their size or composition.

What really stands out to me the longer I study the physics and dynamics of all the elements is how similar—and in fact, virtually *identical*—the designs and patterns that form the structure of all dynamic energetic movement are. Everywhere I look, I see the emergence again and again of flowing, unfolding energy taking on the elegant spiraling, fractal geometry that is reflected everywhere in our known universe. And it is there as well, in all the so-called "inanimate" elements. All our surrounding flora and fauna, mountains, forests, glaciers, and yes, even in our cities, our urban, suburban, and industrial areas. All creation contains within it the same fundamental building blocks of life, from the micro to the macro. It's incredibly deep, fascinating stuff that never gets old for me, but rather evolves constantly and elegantly, providing a lifetime's worth of study, observation, and growth, in the never-ending quest to recapture the magic of the elements in my art.

One thing that is very apparent in this book is that the first three chapters, "The Wave," "The Splash," and "Lighting a Fire," make up the bulk of the book. The chapters that follow, "Blowing It Up" and "Magic: The Art of Animating Pixie Dust," are shorter chapters, with an emphasis on animating the elements themselves and much less on in-depth written details. This is because, like the walk cycle that is so important to learn as a character animator, the wave, splash, and fire chapters cover the essential principles that an effects animator needs to learn in order to animate any effects element well. Starting with the wave, which is the most important animation principle to understand if one intends to be a special effects animator, these chapters will walk you through all of the most crucial things there are to learn about animating effects. Wave action, energy patterns, energy transference, energy flow, displacement, perspective, design, hydrodynamics, timing, exaggeration, drawing styles, and pretty much everything you need to know about animating effects is covered in minute detail in these first three chapters, the backbone of this book, *Elemental Magic II.*

At the end of each chapter, you will find fully animated sequences, many of which are drawings that I created while animating scenes for the website that accompanies the book. These sequences are also included as animated clips on the website, so you can see the actual animation I have created in motion. I always felt this component was sorely missed in the first *Elemental Magic,* and it is my hope that this volume will fill in many of the spaces that my first book left blank.

Chapter 2

The Wave

In this chapter we will look at animating a wave. I have chosen to do this because waves are driven by a fundamental energy pattern that exists in all the elements, the understanding of which will help us understand how to animate all of the other elements. Wave action is found everywhere in nature, whether it be water, fire, smoke, or grass blowing in the wind. Even character animators must understand the principles of wave animation, as it can be present in a character gesturing dramatically, or in the flow of a character's hair or clothing.

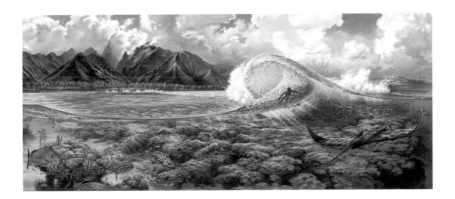

One of the most common places where we see a wavelike motion occurring is in the flapping of a flag in the wind. It is also one of the most common tests that students of animation are required to do in any animation program. Sometimes it is a "wagging dog tail" assignment, or a "flapping flag" assignment. In any case, it is a vital step in understanding how things of all kinds move. Virtually everything that can move, and that's pretty much everything, will move with some amount of wave action, however subtle. Even the tectonic plates of the earth's crust move in waves. Any physicist will tell you that waves drive much of all the energy we perceive. Sound, light, the ocean, wind, and all the elements around us manifest themselves as waves in one way or another. That is why I have started out with this element—in this case, a wave of water.

There are a wide variety of different types of waves, each of which has its own particular characteristics and behaviors. Although all waves share the same basic principles of how they move from one place to another, different subsets of waves are created differently, or resolve themselves differently. For example, if we throw a rock into a pond, the splash that is created will have waves emanating outward from the point of impact. These small waves are usually referred to as ripples. Another example is a boat traveling through the water, creating what we call a *wake:* a series of waves emanating outward from behind the boat.

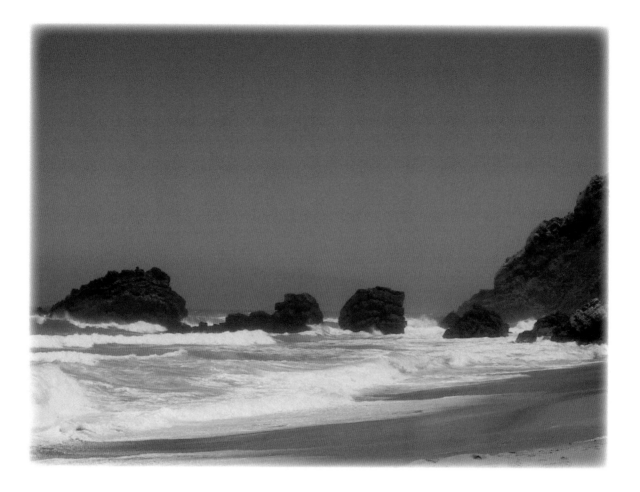

Then we have the classic waves that we see crashing into the shoreline on a typical beach anywhere in the world. Most of these larger waves are created by wind, generated by storms hundreds or even thousands of miles away from the beach in question. When these large waves are created, they absorb an enormous amount of energy from the high winds that push on the water's surface.

This energy propels these waves across vast distances, and over time they become less pronounced and lose some of their energy. Their pronounced peaked shapes smooth out, becoming large sloping waves called *swells*. These still contain a great deal of energy as they churn their way across the ocean. When these swells approach a shoreline, the energy that drives them, much like an enormous rolling engine, collides with the shapes on the bottom of the ocean as it rises to meet the shoreline. This collision pushes the swells up and sometimes over, and the formerly hidden rolling "engine" inside the swell reveals itself, as the waves rise up and roll over, forming the classic rolling beach wave that we all love to watch in wonder and awe.

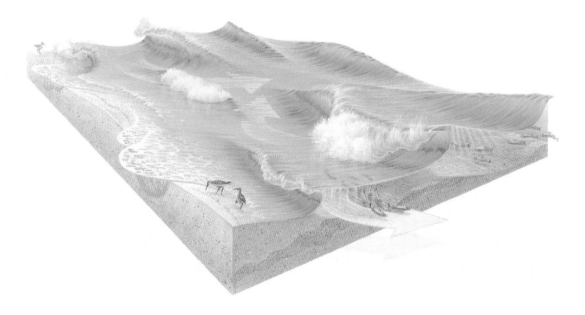

Depending on the size of the swells, and the shape of the shoreline
they encounter, waves rolling onto a beach take on a variety of types.
Sometimes they simply surge forward in gentle, lapping, flat waves that
push up the beach surface and then recede. Sometimes they tumble over
on themselves in a boiling mass of foam, not quite building up high
enough to roll over the top, but just churning into themselves instead.
And then there are the beautiful rolling breakers, the most dynamic and
exciting waves to watch, which rise up to a peak as they collide with the
bottom surface, and then the rolling engine inside the swell pushes the
top of the wave right up and over itself, forming a cylindrical wave that
plunges back down into its base explosively.

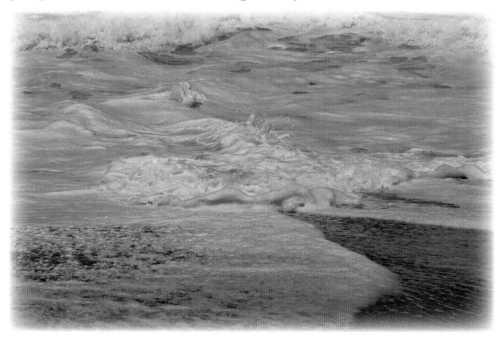

In many cases, if we look carefully, we can see examples of all three of these types of waves occurring as swell after swell rolls into the beach. The larger rolling, plunging breakers will occur farther out, where the swell, rolling in from much deeper waters, first encounters the bottom surface of the ocean. Closer to the beach as the rolling energy continues forward after the initial breaker crashes down upon itself, we will more likely see the tumbling, churning variety of waves that no longer have the size and energy required to form into rolling, plunging waves. And then closer still, as the swells finally run out of energy, we see gentle, relatively flattened volumes of water surging up the beach in shallow layers, gently overlapping each other.

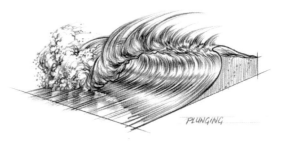

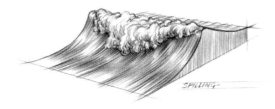

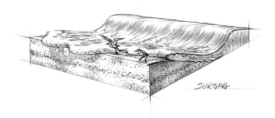

Plunging and Surging Waves
The Anatomy of a Reef Break.

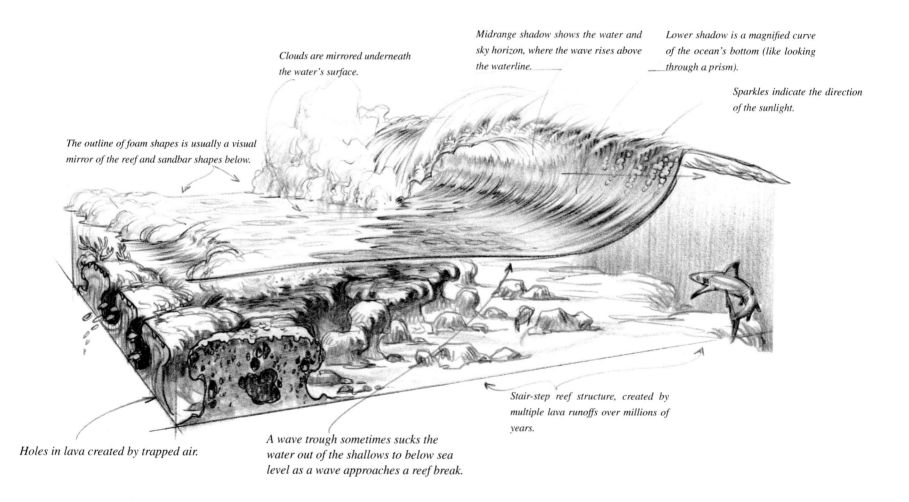

Clouds are mirrored underneath the water's surface.

Midrange shadow shows the water and sky horizon, where the wave rises above the waterline.

Lower shadow is a magnified curve of the ocean's bottom (like looking through a prism).

Sparkles indicate the direction of the sunlight.

The outline of foam shapes is usually a visual mirror of the reef and sandbar shapes below.

Holes in lava created by trapped air.

A wave trough sometimes sucks the water out of the shallows to below sea level as a wave approaches a reef break.

Stair-step reef structure, created by multiple lava runoffs over millions of years.

Spilling Waves
The Anatomy of a Mid-Ocean Breaker.

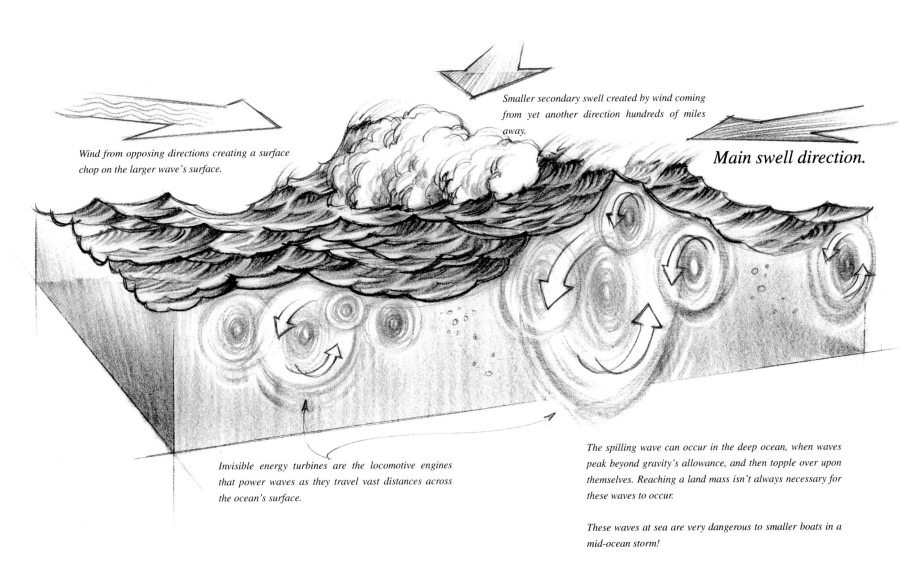

Smaller secondary swell created by wind coming from yet another direction hundreds of miles away.

Wind from opposing directions creating a surface chop on the larger wave's surface.

Main swell direction.

Invisible energy turbines are the locomotive engines that power waves as they travel vast distances across the ocean's surface.

The spilling wave can occur in the deep ocean, when waves peak beyond gravity's allowance, and then topple over upon themselves. Reaching a land mass isn't always necessary for these waves to occur.

These waves at sea are very dangerous to smaller boats in a mid-ocean storm!

How Do Waves Travel, and What Happens When They Reach the Shoreline?

Wave swells are created by storms and wind, sometimes hundreds or even thousands of miles away, on the open ocean. The energy is transferred from the wind to the water, and rolling "engines" of energy are created in waves that can travel great distances, literally "rolling" across the sea.

As the wave reaches still shallower water, the rotating engine inside of it runs out of room, and with nowhere else to go, the energy is forced upward and outward over the top of the wave, spilling over into the classic "tube" shaped wave, so sought after by surfers around the world.

Swells from Distant Storms

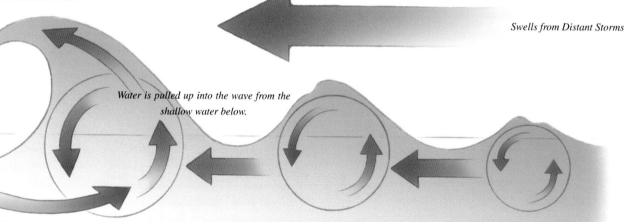

Water is pulled up into the wave from the shallow water below.

The rolling circular motion of the wave's internal energy literally sucks water into its turbine from the shallows ahead of it. This creates the "undertow" that we feel when we wade in the shallow water along a beach.

Rolling, turbinelike engines inside each wave begin to rise up as they approach shallower water. As there is less water below them, there is then less resistance to the water being pulled up into the rotating engine of the wave. This is why we see waves appearing to grow as they approach the shore.

The Great Wave of Kanagan, Katsushika Hokusai, 1831

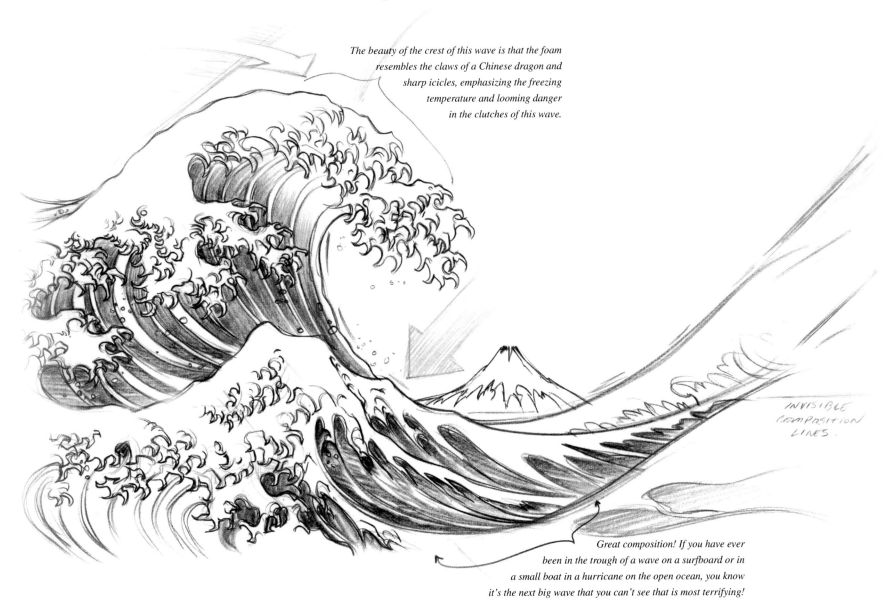

The beauty of the crest of this wave is that the foam resembles the claws of a Chinese dragon and sharp icicles, emphasizing the freezing temperature and looming danger in the clutches of this wave.

INVISIBLE COMPOSITION LINES.

Great composition! If you have ever been in the trough of a wave on a surfboard or in a small boat in a hurricane on the open ocean, you know it's the next big wave that you can't see that is most terrifying!

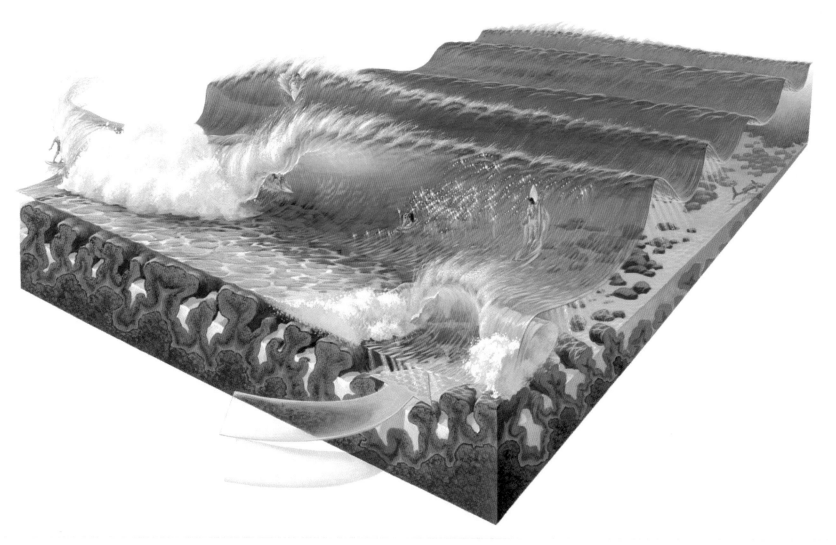

The "Pipeline" surf break on Oahu's North Shore is probably Hawaii's and surfing's most famous wave. In music and films, popular literature and art, this beautifully curling, frequently perfect "tube" of a wave break is truly legendary!

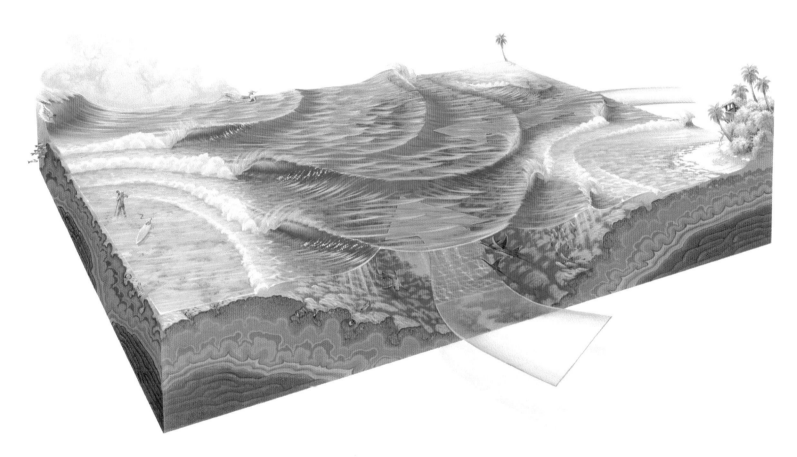

This painting is a detailed visual description of a famous surf break in Tavarua, Fiji called Cloudbreak, by world-renowned surf artist, Phil Roberts.

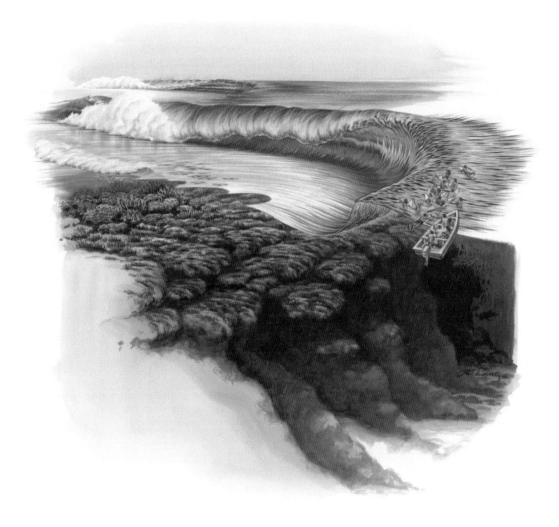

Teahupoo (pronounced cho-po) in Tahiti is one of the most famous surf breaks in the world, and one of the most severe and dangerous to surf. The shape of the underlying reef causes the water to be sucked out quickly as a large swell approaches, pulling the water up into itself. This creates what is sometimes called "the heaviest wave in the world," with an extremely shallow reef in front of it.

Waves in a Pool

In the following pages, for the purpose of analyzing and understanding simple wave physics, I am going to be looking at how waves behave in a slightly more controlled environment than the ocean. We will be looking at a body of water roughly the size of a small swimming pool, and how waves that have been created in this kind of environment behave. Understanding how smaller, simpler waves roll, bob, and interact with each other will give us a good understanding of how to approach much larger ocean waves.

One of the most important principles of how water reacts to being pushed around or moved in any way, is the principle of displacement. Water molecules have a fascinating way of occupying space. If you push water around, its molecules slip and slide fluidly into the most immediate available space around it. This obvious characteristic of water is most easy to describe simply by placing any object into a body of water. Immediately, the water will fill the surrounding available space. We all know this from everyday interactions with water, such as filling a bath to just the right amount of water, and then watching it spill over the sides when we climb in, having not allowed enough space in the tub for the water that would be displaced by our bodies. Or sticking our fingers into a glass of water to fish something out and witnessing the immediate overflow of water.

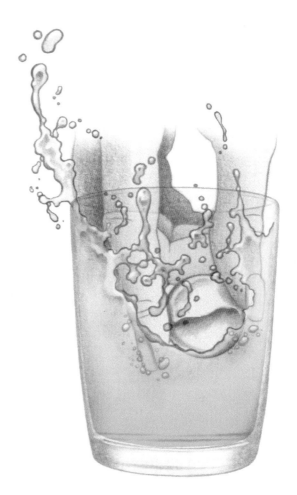

This is one of the simplest examples of water displacement. When we stick our fingers into a glass full of water, the volume of our fingers displaces the water.

But this simple principle of displacement takes on much more interesting characteristics when the body of water is large enough to allow waves to form, and there are much larger spaces available for the water to move into. When we displace the water in a swimming pool with our bodies, the initial reaction, if we jump right in, is a terrific splash, as the water around our bodies is quickly displaced and propelled outward with a great deal of energy.

The effect is obvious, but what we can't see when we are looking at a much larger body of water is that the overall level of water in the pool has risen slightly. The volume of the person's body has displaced that same volume of water, and it fills up the available space around it. As the splash settles and the waves created by the splash settle, if the person stays in the pool, the overall level is now higher.

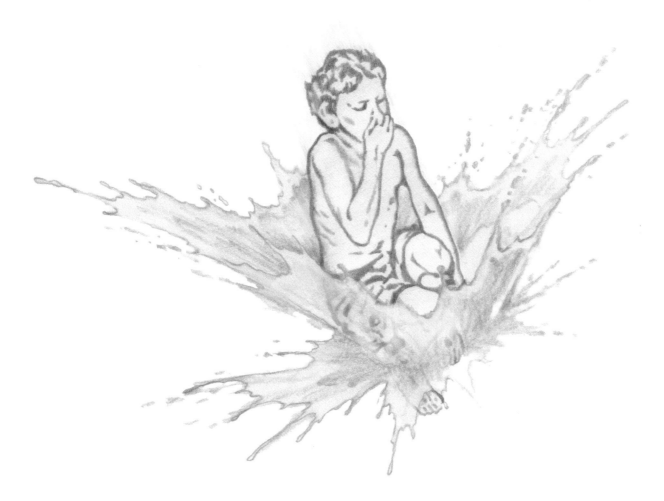

I describe all of these somewhat obvious phenomena to point out just what it is that creates the waves sloshing around in a pool of water, when there are people swimming, splashing, playing, and getting in and out of the pool. Water is forever looking for a way to displace itself, and the energy of the various disturbances in a pool create a myriad of wave movements, with various shapes and sizes of waves rolling in every which direction and crisscrossing each other, trying to evenly fill the available space in the pool. And when waves and ripples reach the walls of the pool, they bounce back, so to speak, and carry their energy back out into the pool, further contributing to the action.

This is the very same thing that is happening to the oceans, seas, and lakes we observe, but on a much smaller scale. On an active lake in the summer, filled with water skiers, wake boarders, people fishing, and swimmers, even on a calm, windless day we will see a choppy surface created by countless disturbances to the water's surface around the lake. If it is a windy day, the resulting directional waves interact with all the other various surface disturbances, resulting in a seriously choppy lake surface. And all these waves are constantly flowing into the shoreline and "bouncing" back into the main body of water.

The enormous waves and chop we sometimes observe on the ocean are the exact same thing, except that instead of being created by things as small as ski boats and swimmers, the large swells we witness on the ocean are created by massive storm systems, sometimes thousands of miles away. But the exact same principles are at work, and I truly had an "aha moment" when I was first able to visualize the ocean as a massive swimming pool that has been disturbed in various ways: in other words, simply a body of water, forever displacing itself, covered in a variety of waves, ripples, and swells, all just looking for the path of least resistance.

Add to this, of course, the fascinating phenomena of global tidal pull, and we can see the ocean as a massive, heaving, pushing, and pulling body of water, forever restless, simply water molecules sliding around against each other, looking for space. Smaller weather systems scattered over the vast areas of open ocean create still more layers of active waves, some in the form of swells, and some as more localized choppiness. People who have spent their entire lives for generation after generation out on the seas can look at an ocean surface and tell you about the multiple weather systems that have created that day's surface characteristics!

Animating Waves

So let's look at some of the techniques I use when I am animating wave action, starting out with the most basic principles. First of all, it is very important to think about strong effects design principles before even getting started with the animation. By far one of the most important is to make sure we include the principle of chaos, or lack of repetition in our design, as with all solid effects design. It sounds simple, and it is an idea I discussed at length in the first volume of *Elemental Magic,* but it is extremely important and bears repeating here.

The human brain, it would seem, is wired for repetition. We see it in everything we create—our architecture, music, and design. Repetition with subtle variations is actually the basis for a great deal of classical music, modern art, literature, and architecture. It is almost as if the waves of creative thought in our brains reveal themselves in waves. We think in waves. And one could very well say, after observing the ocean for hours, that well, if you've seen one wave you've seen them all. The seemingly endless and monotonous march of waves from the open sea to the shoreline does not appear at first glance to be a marvelously varied and infinitely differentiated collection of waves.

Using only the extremely simple and quite perfectly repetitive water design above, and simply repeating it over and over, resizing and repositioning it, we can come up with a serviceable depiction of a water surface. But there is something not quite right about this ordered, evenly spaced procession of waves, and our intuition tells us this at a glance.

But of course we know that, like fingerprints or snowflakes, no two
waves are identical. And although we can definitely use repetition, and
actually must use repetition to our advantage when designing what our
water will look like, we must stay keenly aware of the fact that sets of
waves don't come in identical sizes, or perfectly repeating time frames
for that matter. And the closer we get, the more we must bring these
principles into play. That is to say, from a distance, in a long shot of
an ocean surface, the variation between sizes and shapes of waves can
afford to be minimal.

When our eye is looking at thousands of wave shapes stretching out
to a distant vanishing point in perspective, it cannot easily discern the
difference between every wave. But when we are looking at a small,
close-up section of water, variation in size and shape is of the utmost
importance! So that is what we are going to examine here. There is also a
film clip on the accompanying website www.elementalmagicbook.com, in
which I animate a cross-section of a wavy water surface from scratch.

One of the first things that most artists do when they are thinking
about designing a natural element like water or fire is to dip into the
preexisting history of human cultural icons. These are images that have
come to represent the element in question, symbols that work almost
like letters to tell us "This is water, this is fire." And although this can be
a good place to start, when you look at the organic, fluctuating, fractal,
chaotic nature of the elements, it is apparent that these icons miss the
mark. They are symbols only and lack the true essence of the element in
question.

The icons we have designed as symbols to describe the elements, are elegant, simple, and usually repetitive. They are designed so that they are extremely easy to create and to recognize. So let's start designing our water by taking one of the most recognizable symbols for water, the symbol for the sign of Aquarius in the zodiac, which is simply two squiggly lines, evenly spaced, one above the other.

Here I have drawn up a collection of various symbols associated with the astrological sign of Aquarius. This ancient depiction of water is a perfect example of how human culture has iconified the elements into symbols that describe the elements in a very straightforward and basic way that anyone can recognize.

I took my favorite Aquarian symbol from the collection on the previous page and then just stretched it horizontally a little bit.

Then, I take a few key points on the perfectly repetitious design, and I push and pull them up and down here and there, to create something more natural and chaotic.

Now I have the basis for a drawing that actually looks something like real waves might look! This demonstrates that the perfectly even, repetitive design has within it the potential of a good water design. Its root design is fundamentally sound.

This is not how I would ever go about designing a water surface, but if you are ever trying to draw waves and they are looking too repetitive, try this little trick to whip them into shape. I have to do it all the time when my repetitive logical brain is taking over my drawing!

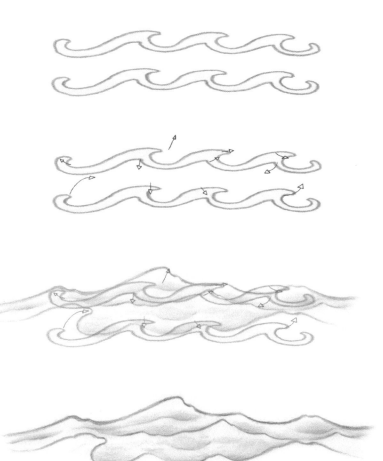

And so from a highly stylized, idealized graphic representation of a wave, we have learned that with just some minor adjustments we can add just the right amount of variety to the shapes to come up with something that looks and feels quite natural. This is a great help when we are animating a wave, because it is simpler to start out with the most basic wave shapes in our drawings, and then add the more chaotic variations as we go.

The following drawings will demonstrate further how I come up with my initial wave designs: first, by keeping my drawings quite rough and the shapes quite simple, and then by nailing down the details and areas that need adjusting. The technique of sketching first is very important, just as when drawing a human figure from life it works best to draw dynamically with energy, to capture the essence of a body's pose, before adding the details and shading. I cannot emphasize this approach to

creating special effects enough, and I will repeat it over and over 'til
the cows come home. In order to properly convey the energy of a given
effect, we must draw with that energy in every stroke of our pencil.

If you are an artist working primarily with digital tools, learning to create elements using this technique will teach you more about them than you could ever learn from working on a computer. When trying to find the essence of an effect, the steps to take are as follows:

First of all, check it out! Look for examples in the natural world around you and immerse yourself in them. Take photos, shoot footage, and whenever possible, attempt to draw the effect you are observing. If you can't find a given effects element, try to find a way to create it yourself. Looking for wave dynamics? Take a bath! Get to a beach, lakefront, or river. And of course, if you can't get out and find it in the great outdoors, there is a wealth of reference to be found on the Internet. But I implore you, do not use the Internet as your first line of enquiry. Look around you first, and get creative about finding out how something works—this is the real key to being a great visual effects animator. Make the effects a part of your life!

On the accompanying website, I will animate a cross-section of a
dynamic wave, step by step for you to watch. The drawings from that
session will follow on the final pages of this chapter, to supplement the
clips of the drawings moving and animated on the website.

Now let's get animated!

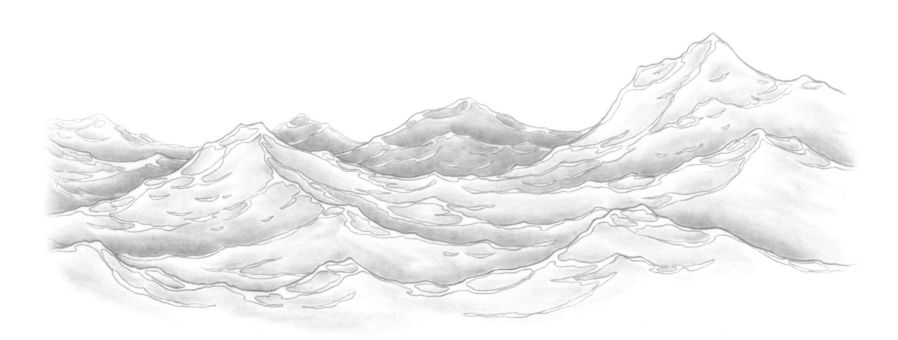

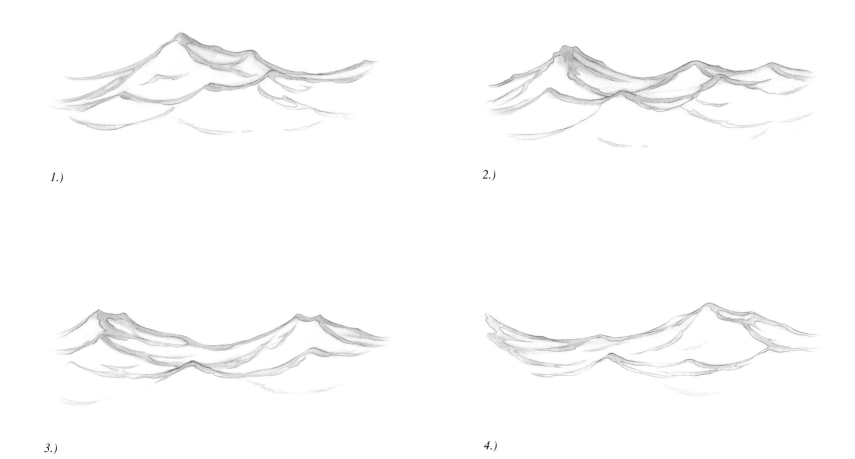

1.)

2.)

3.)

4.)

If this image sequence looks familiar, it is, because it did appear in the first Elemental Magic.
I have included it here, bcause in the first volume, it was accompanied by a multitude of letters,
arrows, and explanations, and I thought it would be far more elegant to present it on its own.

5.)

6.)

7.)

8.)

Look for this sequence and others like it on the Elemental Magic II *website, where I will be posting tutorials, live animation classes, and animated effects clips. It will be updated continually, and I look forward to hearing from my readers and finding out what you would like to see more of. Happy Elemental trails!*

Chapter 3

The Splash

The water splash is one of my all-time favorite things to animate. Although there are very clear and definite physics principles at work in every splash, and each splash is somewhat predictable, every splash is also an entirely unique event. And there is always some sort of a unique twist, or anomaly, in every splash. They are as unique as fingerprints, perhaps even more so. The more splashes I see, even after 50 years of observing them closely, the more I see how utterly infinite the variations really are!

Elemental Magic, Volume II
57

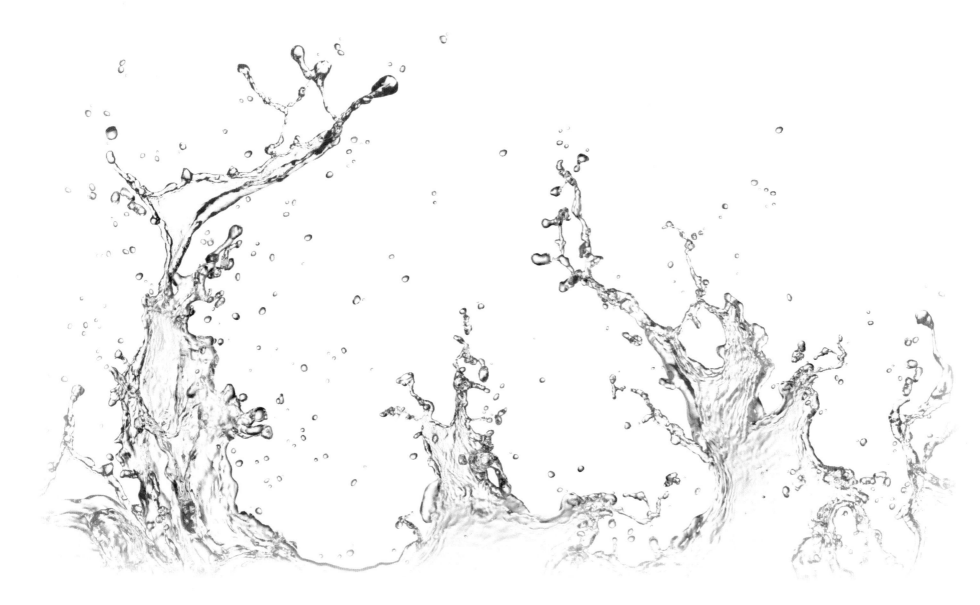

The incredible shapes that water takes on when it is disturbed in any way have mesmerized me ever since I can remember. From the very first memories I have of playing in a bathtub, probably when I was two or three years old, I know that I was completely absorbed by watching the shapes and flowing movement of splashes and ripples. And as I grew up, the fascination only became stronger. Whether I knew it or not, as I grew up I was preparing myself to be a special effects animator, by spending inordinate amounts of time playing with and observing the physical characteristics of the water around me.

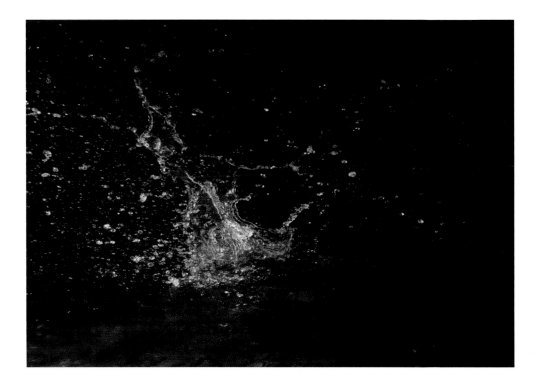

I was a lucky child in that there was lots and lots of water to play with. Even though I grew up in Canada where everything is frozen for six months out of every year, when the weather warmed up in early summer, our family headed straight to a country cottage place, always situated directly on the banks of a lake or river, where I would spend as much time in the water as humanly possible throughout the short summer months. I was taught to swim by the tried-and-true method of sink or swim, tossed unceremoniously into the lake, with my father and big brother watching closely to make sure I didn't sink. Once I was comfortable in the water, it was hard to get me out. And then the fascination with water really began to take hold of me.

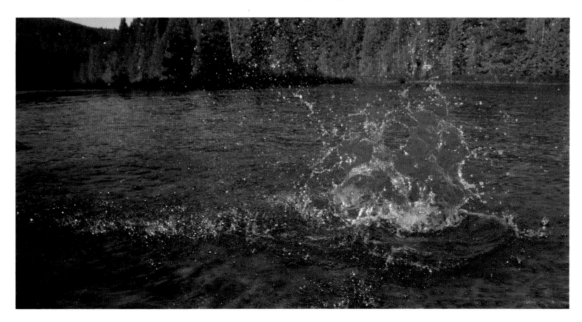

Most of the photos on these pages were taken on the shores of a river near my home, with a typical SLR digital camera. One does not need special equipment to capture exquisite reference photos!

Looking straight down into a small pool of water, I dropped a small rock and snapped this beautiful photo—a great ripple reference!

In a classical splashing match with my brother and sister, long after they had tired of the game and moved on to something else, I would still be making splash after splash just to look at the incredible shapes that resulted. The discovery of cupping your hands and plunging them downward sharply into the water to create a great plopping galumph of a sound, a spectacular splash, and an amazing array of bubbles, kept me busy for hours and hours, repeating the experiment and carefully observing the infinitely varied results. The same thing would happen when we sat on the end of the dock with only our feet in the water. While other people would get into conversations, or maybe contemplate the sunset, I would sit transfixed, kicking away and watching the splashes I was creating with my feet in the water, sometimes for hours.

For me, it was simple and natural fun at the time. But I have realized after many years animating water, that this is the very best way to learn about water, and so I encourage anyone interested in animating fluids to play with them every chance you get. After so many years, it has not lost its fun for me in the least. I can still spend hours skipping stones from the shore, tossing different sized rocks into the water, or just watching the waves roll in. And I'm still learning today, every time that I play!

In fact, as I sit writing this, I can tell you that I actually went to a river near my house today, to take some splash photos with my 25 year old nephew, Ben Duperron. He was my cameraman as I threw different sized and shaped rocks into the water. And, as always, I was surprised many times by the size and shape of the many splashes I created. The most subtle change in the trajectory and angle that a rock hits the water changes the characteristics of the splash completely. While this is something I have known for a long time now, I am still always taken aback by how extremely subtle changes in the way a rock enters the water change the splash entirely.

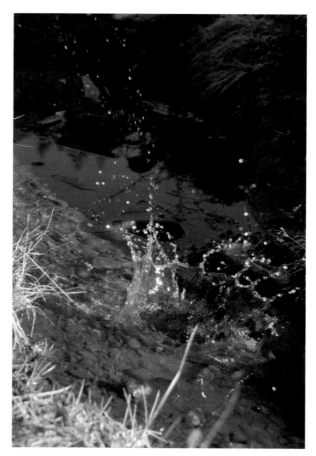

I would find a nice big flat rock, hoping to get a big walloping splash out of it, only to watch it rotate slightly in the air and pierce the water on an angle, hardly creating a dynamic splash at all. Sometimes a rock I was really

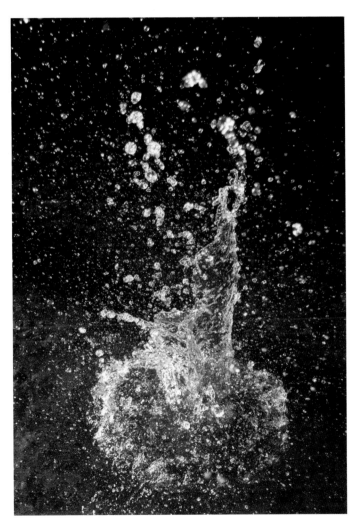

excited about throwing in would turn out to be a complete dud because of the wrong entry angle. Over the course of an hour or so, I developed strategies for getting rocks to land at the desired angle relative to the water surface, to create the optimum splash. Without fail, every bit of water research I do always teaches me something new. So I strongly suggest you try it, if you really want to figure out how splashes work. Go on down to the nearest body of water you can find, be it the ocean, a lake, a river, a small stream, or the local swimming pool, and experiment with throwing things into the water. It's one of the greatest forms of edutainment in the world!

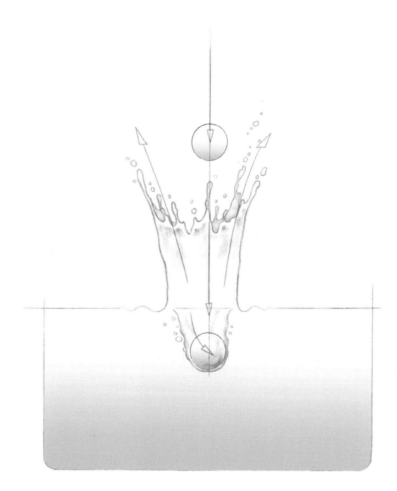

The slightest change in the trajectory of an object striking the water will change the characteristics of the splash immensely! In this drawing, a small ball is dropped straight down into the water, creating a fairly even and symmetrically shaped splash.

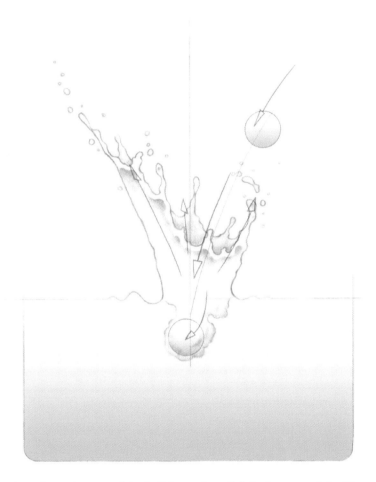

In this drawing, the trajectory of the ball is coming slightly from our right. The splash is now weighted slightly to the left, as the force is stronger on that side on impact. The ball will react to its impact with the water more than the ball that was dropped straight down, and have a more erratic underwater path of action.

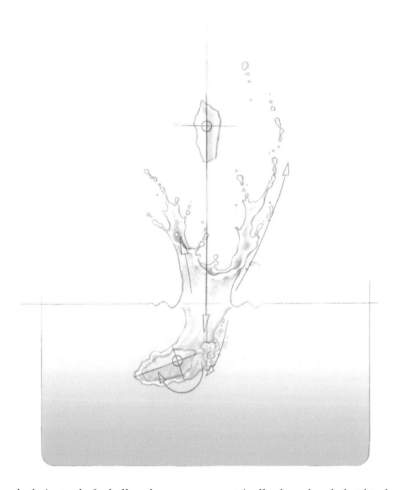

In this splash, instead of a ball we have an asymmetrically shaped rock that has been dropped straight down into the water on its end. It strikes the water with its pointiest end, which allows it to slip into the water without making a very pronounced splash. The rock pivots wildly as soon as it strikes the surface and plunges under the water.

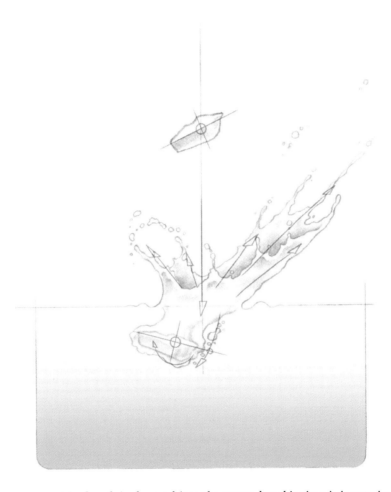

The same asymmetrical rock is dropped into the water, but this time it is rotating as it falls, and it strikes the water with its flat side, which creates a far bigger and more dynamic splash than in the previous example. The flat side of the rock has far more resistance than the pointy end, so the rock decelerates quickly as it plunges underwater.

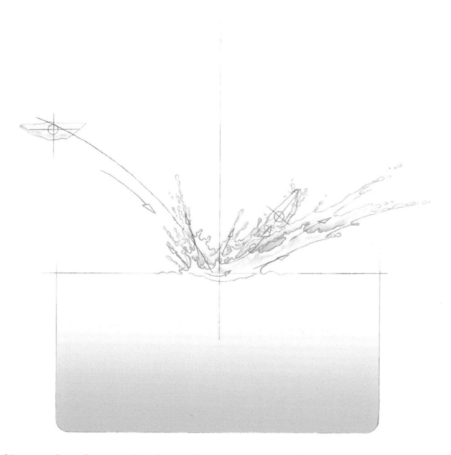

In this example, a flatter rock is thrown from an extreme angle, as we might throw a rock if we were trying to get it to skip along the surface. If it strikes the water on its flat side, the surface tension of the water may be greater than the force of the rock hitting it, in which case the rock will actually bounce, or skip off of the surface of the water. The resulting splash has a smaller volume of water than if the rock had actually broken through the surface, as much less water has been displaced.

In this great photo, you can actually see the airborne rock in the upper-left-hand corner. My intrepid photographer, my nephew Ben, took rapid-fire photos while I skipped rocks. In a splash like this, the rock does not create a very large pocket of air when it hits the water, so the secondary splash will be relatively small. You can see the thin walls of the primary splash just reaching their highest point, or apex, as the small blurb of a secondary splash churns up from the surface where the rock struck the water.

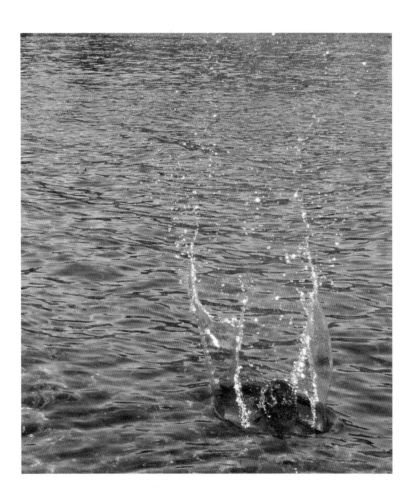

As I mentioned earlier, in some respects splashes are actually extremely predictable. There is a sequence of events that happens every time we throw something into the water. This was covered quite thoroughly in my first book, but let's do a short recap here just to refresh our memories.

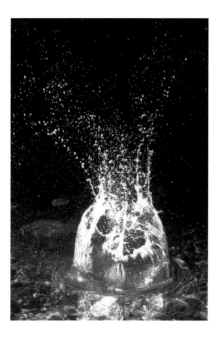

A nice example of a "primary" splash.

We in the effects animation community often refer to a splash as an event that can be broken down into two basic stages: the "primary" splash, and the "secondary" splash. The *primary splash* is the thin sheet or spray of water that shoots up and out around the object hitting the water in the characteristic splash shape on the initial impact.

The *secondary splash* is a result of the hole that was poked into the water by the object, quickly filling up with water that usually shoots straight up from the center of impact shortly after the primary splash. Once we understand these two events, and the forces that cause them to happen, we are well on the way to creating interesting and dynamic splash designs.

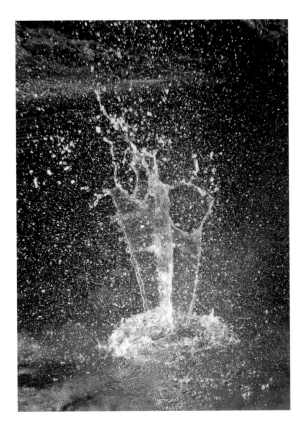

A good example of a "secondary" splash.

The more we observe splashes with an awareness of the primary and secondary splashes that are occurring, the more we see that there are extremely pronounced variations between the intensity and size of each separate event, largely depending on the size, shape, trajectory, and speed of the object hitting the water. In some cases, the primary splash is barely visible, but the secondary splash is huge.

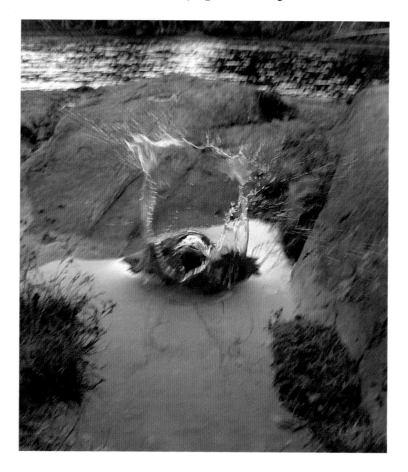

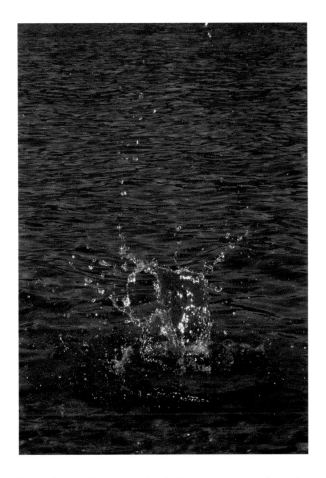

In other scenarios, the primary splash is pronounced and quite large, and the secondary splash is almost nonexistent. In time we begin to see why these differences occur. Then, when it is time to animate a splash, if we can take into account all of the variables in setting up the splash, we can predict with some accuracy whether the primary or secondary splash will be the dominant visible element.

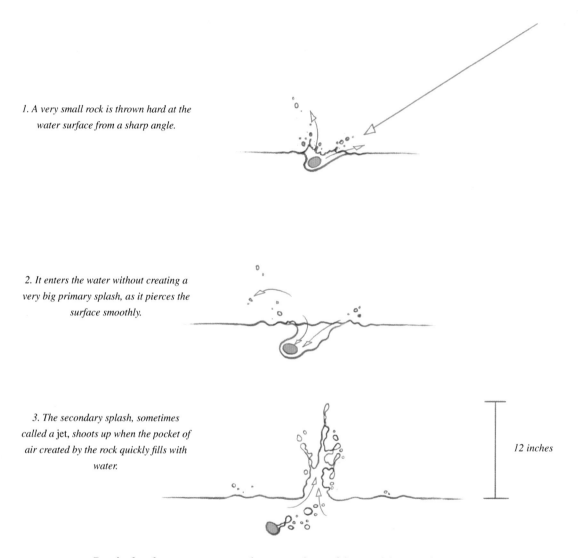

1. A very small rock is thrown hard at the water surface from a sharp angle.

2. It enters the water without creating a very big primary splash, as it pierces the surface smoothly.

3. The secondary splash, sometimes called a jet, *shoots up when the pocket of air created by the rock quickly fills with water.*

12 inches

Let's look at some good examples of how this works. If a relatively small, 2- to 4-inch-diameter round-shaped rock is thrown at the water with some force, and enters the water moving very quickly, we are likely to see a relatively small, almost nonexistent primary splash, followed by a fairly forceful secondary splash.

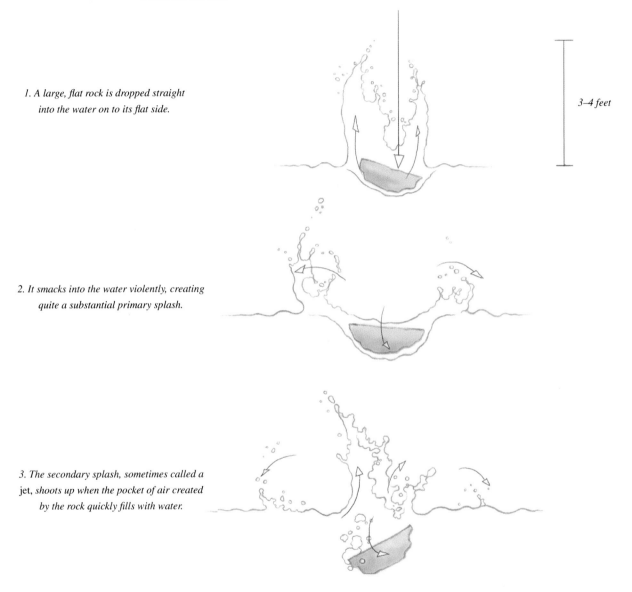

1. A large, flat rock is dropped straight into the water on to its flat side.

3–4 feet

2. It smacks into the water violently, creating quite a substantial primary splash.

3. The secondary splash, sometimes called a jet, shoots up when the pocket of air created by the rock quickly fills with water.

If we drop a large, flat rock straight down into the water, ensuring that it lands on its flat side, we will get a very large primary splash, followed by a pretty substantial secondary splash.

1. A small pebble is dropped straight into the water

2. It strikes the water's surface without displacing very much water. The primary splash is small.

3. The secondary splash, or jet, shoots straight up.

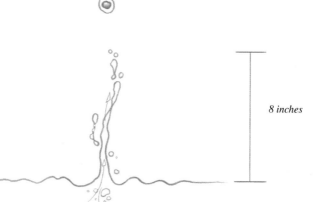

8 inches

A small rock or pebble dropped straight down into the water will create very little primary splash but quite a pronounced secondary splash.

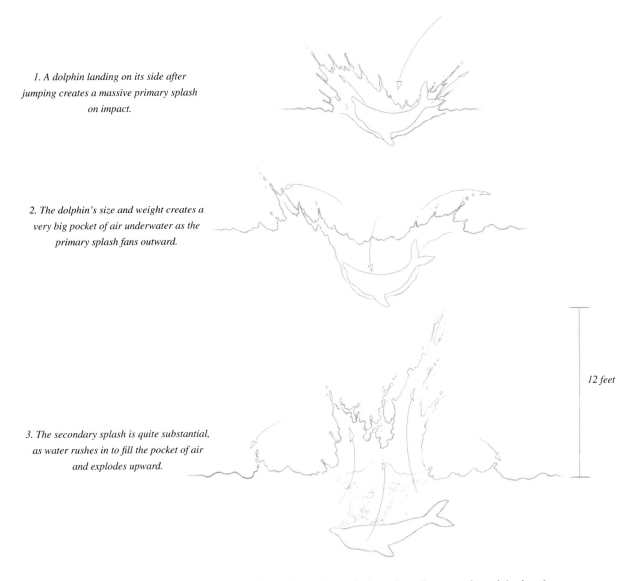

1. A dolphin landing on its side after jumping creates a massive primary splash on impact.

2. The dolphin's size and weight creates a very big pocket of air underwater as the primary splash fans outward.

3. The secondary splash is quite substantial, as water rushes in to fill the pocket of air and explodes upward.

12 feet

A dolphin leaping into the air and then landing on its side in the water will create a fairly large and spectacular primary splash, but then the size and weight of its body will punch a huge pocket of air into the water, resulting in a very big secondary splash.

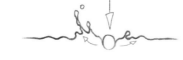

1. A single raindrop falling into the water creates a tiny little primary splash.

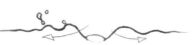

2. The drop, being water itself, is absorbed into the water, but its molecules still have some momentum, pushing a small indent into the water surface.

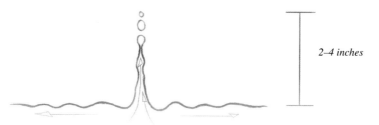

2–4 inches

3. A small jet shoots straight up from the point of impact when the indent in the water surface bounces back.

A single raindrop landing on the water's surface creates an almost imperceptible primary splash, and then a fairly noticeable secondary splash will shoot up afterwards.

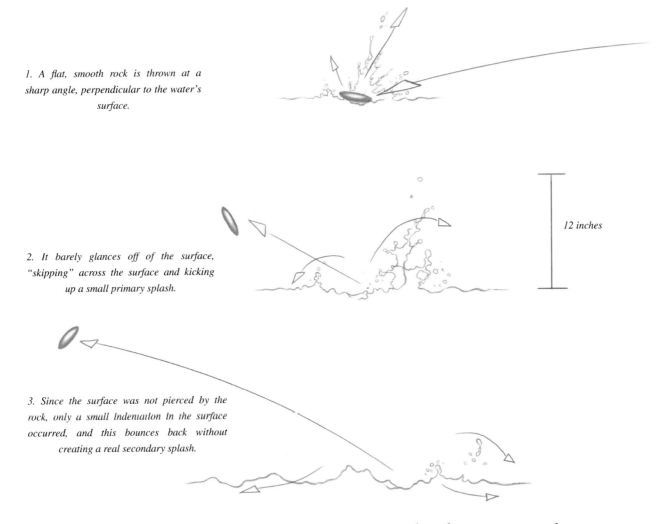

1. A flat, smooth rock is thrown at a sharp angle, perpendicular to the water's surface.

2. It barely glances off of the surface, "skipping" across the surface and kicking up a small primary splash.

12 inches

3. Since the surface was not pierced by the rock, only a small indentation in the surface occurred, and this bounces back without creating a real secondary splash.

Throwing a disc-shaped rock at the water surface from an extremely sharp, low angle will produce a pretty nice primary splash, and almost no secondary splash at all.

1. A person jumps into the water in a curled up "cannonball" pose.

2. This creates a big primary splash as the body displaces a great deal of water.

3. The secondary splash is also quite substantial, as the large air pocket created by the body quickly fills up and shoots upward with force.

5–6 feet

A person jumping into the water can create a great variety of primary and secondary splashes, depending entirely on the position of his or her body and its trajectory on impact with the water. Tucking the body into a ball to do a classic "cannonball" into the water usually creates a primary splash that can be quite large, and a secondary splash that is even bigger.

1. A person jumps into the water with one knee drawn up to his chest and the other leg extended.

2. The extended leg pierces the water, allowing the body to slip into the water with more speed and force than if it had hit the surface directly.

8 feet

3. The body entered the water with extra force and created a very big air pocket, which in turn creates an impressive secondary splash.

Another classic jumping position is called the *can opener,* wherein the jumper pulls one knee up with his or her arms wrapped around it and attempts to land at a very particular angle to the water surface. Properly executed, the can opener creates the optimum enormous secondary splash, after a relatively small primary splash. This is a favorite jump for young boys and girls wanting to make the biggest splash possible.

A neat, carefully executed head-first dive will produce a tiny primary splash and an equally small secondary splash. The scoring of Olympic divers requires that their entry splashes, both primary and secondary, be very small, as this indicates that the diver has entered the water as straight as possible.

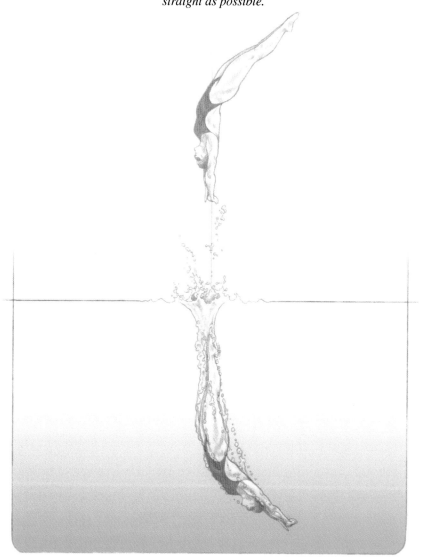

1. *A soccer ball hitting the water lands with a "splat" and shoots out a primary splash that is mostly spray or very thin sheets of water.*

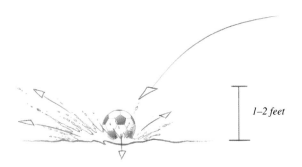

1–2 feet

2. *As the primary splash fans out away from the ball, the ball actually bounces, but it is "stuck" to the water because of the surface tension, so its bounce is hampered and it doesn't get far.*

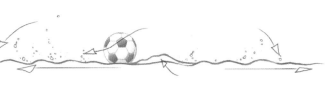

3. *The ball stays stuck to the water surface bobbing slightly. The indent that it made bounces back up creating additional ripples radiating outward.*

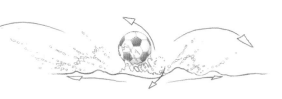

4. *Objects that are extremely buoyant, like a soccer ball hitting the water, will create only a primary splash, with little or no secondary splash at all, because the water surface is not broken and the air pocket required to create the secondary splash is not created, thus, no real secondary splash. There will, however, be a small amount of wave rebound from the indent where the ball hit the water.*

Understanding how the buoyancy of an object will affect the way
it interacts with water is very important: for instance, the size and
dynamics of the splash a waterlogged piece of wood makes, compared
to an extremely dry piece of wood of the same approximate size and
shape. The waterlogged piece of wood is heavy and will penetrate much
farther into the water when it lands. The dry piece of wood, which is
much lighter and more buoyant, will not penetrate the water's surface
as far on impact, and it will bob back up much farther after its initial
impact.

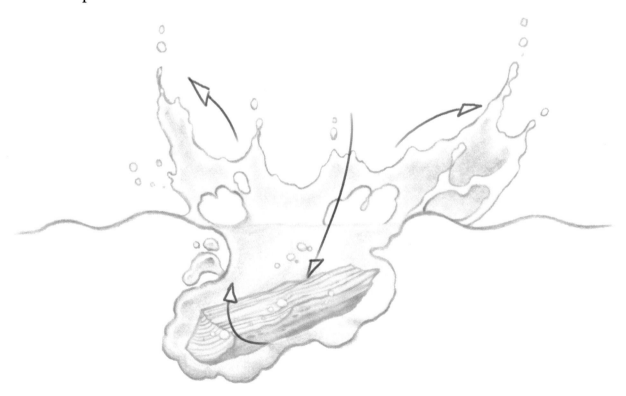

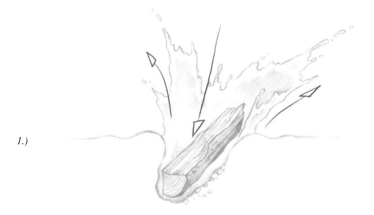

1.)

A very wet, saturated piece of wood is far heavier than a dry piece of wood, and it will collide with the water with more force, penetrating much farther into the body of water than a dry piece.

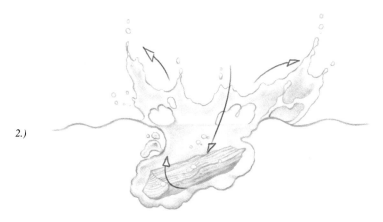

2.)

On impact with the water, a very wet and heavy log will most likely go all the way under the water, due to its weight and momentum. It will create a fairly big pocket of air around itself as well.

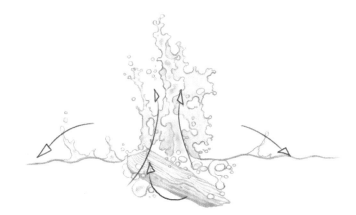

3.)

When the large pocket of air that the heavy log has created is displaced with water rushing back in to fill it, the result is a substantial secondary splash that will shoot upward quite high. It may be much bigger than the initial primary splash.

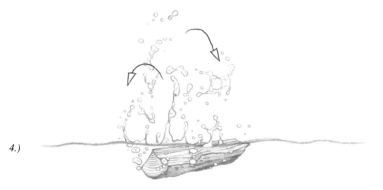

4.)

As the energy of the splash subsides, the wet, heavy piece of wood will bob back up, barely breaking the surface as the secondary resolves, falling back into the body of water.

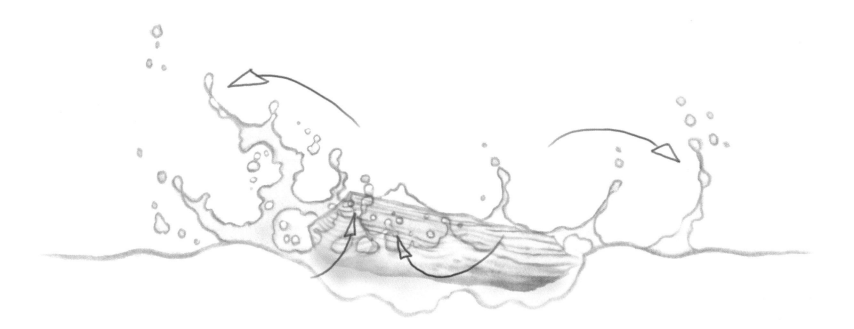

As an effects animator, you will probably end up animating a wide variety of different objects interacting with water, so you must always factor in the object's buoyancy. Even different rocks, being of different densities, will behave a little bit differently when they hit the water's surface. More porous rocks are lighter and more buoyant, and therefore will create more subtle splashes. Denser rocks will collide with the water with a lot more force and move through the water more easily, and so the splashes they create will be different.

In the previous examples, I have illustrated how differently sized and shaped objects create very different splashes. Here now are some examples of how the primary splash is affected purely by the shape of the object, and the angle at which it enters the water. I have touched on it lightly already, but I'd like to point out some additional observations that I have made while observing splashes created with various sizes and shapes of objects

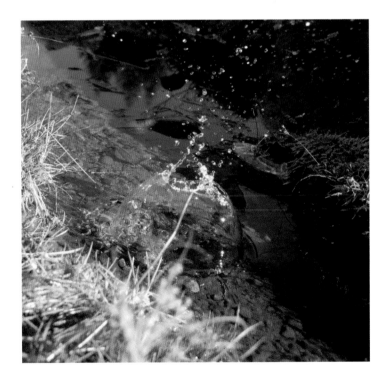

This beautiful little splash has an absolutely perfect bowl shape!

A large round rock, entering the water at almost any angle, will almost invariably create what can be described as a *bowl-shaped* primary splash. This bowl-shaped splash seems to be created by the round sides of the rock, which shape the splash as the water is forced up and around the rock at it enters the water. As it shoots up from the water's surface, this kind of splash will often close in on itself, closing the bowl shape at the apex, or highest point of the splash, and sometimes continuing this trajectory, so the splash is overlapping with itself. In other cases the bowl is pushed up and away from the object causing it, so that rather than closing in on itself over the object, the bowl will spread out and away from the point of impact.

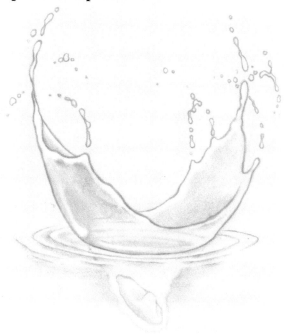

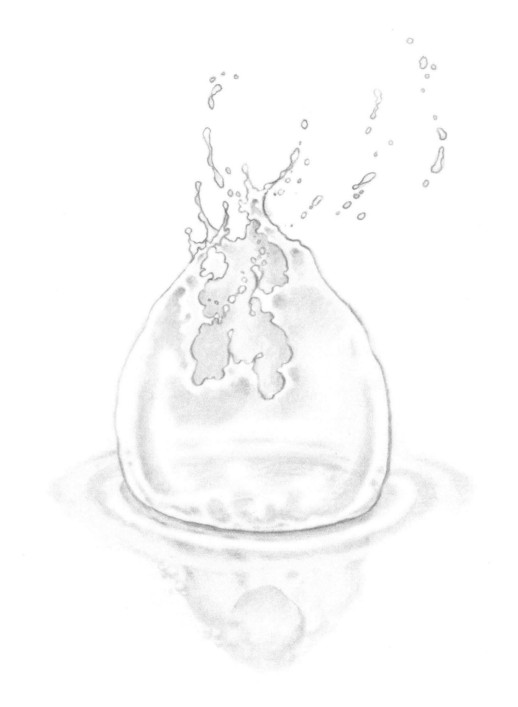

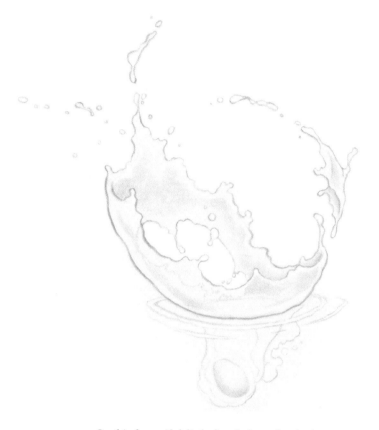

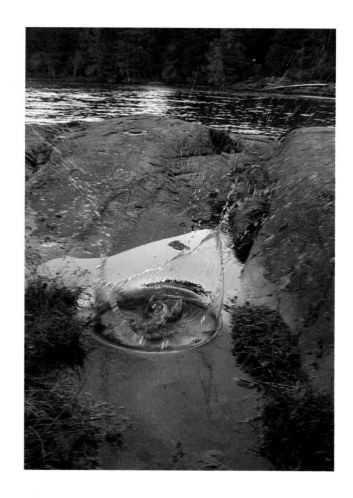

In this beautiful little bowl-shaped splash, you can see the secondary splash just starting to shoot up from the point of impact. The water is very shallow in this little pool, and the secondary splash did not amount to much more than a small, twisted up little water shape that never got much altitude.

When an object is mostly round, but has an irregularity or protruding
shape, the irregularity will cause a break in the bowl shape, so we often
see a fractured bowl shape in a splash that was caused by an object
that is somewhat round but not quite. The variations, as always, are as
infinite as the available shapes of objects.

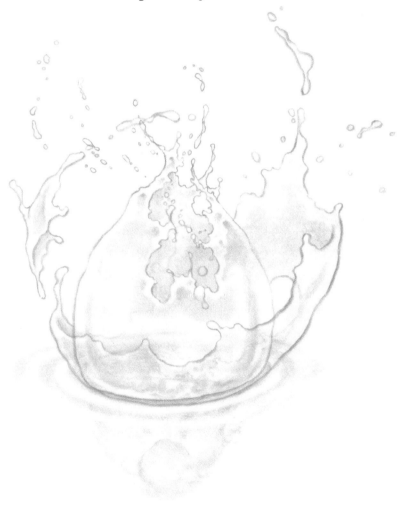

Sometimes an object that is not round at all, that I expect *not* to create a bowl-shaped splash, will indeed create a pretty perfect bowl-shaped splash. From what I can make of this, it has to do with very subtle angles of an object's entry into the water, and also with whether it is rotating or spinning when it lands. A spinning object can create a bowl-shaped splash, because its spinning causes it to create a spherical shape as it pierces the water.

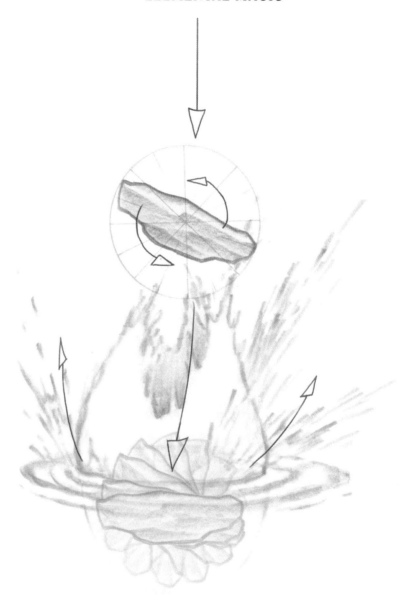

A relatively flat object, or an object of virtually any shape that has a flat side that strikes the water's surface, creates a primary splash that I will call a *sheet-shaped* splash. This "sheet" of water will adhere to the sides of the shape piercing the water's surface and take on that shape as it shoots upward. These sheet splashes can be caused by a great many different shapes striking the water, and depending on subtleties of the shape and trajectory, they will take on concave or convex shapes, be thick or thin, or break up in a wide variety of ways.

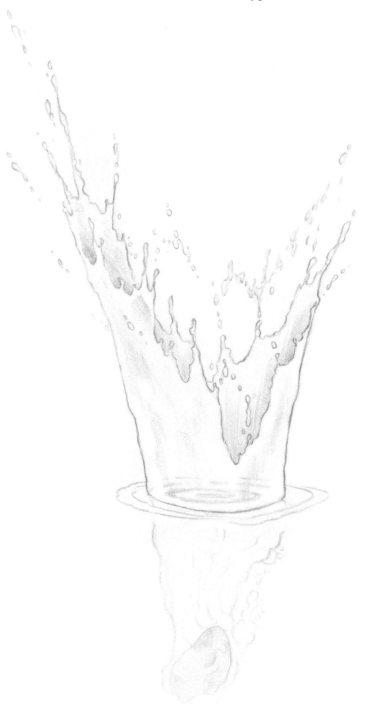

This is a sheet-shaped splash, created by a rock with quite a flat
surface that has collided with the water at roughly a forty-five degree
angle. I have left out a lot of additional droplets that would be visible
in a splash of this nature, to demonstrate more graphically the sheeting
action of the splash. This is an important feature of animating
elements like this by hand. We must simplify our drawings
compared to the real thing, as the complexity of even the
simplest splash is staggering. Although this could be seen as
a drawback to creating traditional special effects
by hand, it can also be used to our benefit,
as we are able to modify, or even cheat the
design of a given effect, to help it fit in
better with the various background
and character elements that it
interacts with.

Sometimes primary splashes take on bowl shapes, or are a combination of flat, bowl-shaped, convex, and/or concave forms. The possibilities for variety are utterly endless, and it is only through many hours of astute observation that we can really begin to understand the correlations between the shape, size, texture, weight, and speed of the object entering the water, and the outcome of the resulting splash.

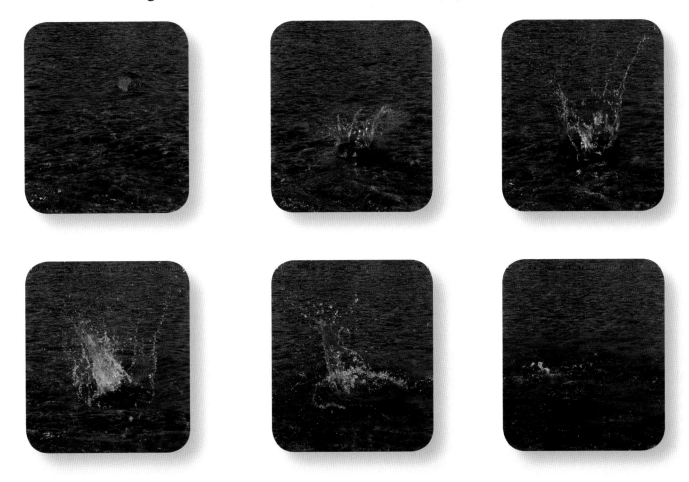

It is also extremely important to get a feeling for the way these primary splash shapes, bowls and sheets, will stretch and tear as they shoot out farther from the point of impact. This is a key element in creating convincing splash animation. It is a phenomenon caused by the physics of the water molecules that create water surface tension, giving water its fascinating fluid qualities. This comes into play as the primary splash extends and expands away from its origins, the energy pushing it up and away from the point of impact. The adherent quality that holds water molecules together cannot stand the force of the energy pushing it, and the result is that the sheets of water rip and tear up in a very particular way.

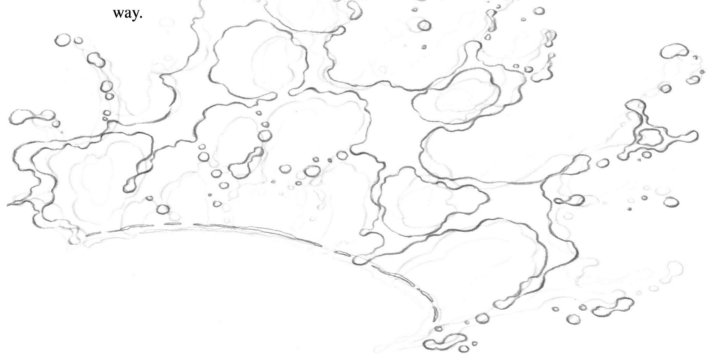

At first we may see small holes appear in the wall of a splash that expand and spread apart, eventually breaking the sheet of water up into hundreds, thousands, or even millions of tiny water droplets. *It is extremely important to always remember that this tearing and breaking apart of the splash's wall must also follow the directional path of the energy that created the splash in the first place.* These holes and tears do not ever appear at strange, obtuse angles contrary to the forces propelling the splash. They must always reflect the pattern of those forces!

The way I imagine this process occurring, is that the initial splash contains all of the energy of the impact that created it. Then, as the splash shoots up and away from the point of impact, the energy weakens, and the water molecules begin to return to their natural state. So what starts out looking like an explosion with a great deal of directional energy and design, becomes more fluid and "water-shaped" as it loses its energy.

1.)

2.)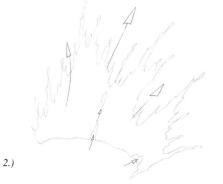

3.)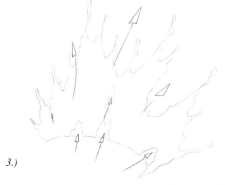

Following these drawings, we can see how a splash "sheet" of water tears as it expands.

As the splash animates upward and outward, small holes or tears begin to appear. . . .

The sheet continues to expand outward, losing momentum as it pulls apart. . . .

This technique of tearing holes in the walls of a splash can come into play in many different water animation scenarios. Virtually any size or shape of splash will break up in this way to some degree, and so it is a very important principle to learn. Every effects artist has his or her own particular style of approaching this, but the principle is the same. Small holes appear in an expanding splash and grow larger, quickly transforming what was a well-formed solid shape into bunches and strings of droplets. The process begins as the splash is still shooting upward and continues through until the last droplet has fallen back to the water. It is very interesting to see the resulting shapes that occur as the various expanding holes intersect and take over the main shape of the splash. Fantastic fractal shapes seem to magically appear as part of the natural decay process.

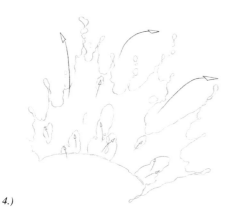

4.)

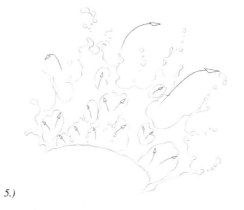

5.)

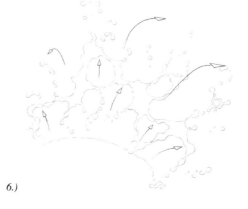

6.)

The holes increase in size and number very quickly, within a mere 24 frames or one second.

The splash is losing its momentum, beginning to fall back down and still spreading apart. . . .

Now the holes have taken over, and the sheet is reduced to strings of droplets loosely strung together.

1.)

In these drawings, rather than indicate the process with arrows, I have made the previous drawings visible so we can see the process more clearly. The initial splash is explosive and energetic, and it resembles many other types of explosions caused by a collision of elements.

2.)

As the splash animates upward and outward, very small holes or tears begin to appear in random areas in the sheet of water. These should not appear repetitive or regularly spaced in their appearance.

3.)

The sheet continues to expand outward, losing its directional momentum as it pulls apart. At this point gravity starts to take over, and the shapes become more fluid and "watery."

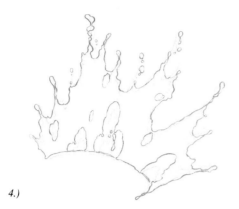

4.)

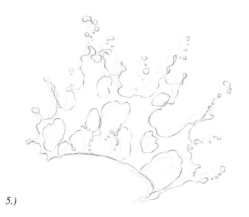

5.)

The holes increase in size and number very quickly, within a mere 24 frames or one second.

The splash is losing its momentum, beginning to fall back down and still spreading apart. . . .

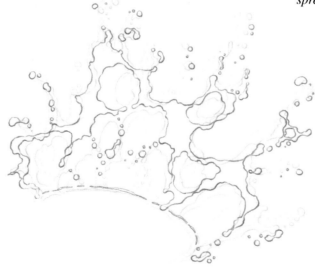

6.)

Now the holes have taken over, and the sheet is reduced to strings of droplets loosely strung together.

In some cases, if the object hitting the water is extremely uneven or jagged in its shape, if the object has a great deal of velocity upon impact, or if it only glances off of the water's surface, the primary splash will be mostly a spray of individual drops, rather than a solid sheet of water. A bullet fired into the water will create a primary splash that is entirely spray. Generally, if we throw any object into the water at a very high velocity, the resulting primary splash will be mostly made up of spray.

Primary splashes generally take on one of the three main characteristics I have just described here. Bowl, sheet, and spray shapes. It is the nature of the way water is first forced up and away from an object striking it that causes these signature formations in primary splashes.

Now let us look at the most typical kinds of secondary splashes, easily observable through simple experiments, by throwing various sizes and shapes of objects into the water.

The most commonly seen secondary splash that we see if we toss a small, average, or even very large rock into the water, is what is sometimes referred to as a *jet* by some effects animators. It is clearly illustrated in several of the splash illustrations on the previous pages of this chapter. This secondary splash jet of water squirts up after the primary splash has almost entirely resolved itself, usually in the exact point of impact where the water was initially struck by an object. It is a result of the pocket of air created by the object entering the water filling up very quickly with water, as the weight and molecular behavior of the surrounding water rushes in to fill the space. The force of this water rushing in is great enough that it forces a column of water straight up into the air.

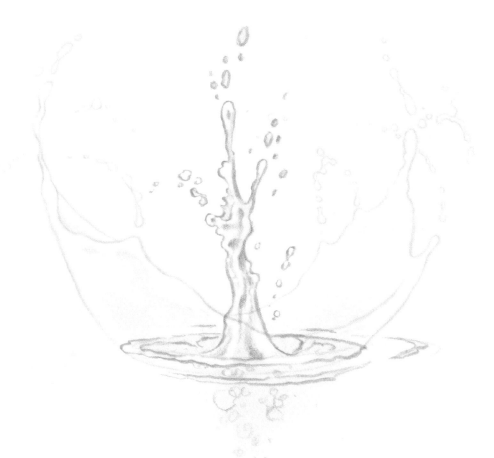

The "secondary" splash, or "jet," comes shooting up the middle of a splash at the point of impact, as water rushes in to displace the air bubble created when the object initially penetrated the water's surface. This occurs as the primary splash, seen here in a faint outline, is just beginning to fall and rapidly decay.

This sinuous, fluid column of water will
shoot straight up, sometimes twisting and
seemingly writhing, and often throwing
off droplets, as it quickly reaches its
apex, or highest point of trajectory.
It then collapses back onto itself and
pushes its energy 360 degrees outward,
creating a series of small waves or
ripples emanating away from the point of
impact.

These water jets add a great deal of
character to a splash, and it is this
secondary splash that really separates
great splash animation from average
splash animation. The shapes that they
take on can be quite comical and bizarre
looking, similar to the shapes we see in a
small gurgling fountain that shoots up a
small jet of water. We can also see these
shapes taking place if we hold a water
hose on its end, with the water on fairly
low pressure, and watch how the water
shoots straight up and falls back over
itself.

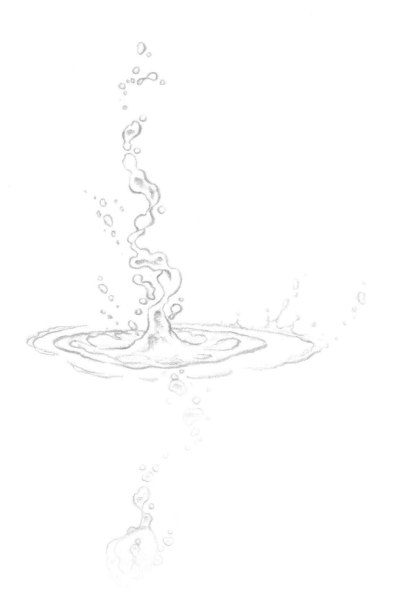

Researching water splashes can be an awful lot of fun, especially during hot sunny weather when getting wet is a joy! Just give a couple of kids a water hose and let them go crazy, and take lots and lots of photos.

Watching something like the gurgling water hose pictured here, can give us inspiration for creating shapes when we animate a secondary splash. Water fountains are a wonderful source of research and inspiration.

Every time I have a chance to observe water I see something unexpected, and this is after many, many years of careful observation. Don't ever pass up a chance to play with water: if you pay attention it will surprise and delight you with its infinite variety of fantastic and bizarre shapes and movements.

As noted earlier in this chapter, certain objects, usually very small, dense objects, like a small pebble or a raindrop, create virtually no primary splash, and this secondary jet squirting up is sometimes all that is visible. However, in these cases it is still a secondary splash, and so there should be a beat, or a pause of several frames, perhaps one half of a second, before the secondary jet shoots up.

I should also note here that in certain cases, a *second* secondary splash can sometimes be observed, if the force of the first secondary splash falling back into itself is adequate to create yet another pocket of air in the water's surface that must then resolve itself.

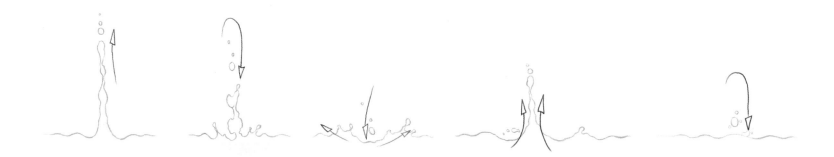

1.) As long as any secondary splash is big enough to create another indent or air pocket in the water surface, additional secondary splashes can be created again and again before a splash finally resolves itself. Sometimes a tiny splash created by a single water drop will generate two secondary splashes. Recent advances in high-speed photography technology have enabled us to watch splashes at thousands of frames per second.

2.) It has been observed that up to four or five secondary splashes may occur from even the tiniest water droplet colliding with a water surface! In larger splashes, enormous numbers of tiny "after splashes" occur as hundreds of droplets land on the surface following the main splash. When we are animating a splash by hand, one or two extra secondary splashes will tell the story perfectly well.

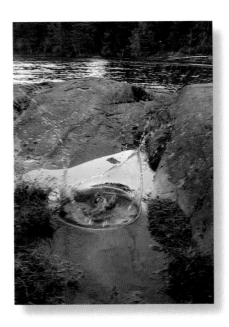

The photo above appears on page 88, with a caption stating that the secondary splash in this shallow pool of water would not amount to much more than "a small twisted up little water shape." Here then, on the right, is just such a twisted little water shape, in a photo taken in the same pool of water, on a different day but with a very similarly sized rock and trajectory, in an attempt to reenact the splash above.

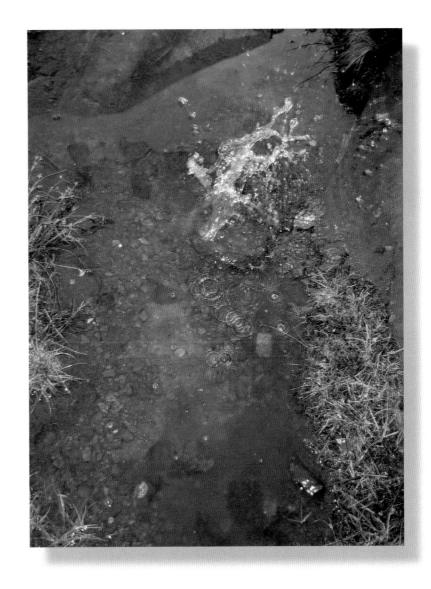

The next most commonly seen secondary splash occurs after a very
large, heavy, dense object has collided with the water, and the primary
splash is just beginning to spread out away from the point of impact,
ripping and tearing as it resolves itself. In these cases there is a very
big pocket of air trapped under the water, and when it is filled up by
the weight and viscosity of the surrounding water rushing in to fill the
space, a very large, solid surge of water shoots up at the original point of
impact.

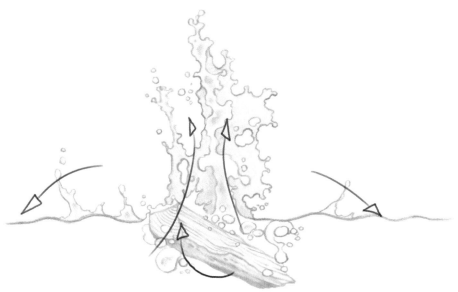

I call this a *surge* or *geyser* secondary splash. As with the smaller jet,
this secondary splash is sometimes the most visible part of a splash.
It depends always on how the object landed and how pronounced a
primary splash was created.

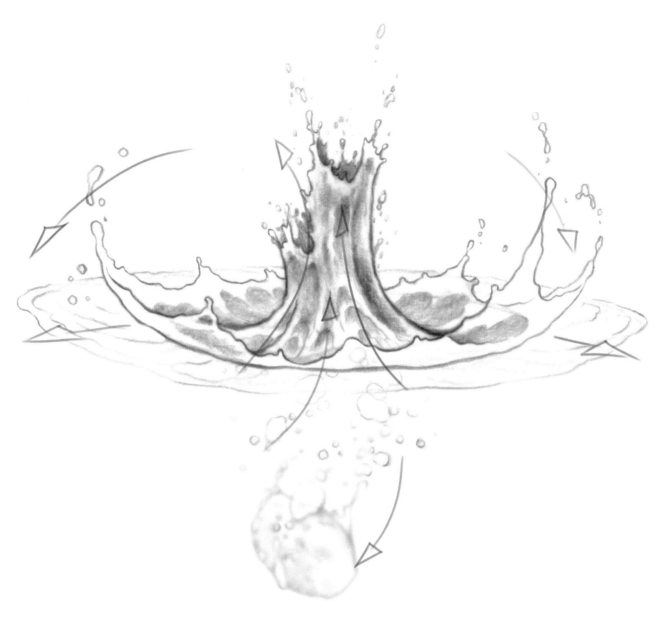

I call this a surge *or* geyser *secondary splash.*

A third classification of secondary splash is what I will call a *boil* or *surfacing bubble* variety. In some cases, the air pocket that has been created by the object colliding with the water gets pushed completely below the surface, sometimes by the velocity, weight, or shape of the object. In any case, when this big bubble, or group of bubbles, rises back to the surface, it will not so much shoot upward like a jet or a surge, but it will push up and out in a rolling fashion, creating a convex shape rising up higher than the surrounding water surface, and then resolving by rolling outward away from the point out of which it emerged in a series of waves and ripples.

If the object in question has the appropriate shape and weight, it will sometimes continue to drag a lot of air bubbles, large and/or small, down below the surface as it sinks. These bubbles will detach themselves from the sinking object and pop back up at the surface, sometimes for a very long time after the initial splash is over. This generally happens with much larger objects, and it is even more pronounced if the object has a lot of inner shapes and spaces that can keep big air bubbles trapped for longer periods of time, such as with a sinking car. We have all seen a sinking car in a movie at some point, and we see lots and lots of big bubbles boiling back up to the surface, long after the car has disappeared below.

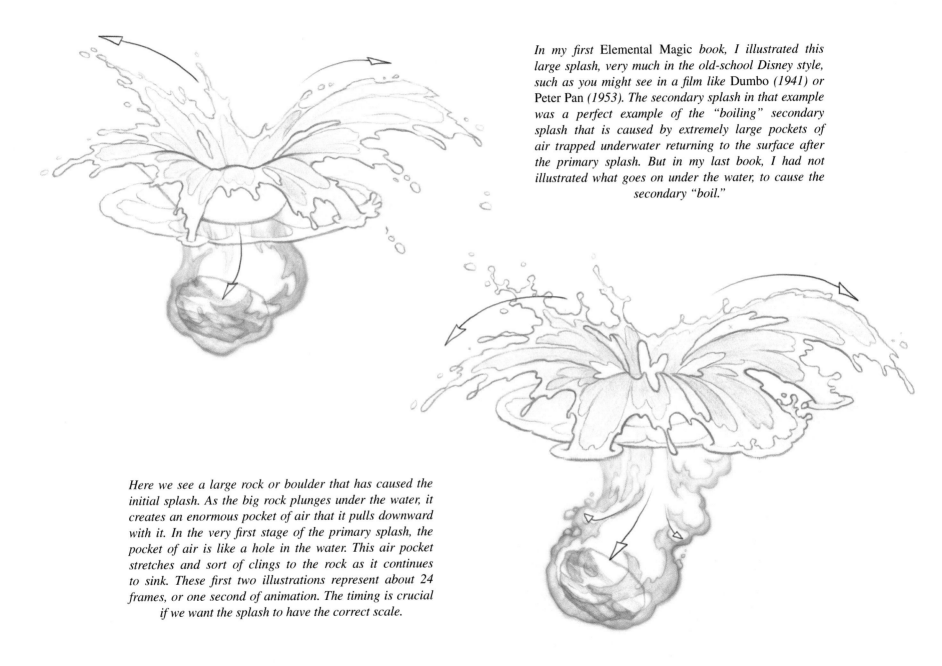

In my first Elemental Magic *book, I illustrated this large splash, very much in the old-school Disney style, such as you might see in a film like* Dumbo *(1941) or* Peter Pan *(1953). The secondary splash in that example was a perfect example of the "boiling" secondary splash that is caused by extremely large pockets of air trapped underwater returning to the surface after the primary splash. But in my last book, I had not illustrated what goes on under the water, to cause the secondary "boil."*

Here we see a large rock or boulder that has caused the initial splash. As the big rock plunges under the water, it creates an enormous pocket of air that it pulls downward with it. In the very first stage of the primary splash, the pocket of air is like a hole in the water. This air pocket stretches and sort of clings to the rock as it continues to sink. These first two illustrations represent about 24 frames, or one second of animation. The timing is crucial if we want the splash to have the correct scale.

As the primary splash resolves itself, the big pocket of air that was dragged under by the rock begins to push up back towards the surface. The pressure of the water around it forces the air bubble to cave in on itself, and it begins breaking up into smaller groups of bubbles. The rock continues to sink, and depending on its shape, size, and texture, it may continue to pull some smaller air bubbles down with it. These will break off and return to the surface eventually.

Now we see the primary splash is almost entirely resolved, and the main mass of the huge air bubble has surged up to the surface and is beginning to push up above the water surface. Below the main part of the large bubble, closer to the rock, we see the water pressure breaking the bubble up into smaller and smaller individual bubbles. The rock continues to sink, with clusters of smaller bubbles clinging to it, breaking off irregularly and creating tapering streams of little bubbles.

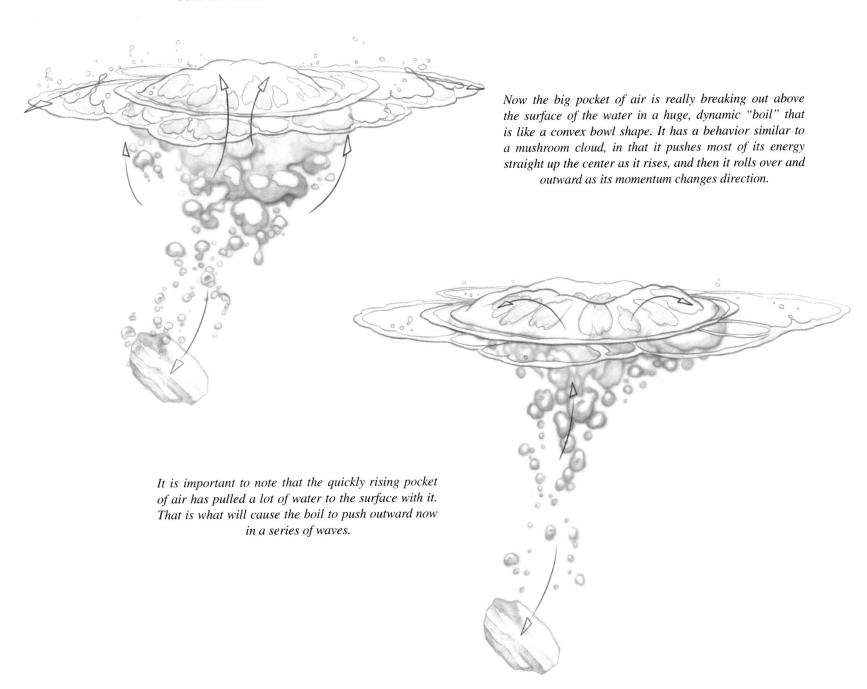

Now the big pocket of air is really breaking out above the surface of the water in a huge, dynamic "boil" that is like a convex bowl shape. It has a behavior similar to a mushroom cloud, in that it pushes most of its energy straight up the center as it rises, and then it rolls over and outward as its momentum changes direction.

It is important to note that the quickly rising pocket of air has pulled a lot of water to the surface with it. That is what will cause the boil to push outward now in a series of waves.

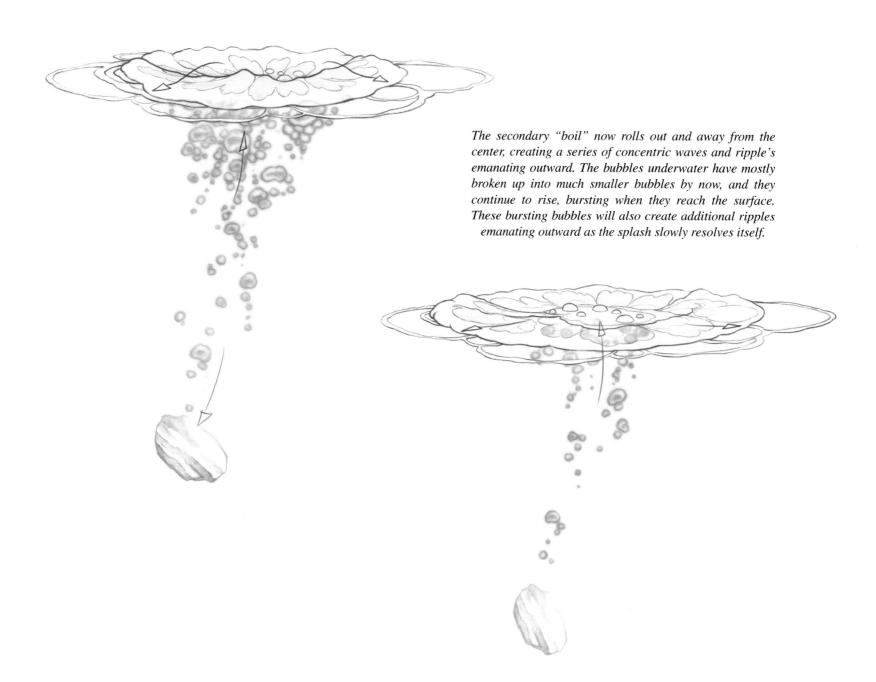

The secondary "boil" now rolls out and away from the center, creating a series of concentric waves and ripple's emanating outward. The bubbles underwater have mostly broken up into much smaller bubbles by now, and they continue to rise, bursting when they reach the surface. These bursting bubbles will also create additional ripples emanating outward as the splash slowly resolves itself.

The more you watch splashes in action, the more you'll *see* these separate events occurring, and slowly but surely you will see patterns begin to emerge. Certain shapes, striking the water surface in certain ways, can create a particular type of splash with some consistency. With practice, one could easily learn how to pick certain objects and throw them into the water at specific angles and velocities, to create each one of the splash types I am describing here.

We see lots and lots of big bubbles boiling back up to the surface, long after the car has disappeared below.

Of course there are lots of splashes that are not created by a single object striking the water. From washing our hands and brushing our teeth to water skiing or playing water polo, our interactions with water are constantly creating splashes, ripples, and waves. And then there are a wide variety of splashes that occur in nature. Waves crash into a rocky shoreline, raindrops splatter on every surface imaginable, or a tree falls and crashes into a river. The list could go on and on.

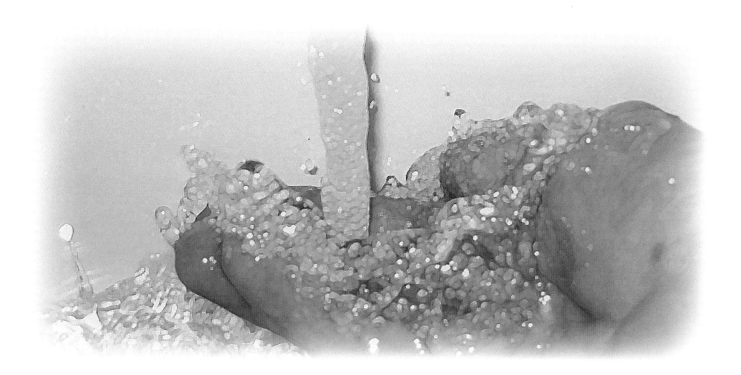

Up until now in this chapter every single water drawing is a product of my imagination, drawn by hand without looking at any reference, although admittedly, I do have a great deal of photographic reference on hand. It is for that very reason that in the next few pages, I use photographic references and discuss much of what I've learned about drawing water through direct reference to "reality" via photography.

Being able to stop water in motion with photography is an incredibly valuable tool that I truly appreciate, having been around when it was a far more complicated affair to take photos and develop them. Unless you played with a polaroid camera (which I did do for years), you had to wait for days to see your photos. Today we're able to take high definition movies with tiny, slender little devices that we carry with us everywhere we go. It makes no sense not to have hundreds of hours of special effects animation reference at your fingertips if you want it. And the best part of this deal is, you get to play like a kid in the water (or even play with fire safely, or smash things apart) and be a useful special effects director, at the same time.

Every day we interact with water splashes in our day-to-day activities. Washing our hands, brushing out teeth, showering and bathing, washing dishes, making coffee or tea. The opportunities for researching splash effects is right under our noses throughout the day! Although we have all watched how water reacts when we wash our hands literally thousands of times, it's amazing that when it comes time to animate such phenomena, we often go blank when trying to imagine what it would look like. Being an effects animator means paying attention to these details and storing the information for later reference.

Taking our inspiration from photographic reference can be a double-edged sword. While the images we capture can teach us a great deal about water physics and shapes, if we try just to copy the reality of a photo, we will quickly get lost in the details, and wind up with a design that is not conducive to being animated. Our goal is to get the essence of the splash into our design, and then use the classical principles of animation to actually improve the way it behaves, through exaggeration and stylization.

For the sake of practicality, the exercises and examples in this book focus for the most part on splashes created by a single object falling into the water. This study will enable the artist to understand how water reacts to outside forces acting upon it, and this can be applied to the entire plethora of splash shapes, sizes, and causes. However, in the next few pages I will touch on some of these different kinds of splashes, and describe the way water behaves in these different instances.

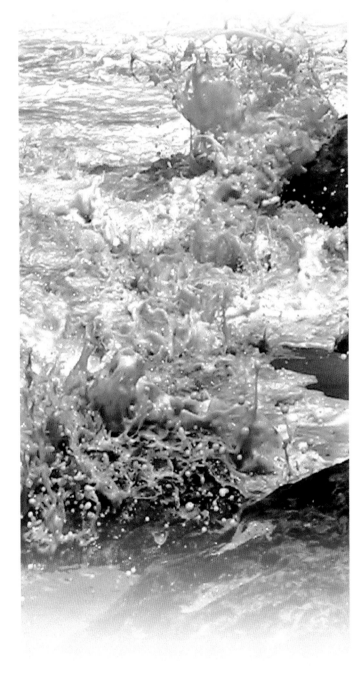

A great many of the splashes we experience in this world are the splashes caused by waves crashing into the shore on every coastline around the world. The previous chapter on waves touches on these splashes. Of course, waves and splashes go hand in hand, almost like fire and smoke. Wherever waves come up against solid resistance, splashes occur, and the largest, most dynamic and dramatic of these are waves crashing into a rocky shoreline.

From the smallest splashes boiling around our feet when we walk in the surf, to the most powerful and grandiose mega-waves splashing into cliffs, each splash is similar and yet entirely unique. All of the most simple splash principles that I have discussed thus far in this chapter come into play. Once the energy that creates a splash progresses, the follow-through and resolution of water molecules in motion will follow distinct behavior patterns. The only difference with ocean waves colliding with the shoreline is the scale of the waves, and the incredible variety of shapes that it will collide and interact with.

If we have to animate these monumental and fantastic splashes by hand, we are definitely in for a lot of work. In order to give our animation scale and power, we must work with large drawings and move them much more slowly. I have watched massive waves breaking on the cliffs of Kauai's North Shore that take several seconds to reach their peak height and then finally fall and resolve. It is almost freakish how long a really big splash can hang in the air.

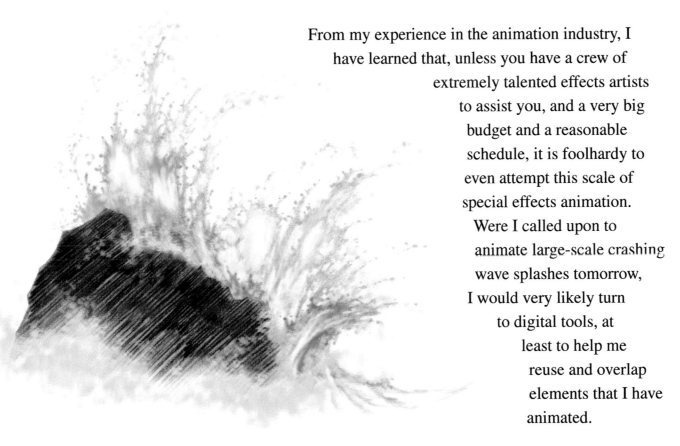

From my experience in the animation industry, I have learned that, unless you have a crew of extremely talented effects artists to assist you, and a very big budget and a reasonable schedule, it is foolhardy to even attempt this scale of special effects animation. Were I called upon to animate large-scale crashing wave splashes tomorrow, I would very likely turn to digital tools, at least to help me reuse and overlap elements that I have animated.

Creating a small collection of spectacular crashing waves and then compositing them together to build up larger splashes could be a very effective and reasonable way to proceed.

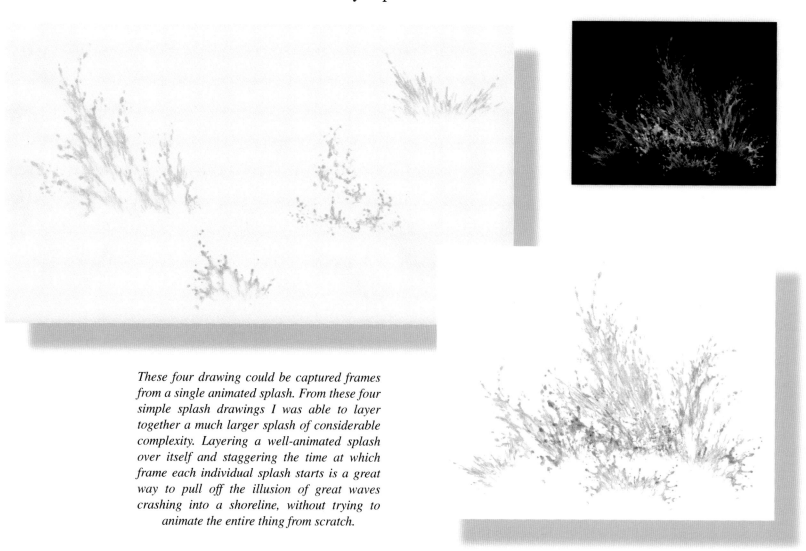

These four drawing could be captured frames from a single animated splash. From these four simple splash drawings I was able to layer together a much larger splash of considerable complexity. Layering a well-animated splash over itself and staggering the time at which frame each individual splash starts is a great way to pull off the illusion of great waves crashing into a shoreline, without trying to animate the entire thing from scratch.

The wake that a powerboat creates as it cuts through the water is a unique set of splashes and waves; it shoots out from the sides and back

of the boat and spreads out to each side as the boat moves forward. I did this drawing based on my memory of what a wake looks like, without looking at any additional reference, just to see if I could. While it is, I'll admit, a fairly cartoony rendition of a boat's wake, you can see that my years of observing boat wakes gives me a fairly good idea of how it works. If I were to combine this knowledge with some fresh research, I'd be well on my way to being able to animate something very convincing.

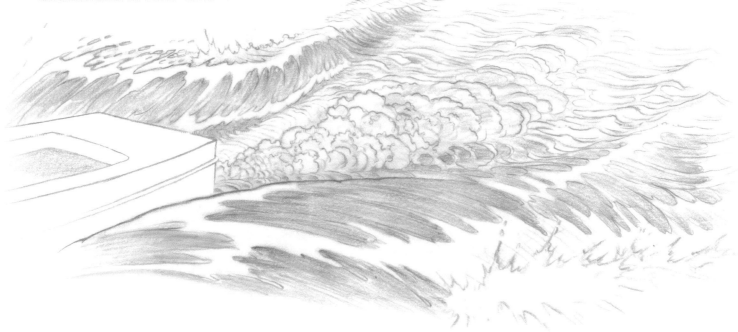

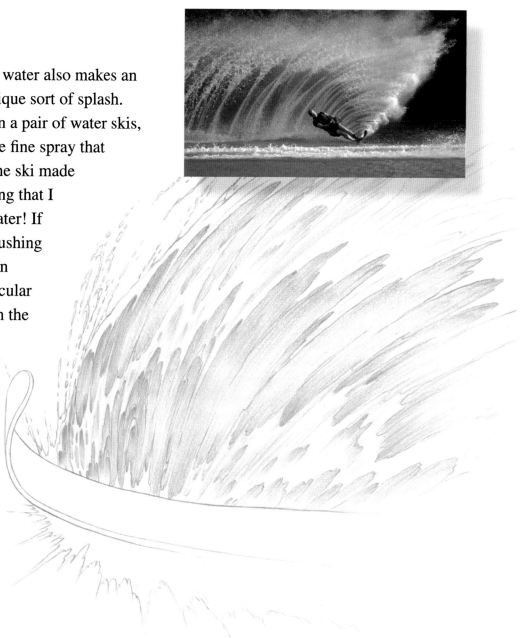

A water ski slicing through the water also makes an
extremely recognizable and unique sort of splash.
The first time I ever stood up on a pair of water skis,
I remember looking down at the fine spray that
was shooting out from where the ski made
contact with the water, marveling that I
was actually standing on the water! If
pressure is applied to the ski, pushing
it out and away from the skier in
order to initiate a turn, a spectacular
splash shoots up and away from the
ski in a beautiful soaring
sheet of water. As with
the boat wake, I created
this very stylized
drawing of a water ski
splash entirely from my
memory of it.

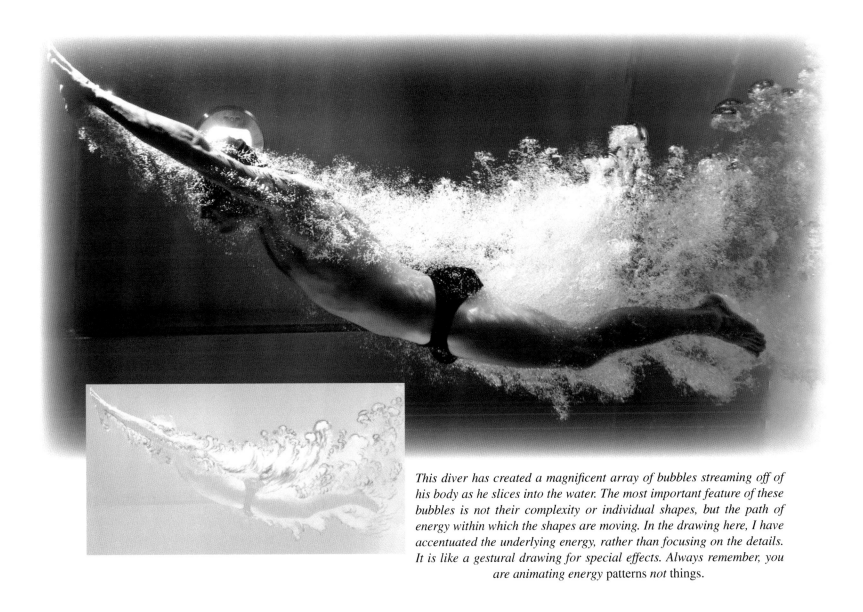

This diver has created a magnificent array of bubbles streaming off of his body as he slices into the water. The most important feature of these bubbles is not their complexity or individual shapes, but the path of energy within which the shapes are moving. In the drawing here, I have accentuated the underlying energy, rather than focusing on the details. It is like a gestural drawing for special effects. Always remember, you are animating energy patterns not things.

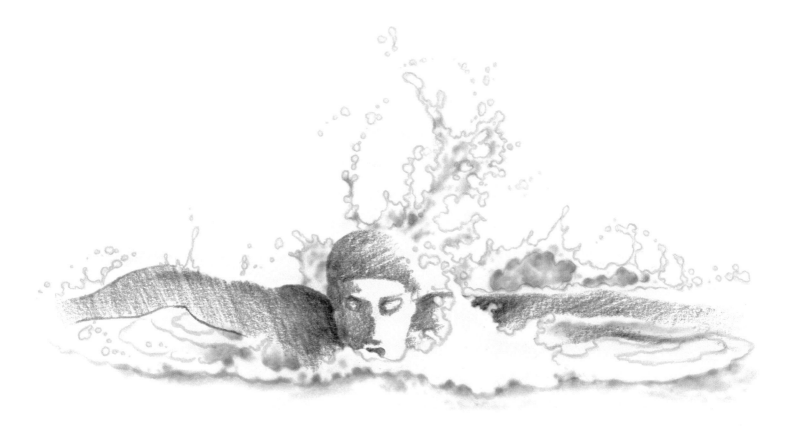

A swimmer creates quite a complex jumble of splashes around him or herself, especially when doing something as dramatic as a butterfly stroke. There are primary and secondary splashes galore, overlapping in every which way, and interacting with each other to create the overall effect. To animate such complexity, I would be inclined to first animate a simple wake and some ripples emanating around the body of the swimmer. Splashes would be added separately, and if possible, I would create some splashes that could be reused more than once, to minimize the amount of work involved.

Splash Design

Animating water *by hand* would be absolutely impossible, if we didn't develop stylized ways of drawing water. One look at any photograph of even the simplest splash, and you can see that there is a staggering amount of detail going on. This is due to a couple of very important facts about the liquid nature of water.

First of all, water is a clear, extremely reflective substance. In fact, what we see when we're looking at most water is 99% reflections and refractions. Water is a perfect mirror of everything around it, and when the water surface is disturbed with an incredibly complex array of rippling convex and concave shapes, the resulting reflections are too complex to really wrap our heads around. Unless we are working with extremely powerful 3D computer graphics that are able to do highly complex ray-tracing calculations to map reflections of the surrounding environment onto the water surface, we have to greatly simplify our water designs, while still retaining all of the most important design elements that make water look like water. This is the real challenge of drawing water, and as soon as you try drawing it, this becomes abundantly apparent.

Secondly, besides the complexity of the reflective surfaces of water, there is the complexity of the shapes themselves. A small splash created by a stone that's only two inches across might have hundreds or even thousands of water droplets breaking off from the main body of the splash. Careful analysis of a photo of simple ripples in a puddle, created by only a few raindrops, reveals incredibly complex intersections of ripples, resulting in thousands of tiny details. An extremely large splash, created by something like a dolphin jumping, or a boat, or a water skier falling, is completely off the charts as far as complexity goes. We are talking about literally millions of droplets and complex surfaces.

Attempting to recreate the ripples in the photo on the previous page by hand, it becomes immediately apparent that what looks like a fairly simple collection of ripples, is actually an incredibly complex array of overlapping and interacting concentric rings. We must decide just how much detail we really need to make our effects "effective." Thanks to the digital tools we now have, recreating this effect using some simple digital compositing techniques is far easier than attempting to draw every single ripple interacting with the next.

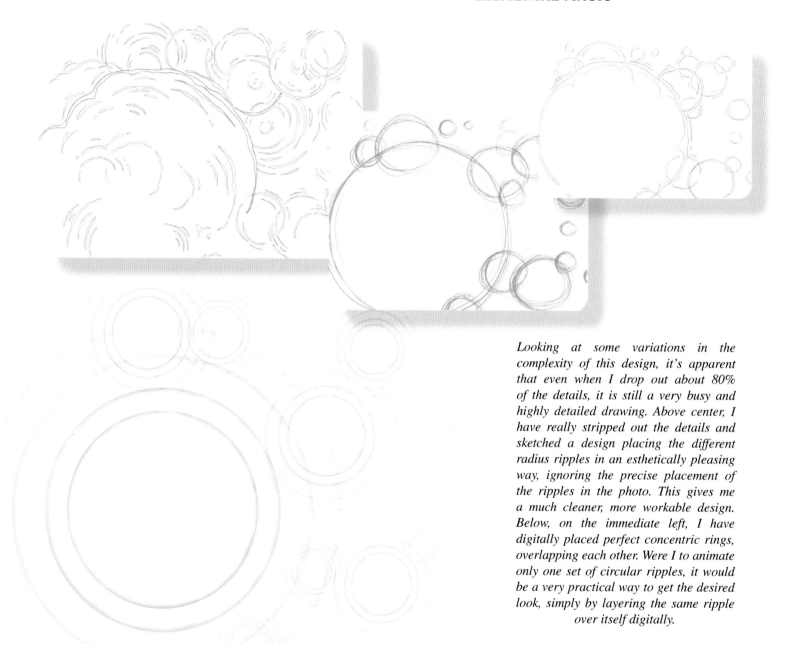

Looking at some variations in the complexity of this design, it's apparent that even when I drop out about 80% of the details, it is still a very busy and highly detailed drawing. Above center, I have really stripped out the details and sketched a design placing the different radius ripples in an esthetically pleasing way, ignoring the precise placement of the ripples in the photo. This gives me a much cleaner, more workable design. Below, on the immediate left, I have digitally placed perfect concentric rings, overlapping each other. Were I to animate only one set of circular ripples, it would be a very practical way to get the desired look, simply by layering the same ripple over itself digitally.

Even CGI water has to be greatly simplified compared to the real thing, in spite of the incredible number-crunching power and rendering ability of today's computers. However, lucky for us, the human imagination is extremely good at recognizing symbols, and to give the *impression* of great detail, an artist only has to *imply* a tiny fraction of the actual detail that exists in the real thing. This is an extremely important point to understand and exploit, if we are going to successfully pull off any water animation at all.

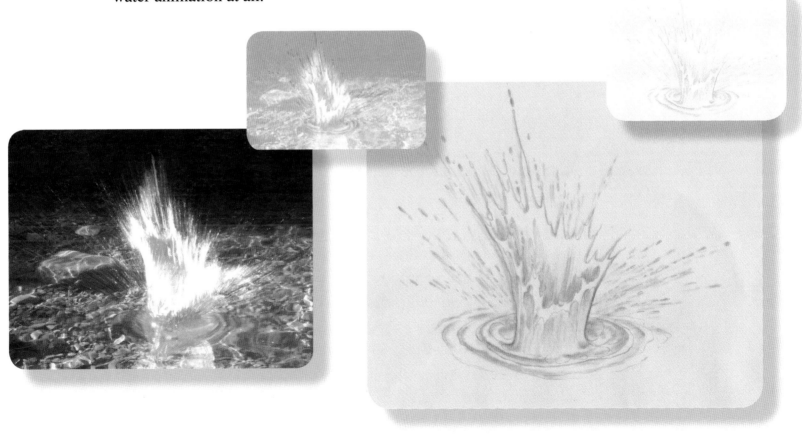

If you scan back through the earlier pages of this chapter and look at
the many splash photos and drawings, you can see clearly what I am
talking about. In the photos there are thousands of droplets flying off
of a splash in every direction, whereas in my drawings, you might see
a couple of dozen droplets. However, the drawings still convey the idea
of the splash with just enough detail and dynamic information to tell us
approximately how big it is and how it is behaving.

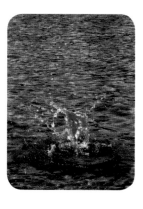

If you look at actual film footage of a live-action splash, you can see
that there are countless thousands of droplets of water shooting up
and then falling, each one creating its own individual little splash as it
collides with the surrounding water surface. If we attempt to animate
even a measly 10% of those water droplets by hand, the shear numbers
of separate events we have to keep track of will overwhelm us. But it is
incredible how we can *imply* that there are countless thousands of drops
by only animating, at most, a couple of dozen resolving droplets.

In the following illustrations and photos, I will demonstrate how this works for us as effects animators, and show some good examples of how an impossibly complex water splash can be reduced to a manageable drawing design that we have some hope of being able to animate!

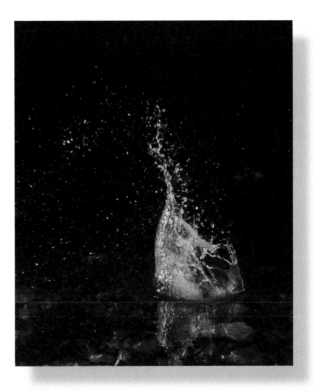

In the following series of images I have digitally modified a photo to illustrate clearly just how much we need to simplify the design of a water splash, in order to make it more manageable to draw and animate. In this photo, there are clearly a very large number of water droplets, however, by enhancing the photo digitally, I am able to isolate the droplets even more to better illustrate this point.

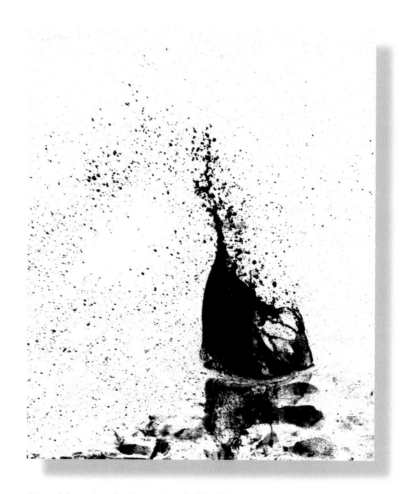

Here I have pushed the threshold of the photograph until we see only a stark, black and white image, more clearly illustrating just how many hundreds or even thousands of tiny water droplets there are in this splash. It is inconceivable to consider animating something this complex. Even if we were doing CGI water effects, it would be extremely desirable to simplify this splash.

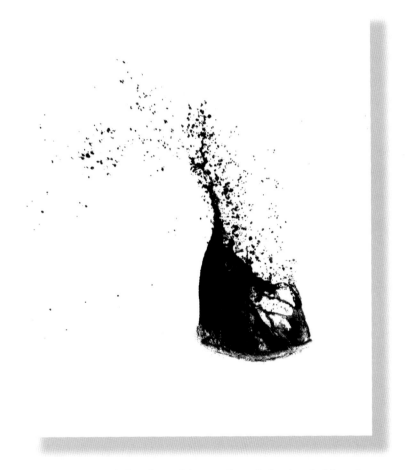

In this version of the photo, I have adjusted the threshold setting even further, to exclude the majority of the droplets seen in the previous image. I also went in and manually removed additional droplets, relying on my eye and design sense rather than letting a digital preset determine the outcome. Now we have a more manageable splash design to work with that will still tell the story.

The Art of Scribbling, Part 1

Perhaps the most important thing that I can attempt to teach a student of special effects animation is the fine art of *scribbling,* or perhaps more correctly, sketching, or gestural drawing. I like to use the word scribbling, because it is often what it looks like I am doing when I first start drawing water, fire, smoke, or just about any elemental effect.

When I first started out in the animation industry, I was very proud of my drawing abilities. I put extra care and attention into my drawings and lines. My draftsmanship was almost impeccable, and I produced extremely clean and polished work. I was an animation machine. However, when I really started to animate a lot of water, which was on a film called *Shamu: The Beginning* (1989), my clean approach to drawing was keeping me from animating the kind of water effects that I really wanted to do. And then one day my director at the time, Milt Gray, one of the most interesting characters I've ever met in my animation career, gave me a quick little water drawing lesson. He showed me how to scribble out my water designs, sketching quickly with erratic hand motions, and then turn those scribbles into exquisite little masterpieces, and that was a major turning point in my ability to animate special effects well.

Up until that point in my career, I had been creating some pretty convincing special effects animation. Especially when animating water, I seemed to grasp the fluid motion very well; I understood the physics of fluid displacement, its flow, and the animation principles of exaggerated timing and dynamics to really bring it to life. But something about my water drawings was stiff and unnatural; they were missing a natural feeling that I couldn't put my finger on, and I couldn't for the life of me figure out how to get it right.

Well it's all in the scribbling. Learning how to draw with feeling and natural energy, rather than thinking about it. It's letting that energy direct your drawing for you.

"I'm not really drawing so much as channeling the unfolding fractal energy of the universe through the side of my pencil."

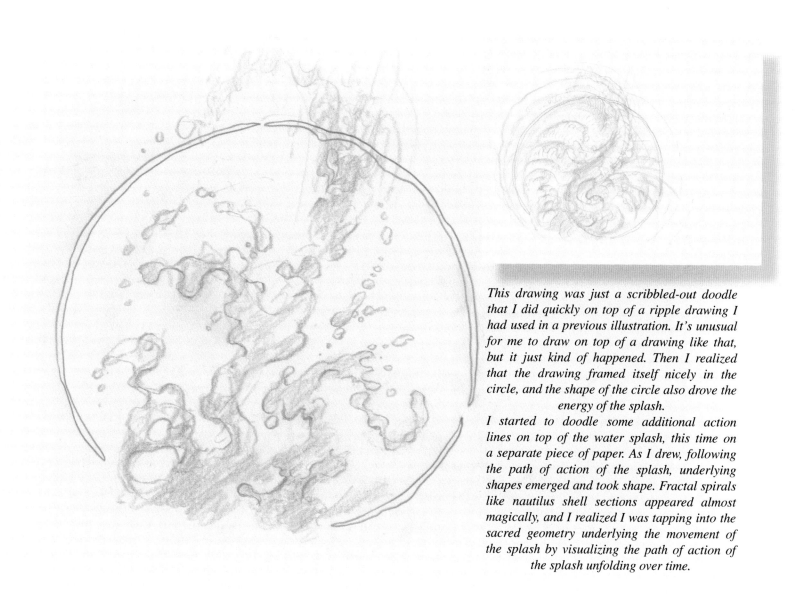

This drawing was just a scribbled-out doodle that I did quickly on top of a ripple drawing I had used in a previous illustration. It's unusual for me to draw on top of a drawing like that, but it just kind of happened. Then I realized that the drawing framed itself nicely in the circle, and the shape of the circle also drove the energy of the splash.

I started to doodle some additional action lines on top of the water splash, this time on a separate piece of paper. As I drew, following the path of action of the splash, underlying shapes emerged and took shape. Fractal spirals like nautilus shell sections appeared almost magically, and I realized I was tapping into the sacred geometry underlying the movement of the splash by visualizing the path of action of the splash unfolding over time.

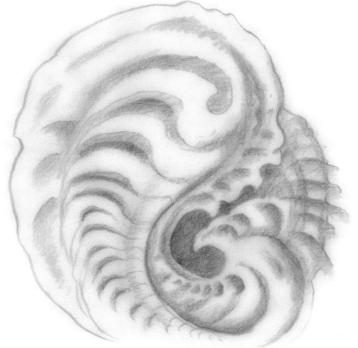

I was excited at the design I discovered underlying the roughly scribbled splash I had drawn. If you look at these seemingly abstract shapes closely here where I have combined them with the water splash, you can see that I was very closely following the shape of the splash. However, when I first scribbled this splash out, I was unaware of the strength of its underlying design structure. By sketching naturally, I had unconsciously and intuitively followed a very distinct path of action when creating the splash shapes. What we see here is in effect the natural structural "skeleton" of the water drawing, based on the geometry of how the energy of the splash unfolds itself over time. It's amazing to see the same sublime shapes that form our galaxies shimmering out from within the energy of a splash!

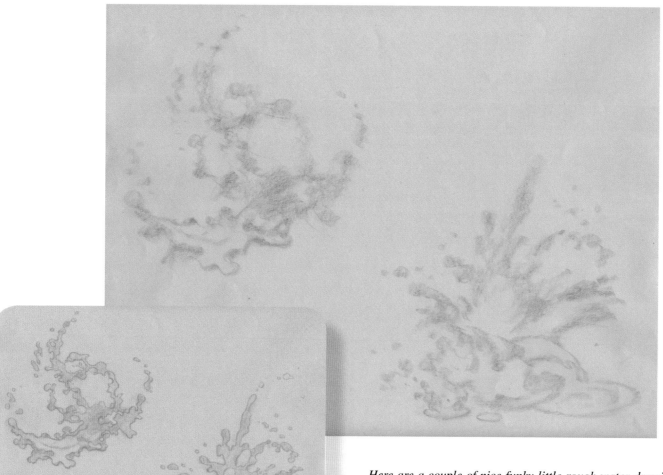

Here are a couple of nice funky little rough water drawings that I sketched in about two or three minutes. On the left you see how I began to turn the scribbles into clean, fluid shapes, drawing on the subtle shading of the drawing, the sinuous thick and thin lines drawn roughly with the flat side of a pencil in the original rough drawing influencing the cleaner line's placement.

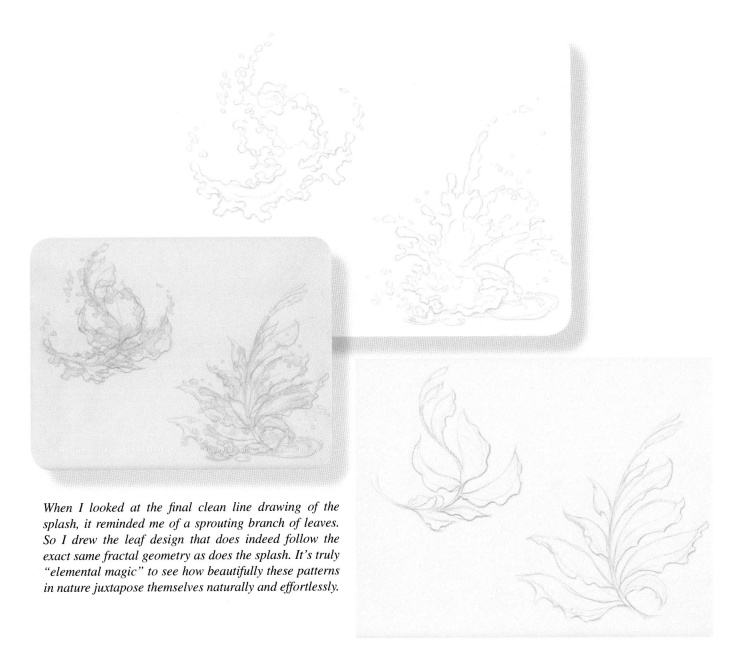

When I looked at the final clean line drawing of the splash, it reminded me of a sprouting branch of leaves. So I drew the leaf design that does indeed follow the exact same fractal geometry as does the splash. It's truly "elemental magic" to see how beautifully these patterns in nature juxtapose themselves naturally and effortlessly.

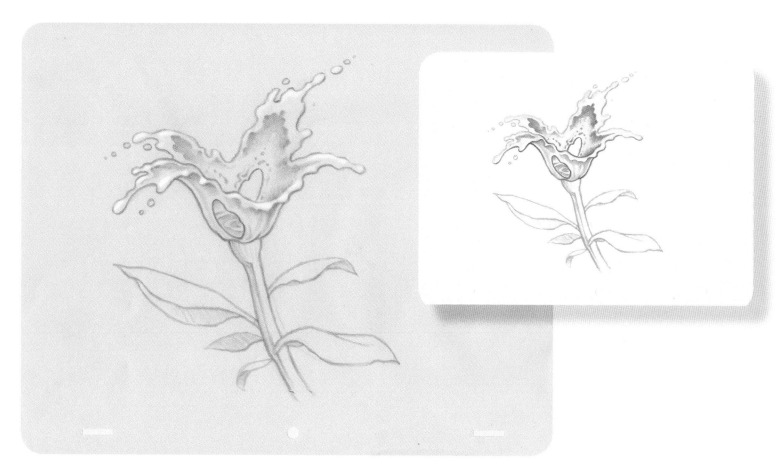

"Each splash is like an exquisite crystalline flower."

It's fun to imagine splashes as flowers. It's incredible how much they have in common with the many ways flowers grow and manifest their beauty. This bowl-shaped splash has a bit of a lotus shape to it.

Rather than draw an actual lotus flower underlying the splash, I decided instead to draw what you could call the sacred geometry that forms the splash and has in it the mandala-like concentric spirals of expanding energy upon which the water molecules are traveling.

Splashes have within them the pure energy that has been transferred to the water by a colliding object. The energy radiates outward in magnificent spiraling geometry that unfolds in complex interlocking waves.

The entire process of a splash shooting upward into a sheet, and then pulling apart into strings of twisting droplets, happens on a structural grid that reveals the energy expanding outward.

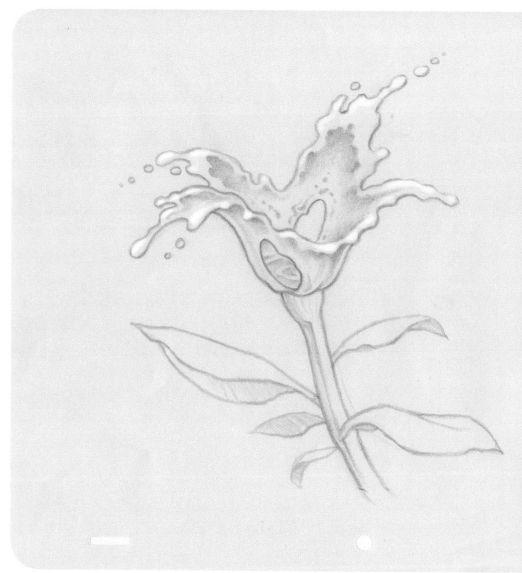

The idea of a splash as a flower has its roots in some of the masterful splash animation created in the original *Fantasia* (1940). It is a truly idealized and heavily stylized approach to water design and water physics. These splashes resolve in a way that no natural splash really does, folding over themselves in velvety sheets, and breaking up with incredibly smooth follow-through shapes. It is a visually stunning way to demonstrate how sheets of water shoot up and resolve, a graphic illustration in time of how a splash unfolds. Looking at a real splash in real time, our naked eye doesn't even have time to catch how the primary splash shoots up in a sheet and tears apart. It happens too fast to really make it out clearly.

By stylizing and idealizing the timing of a splash, the early Disney effects animators were able to develop a way of animating water that tells the visual story of how a splash happens, rather than trying to mimic the real thing.

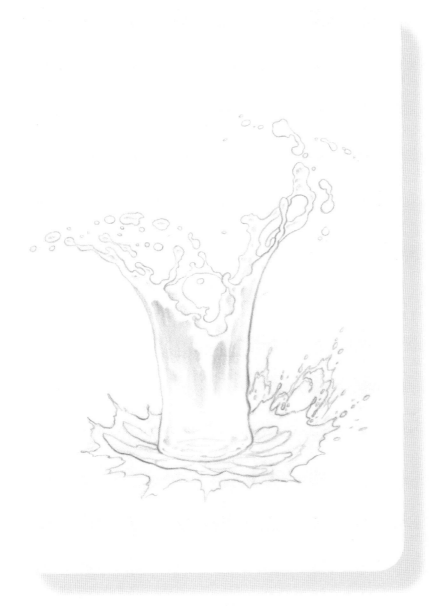

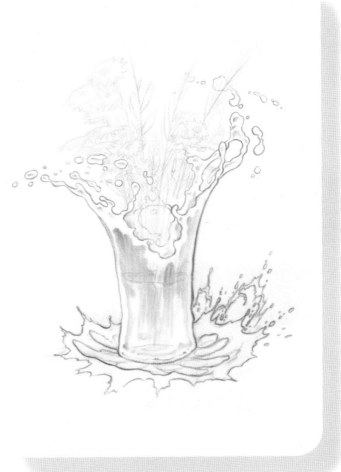

This splash looks so much like a slender glass vase, it's almost hard not to imagine filling it with fresh flowers! Thinking of water designs as having the same stylistic cues that inform all the other design elements in a film really helps to integrate the effects into the overall look.

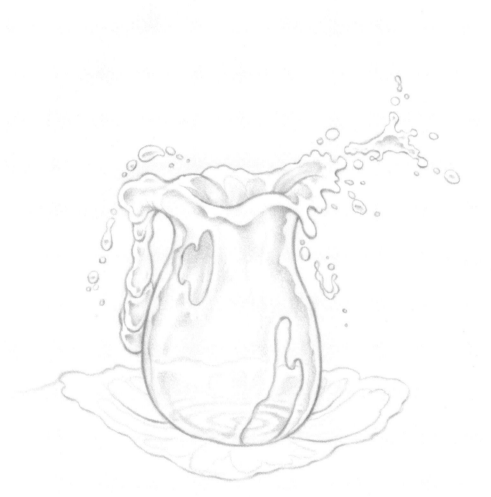

I stylized this splash to look like a typical old-fashioned jug. In the years from the early 1990s through to the new millennium, the effects artists at Disney focused more and more on integrating the design of the effects closely with the overall art direction on any given film.

On the Disney film *Hercules* (1997), the effects artists studied Greek design very closely, and ended up designing beautiful splashes that looked like classical Greek urns and vases.

When we designed effects for the movie *Mulan* (1998), special care was taken to add the classical Chinese paintbrush style of illustration to all of the effects elements. It is extremely challenging to animate in a particular drawing style. It may be easy to do one design drawing that looks like it was painted by a Chinese brush artist, but try moving that design in a natural organic manner, and it is very easy to lose track of the stylization. Care must be taken to constantly redraw key drawings in an animation sequence in order to get the style consistently correct.

I couldn't look at this jug splash design without imagining a big slurp of creamy white milk spilling out of the top of it.

The practice of seeing other familiar shapes and forms within the workings of our fluid dynamics animation is a fantastic way to broaden our special effects vocabulary. Being able to visually tag our effects with design principles drawn from different creative disciplines, we add a whole new dimension to the creation of compelling special effects animation.

When we can imbue our effects animation with something familiar that resonates with the viewer, we hook that viewer more deeply into the divine state of the suspension of disbelief. So even if our splash design is ostentatiously derivative of a particular drawing style, or extremely cartoony, we can add to that additional design hooks taken from everywhere in our visual vocabulary. From everyday objects to exotic or imaginary beings, plants, and flowers, these can give our effects drawings a truly familiar feeling of "fitting in" with their surrounding design world.

Inkblot designs often come to mind when I am observing splash shapes. While splashes are rarely symmetrical, it is fun to add elements that echo inkblot designs with their perfect symmetry. Creating inkblots yourself is a fantastic exercise for observing some of the wonderful shapes that form from splattering, blowing, or squeezing wet ink around.

Victorian lace and Persian rug designs also carry a lot of visual hooks that can influence our effects designs. The way the visual ideas radiate outward from a center point, and the various objects, animals, plants, and simple design shapes all fall along an underlying energy form, just as our water molecules must when we are animating water.

The Beauty of Fluids

One of the most important aspects of animating water and other fluids that I haven't really touched upon yet, has to do with the morphological tendencies of water. That is to say, water in motion is constantly morphing from one shape to another. It is extremely inconsistent as far as holding on to a specific shape. Although the underlying structures of a splash, or a wave, or a ripple can be extremely consistent and have an ordered mathematical certainty to them, the water shapes that ride on that perfectly structured energy are in a constant state of flux, moving all over the place at once, breaking off and joining together, rolling, bubbling, and boiling in a froth of delightful fractal abstraction.

The result of this characteristic of fluids is that when we are animating water, we can allow it to fluctuate wildly from one drawing to another, as long as the physics and directional energy of the movement is working well. If you watch slow-motion water splashes filmed with an extremely high-speed camera, you can see this in action. Watch a single droplet of water flying through the air, and you see that it is stretching and getting squashed constantly, like a wobbling piece of jello. Therefore, if you are doing your key drawings or your in-between drawings of a droplet, there is no need to make sure that the droplet is precisely the same shape as it was in the previous drawing, or will be in the next drawing. As long as the volume is reasonably close, the droplet can wobble very inconsistently and will actually look *better* for it! This is true for us when we are animating fire and other elements as well.

This is in sharp contrast with character animation, or animating solid elements, where we need to pay extremely close attention to the exact shapes and volumes of every object when we are doing our key drawings and when we are doing breakdown and in-between drawings. I have often worked with assistants who had previous experience assisting character animators but had not had much experience with effects like water or fire. I have had to teach them to actually stop trying to make perfect in-between drawings and seriously loosen up their approach to what they are doing.

The best effects animators and assistants understand this concept very well and will not waste their time trying to make their drawings too perfect, because that will just hurt the natural feel of it.

A very good example to illustrate this point is that of simple ripples emanating out from the impact point of a small splash. If you understand that what we see when we're watching ripples is a sliver of light bouncing off of an undulating, rolling, morphing little wave traveling through the water, then you'll also understand that it should not keep a perfectly consistent width or shape as it travels. It actually should fluctuate and wobble in order to look like a real ripple.

This is one of the reasons I enjoy doing fluid special effects drawings so much. There is a freedom to loosen up and let your lines flow, even in the finished drawings. Whereas when you are animating a character, the attention to detail and draftsmanship required to make sure the ears or eyes or chin are precisely perfect in every way in every drawing turns the process into the workings of a drafting machine, at least once the loose, rough character drawings are completed.

Elemental effects give us a unique opportunity to "go with the flow" in a way that other forms of animation seldom do: we can literally make up each new frame as we move forward, animating straight ahead in the case of most fluid animation. There may be key drawings with timing charts for separate splashes or direct physical interactions of fluids with characters or props, but I animate the vast majority of my fluid effects drawing straight ahead. Making one drawing after another, I usually think of each drawing as 1/12 of a second, but sometimes I'll work on every forth drawing if the action is broader.

And we must not forget, there are many special effects elements that require an even greater amount of perfection than animating a character. Any solid elements, such as props, vehicles, doors, or machines of any kind, are more solid and immovable than a character is. Characters do have some fluidity to their movement, and a great deal compared to a chair, for instance. Drawing and animating solid geometric objects well is akin to being a mechanical drawing machine, and an effects artists should be as good at it as they are at drawing the organic stuff!

So as effects animators we get a bit of both worlds. It is a profession of extremes. Extremely precise and extremely loose both come into play. But in the case of fluid animation of water, fire, smoke, and magic, inconsistency is sometimes the key to giving your animation life, and this is an important facet of the art form to understand. Wobbly fluids are beautiful fluids.

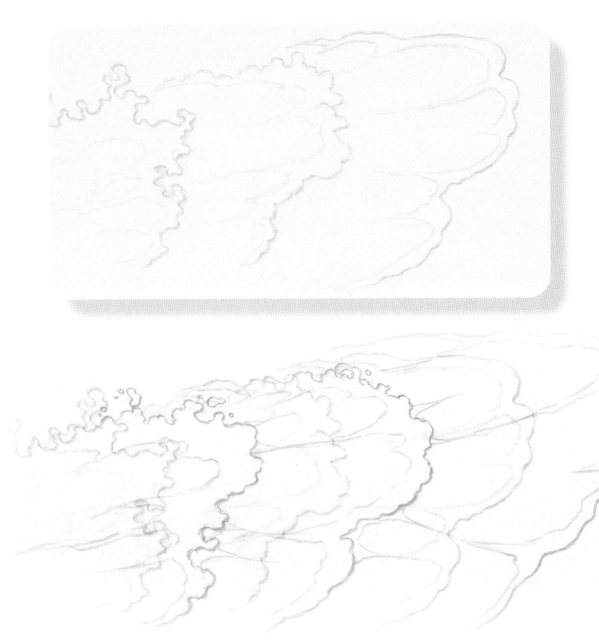

Imagine, if you will, that the drawing you see here is three different poses of the same advancing wave. The splashes foaming up along the leading edge look jumbled and erratic, and they are.

One of the really fun things about animating water is that you change the leading edge of an animating, frothy, foamy wave with whatever abstract tumbling shapes you want to, and they will animate nicely as long as the design and physics of the overall animation is tight. So to get a really nice tumbling, rolling froth on the leading edge of an advancing wave, each new drawing can be completely unique and abstract, with only some of the underlying shapes following through smoothly.

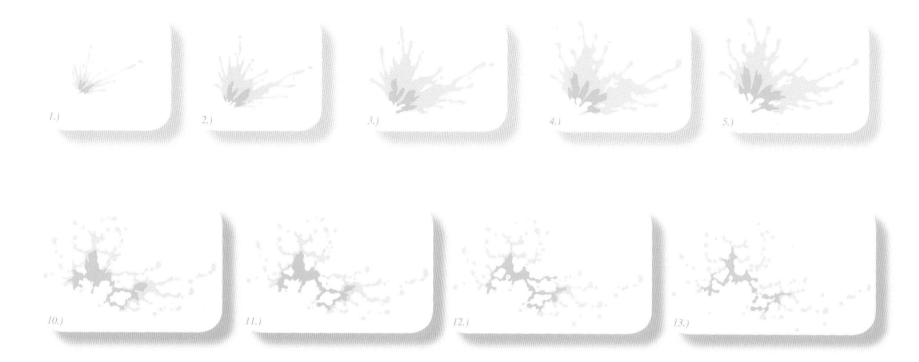

This sequence of drawings was created drawing by hand on a digital tablet, using vector-based software. I still approached it with rough energetic drawings at first, and then cleaned it up to finally look like this. This is very similar to the detailed description of how a sheet of water decays on pages 94 through 98. Here, however, you can see how I went about breaking it down into two colors only, to make it simple to draw and paint, and very easy for the eye to read. The lighter color represents the thicker, foamier leading edge of the splash, while the darker areas would be the thin spreading sheet. It is an oversimplification, but it works very well, and has its base in the original classical effects designs of the early Disney effects artists.

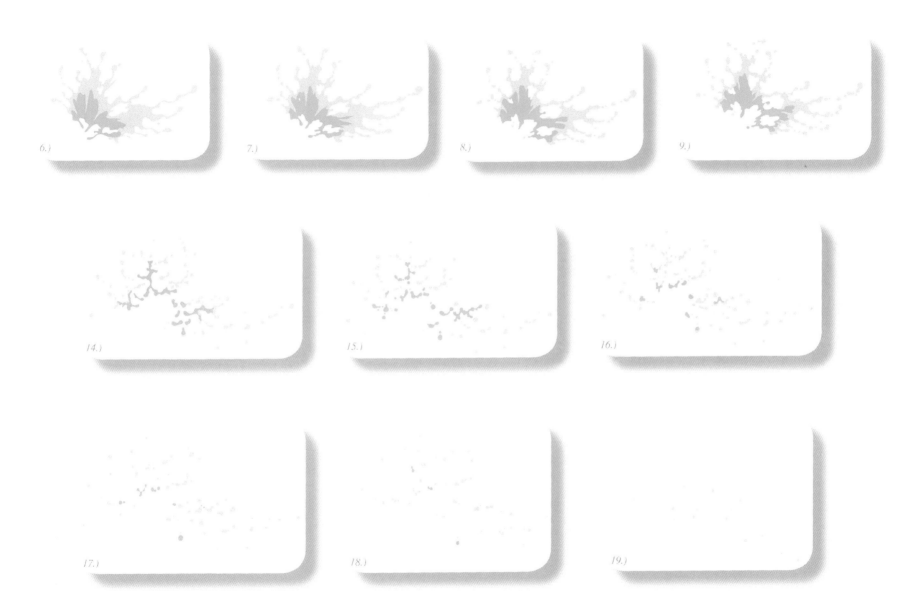

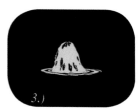
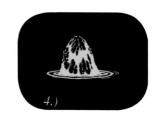

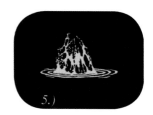

As on the previous pages, this animation sequence was also animated on a digital tablet. This particular splash was specifically designed to be used when an object or character rises up out of the water. You see a bowl-shaped bubbly-looking convex shape form up out of the water surface, and then tear and rip apart as it gets pulled too far for the water tension to hold it together. Interestingly, I found that if I turned this animation upside down, it also works well as an underwater element, looking as if it is a bubble of air being pulled downward by an object that has collided with the water. The two last images are from a different splash sequence, using the above drawings as the underwater element.

6.)

7.)

8.)

9.)

10.)

16.)

17.)

18.)

19.)

20.)

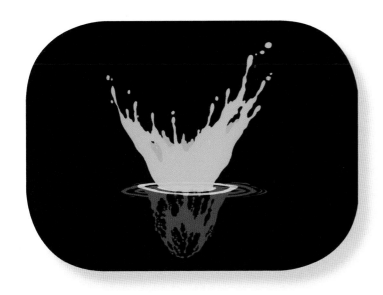

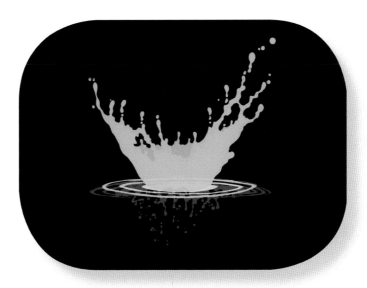

The following drawings were created from an effects animation exercise that I used to give to students studying classical animation. The students were given a drawing of a simple wooden trough and a wooden bucket in two positions. The exercise is to imagine that the bucket is full of water and it gets poured down the trough.

I have redrawn the trough and the bucket here. The original artwork that we used in the past were some very old photocopies of drawings whose original author remains unknown to me. If the artist who originally drew this trough and bucket should ever read this book, please contact me so I can credit you properly in the next edition!

While this looks like a fairly simple exercise, this effects assignment was quite difficult for most students. Although most of us spend a lifetime interacting with water in one way or another, we seem to get stuck when we try to think about how water should move. I try to teach students to stop thinking and feel it!

Usually I do a few drawings for the students to demonstrate how I would go about planning, designing, and roughing out the scene before actually trying to animate it. I do one drawing of an example of the possible drawing style, emphasizing to the students that the design would have to be simple enough to animate, otherwise their one-week-long assignment could turn into a nightmare of details.

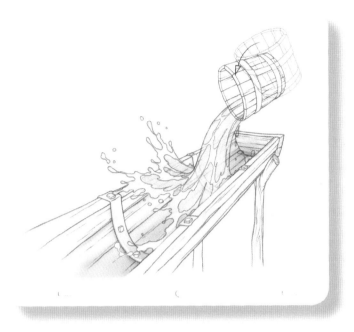

Using very rough drawings, and arrows to show where and how the water would react to being poured into the trough, I talk the students through the exercise. But after handing out this assignment to a couple of classes, I decided I would actually animate the scene myself, from scratch, while the students watched.

This became the cornerstone of my teaching style. To stop talking about animating and actually animate for the students. To let them see every stroke of the pencil, from a blank sheet of paper to a finished scene. I give myself a one-hour time limit.

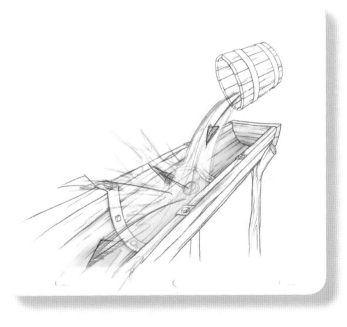

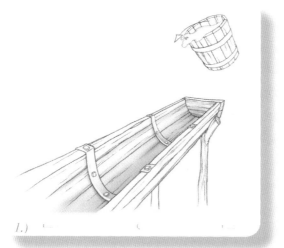

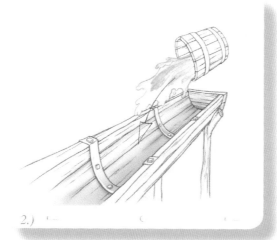

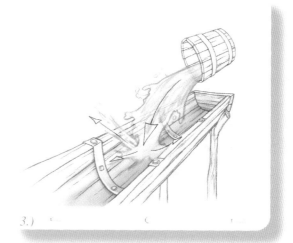

In the very first drawing, the bucket is still upright, with just a little water sloshing over the edge. I didn't bother animating the tilting bucket, just had it fully tipped over in the second drawing so the water would pour out quickly.

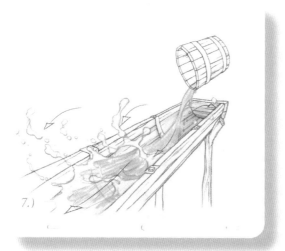

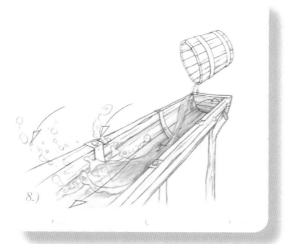

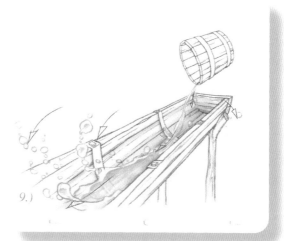

As the water collides with the trough and then carries on down it, the water that shot out explosively when it first collided with the trough collapses into strings of droplets that then fall away from the original point of impact.

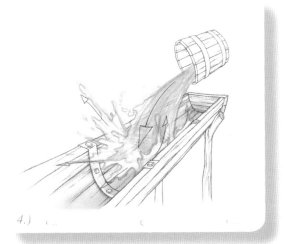

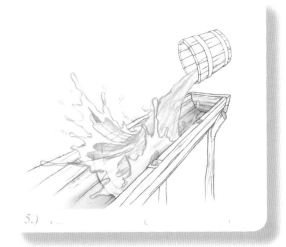

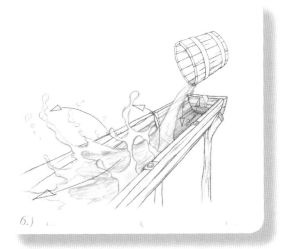

Notice how, in drawings 3 and 4, my drawings are rough and energetic where the water first collides with the trough. That is because of the explosive nature of the collision. When the bucket is tipped, the water runs out smoothly, but when it hits the trough it explodes outward.

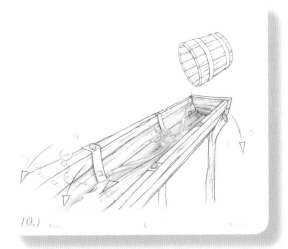

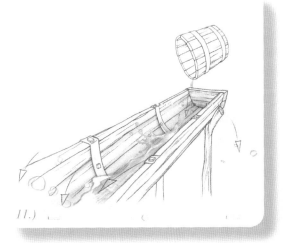

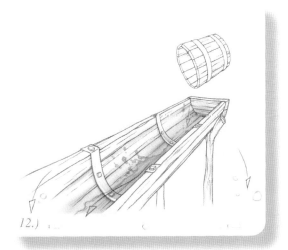

Although my drawings are not clean and perfect, this animation works nicely, with good flow, follow-through, and some overlapping action as well. It's very important for students to see that from very rough and quickly drawn animation, we can get beautifully fluid, flowing animation.

In the last two drawings the water is flowing down the trough with a subtle wave motion. I have added the red arrows to show the various paths of action throughout the animation.

In drawing number five you can see that there were already some arrows that I had drawn while I was animating, to show the students how the water was exploding outward from the point of impact with the trough.

Here I have layered all of the drawings together for an interesting look at how they all flow together. There is a strange ghostly quality to this drawing that I really like; it illustrates the movement quite dramatically.

Chapter 4

Lighting a Fire

When I went looking for great fire animation, I found out that at the time when the Disney special effects animators were doing incredibly masterful water animation on movies like *Pinocchio* (1940) and *Bambi* (1942), their fire animation, while dramatic and beautifully done, did not have the same fluid mastery of their water effects by any stretch of the imagination.

The fire in *Bambi,* for instance, shoots and licks forward, but it does not roll and boil in heat waves and belching smoke with the voluminous intensity that later Disney effects animators mastered in their fire and smoke animation. The fire in *Bambi* was stiff and seemed almost directionless as it only crawled forward with pieces shooting off of it; there was no waving action that could have been created by hot and cool air currents. It was a stylized, graphic representation of fire, without the real physics. There was also a lot of hellfire and brimstone in the "Rite of Spring" sequence in *Fantasia* (1940), but the best of that animation was the very fluid molten lava, flowing in rivers and belching big bubbles of heat. There is even some smoke in that sequence, which was done by pouring white dyes into water and filming it and then turning the film around 180 degrees so that it is moving upward. Fluid dynamics was already being used to create smoke and fire dynamics, and effects artists learned very early on that fluids and fires have some extremely similar dynamics going on.

What I learned about animating fire and smoke, I learned from an amazing group of mostly former Disney effects animators who had ended up working for renowned animator and filmmaker Don Bluth at one time or another. Eventually, that same group slowly migrated back to work at Disney, and we all worked together on several features together, learning each other's styles and design specialties. Each effects artist has an element he or she is particularly good at and passionate about doing. We sometimes become very finely tuned "ultra" specialized artists who fill a niche like bubbles, or water surfaces seen looking up from underwater, or of course, *fire*.

One effects animator who really showed me how to animate fire through his work was Dave Tidgewell. Dave was a pretty quiet and unassuming fellow. He had been my supervisor at the Don Bluth studio in Ireland, and then supervised me at the Disney studio in Florida as well. When Dave animated fire, you could see the hot and cold air sucking up and mushrooming clearly, like smoke inside the fire, or fire inside the smoke. Dave drew a fine line there too, drawing neither fiery smoke nor smoky fire, but beautiful billowing flames that roll, tumble, spin, and mushroom outwards.

Dave created a hybrid of flames and smoke that embodies the physics of both and describes a fire better than any animation I had ever seen before. Looking at Dave's fire and smoke work would forever change the way I approach my own. And sure enough, Dave also had the same classical approach that I do towards drawing rough, with the side of a pencil, and capturing vital natural energy in his strokes. We were eager effects animation colleagues, and we enjoyed learning from each other for years.

I think that one of the reasons that it took the Disney animators a little bit longer to figure out how fire dynamics could be exploited similarly to water dynamics, is that it was more difficult for them to observe and conduct experiments with fire than it was with water. Hanging out at home where you have a swimming pool is a pretty easy way to do some water research, but getting a really big fire going in your backyard has some drawbacks and is a much more serious proposition.

The greatest fire effects discovery since the days when fire was animated with a stiff staccato intensity is that *fire* dynamics are *fluid* dynamics. That's right, fire and smoke both move beautifully as fluids. That's one of the reasons I focused so much on the splashes in the previous chapter. Many of the design and dynamic characteristics of water translate well into drawing fire. You really start to have fun animating fire when you actually treat it like fluid. You can make your fire animation oily and slick, stretching and squashing and tearing it like an ultra-stretchy fluid fabric. You can imagine a ripped-up rag stuck on a branch in a river, flowing in the current, and the possibilities are infinite!

Imagine a torn-up old rag stuck on a log, flowing with the current of the river. The way it will wave along with the water surface, as well as the way the holes have been worn into its fabric, are extremely reminiscent of fire shapes and are another imaginative way to think about what fire actually looks like. In this smaller drawing, I have simply expanded the size of the holes in the fabric, and added a few new holes, to create an even more fiery-looking image, long after the rag would have disintegrated too much to hold together.

Understanding just how fluid fire animation is is a really big step in doing it well. When I watch the crest of a swell of water riding over a rock in a fast-flowing river, I can see it quiver, expanding and contracting and fluttering in ways that move and express themselves exactly like thick fire shapes do where a fire is forming up out of the logs. It is a perfectly clear illustration of this, to be able to see the fire emerge in this artwork, from a rotting rag flapping in the current, to a very sharp and hot-looking fire design.

"You could see the hot and cold air sucking up and mushrooming clearly."

"Looking at Dave's fire and smoke work would forever change the way I approach my own."

When I saw fire animated with all the dynamic energy of the underlying hot and cold air currents it changed the way I animated fire forever. And it drove home the fact for me that we are not animating "things," so to speak, we are animating the energy that carries those things on it. Fire is super-heated particles reacting to the rapidly rising and interacting hot and cool air currents.

In my first *Elemental Magic* book, I gave a fairly clear description of how I go about animating fire and smoke: however, it was more of an overview than a focused, detailed account of the actual process. Here, in *Elemental Magic II,* I would like to delve far more deeply into specific aspects of the process. I will describe for the reader exactly how I animate a rough fire from scratch, and then how I go about finessing the design and adding the details to the animation that really make it come alive.

I'd like to look at fire for a moment from a slightly more scientific and technical point of view. Then we will look back into the deep organic aspects of how I approach animating fire, keeping the scientific details in our back pocket to help the process along.

OXYGEN

HEAT

FUEL

CHAIN
REACTION

Fire occurs when there is an
extremely rapid oxidization of
a given material during the
chemical process of *combustion.*
This combustion and oxidization
releases heat and light, or what
we know as fire. When the
combusting, oxidizing material
is impure matter like wood, paper,
plastic, or rubber, other by-products
are produced, like soot and smoke. This is
the result of the chemical impurities inherent
in this matter not fully burning up, instead
turning into carbon, or ash. In the case
of very clean fuels, like propane or
kerosene, all of the matter is consumed
in the process of oxidization, resulting
in an extremely clean burning flame that
produces very little if any smoke. The flame
is the most visible part of the fire and is
made up of hot, glowing gases that are
released during the chemical oxidation
process.

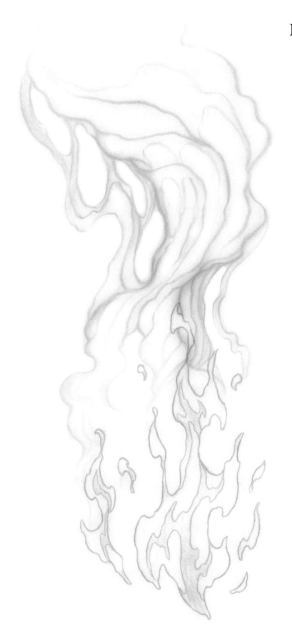

For a fire to light in the first place,
the combustible material must
be exposed to temperatures
above what is called the
flash point, as well as
an adequate supply of
oxygen or some other
form of oxidizer. When all
the conditions are perfect,
an incredibly fast form
of oxidization occurs, and
voila, fire! And if there are
enough of these combined
elements available, the fire will
continue or grow, resulting in
what we call *conflagration.*
(I love that word!) Depending
on the material being burned,
the color and intensity of the
fire can vary greatly. And
depending on the quantity of
the combustible material, and
the availability of oxygen, the
size, behavior, and color of the
fire will also vary.

Of course I always stress the importance of being intimate with the elements from a far more "touchy-feely" artistic standpoint, and as an effects animator, one should be constantly observing these phenomena. In doing so we become familiar enough with how fire works to know these *scientific* things intuitively. We all know that a butane or propane fire burns cleanly, without smoke, and tends to have a much bluer flame than, say, a camp fire. And we all know that some candles burn quite cleanly, while others make a great deal of smoke, depending on the quality of the wax and the material used for the wick as well. We don't necessarily have to know the precise chemical compounds and why they react the way they do, we just need to be familiar with the stuff!

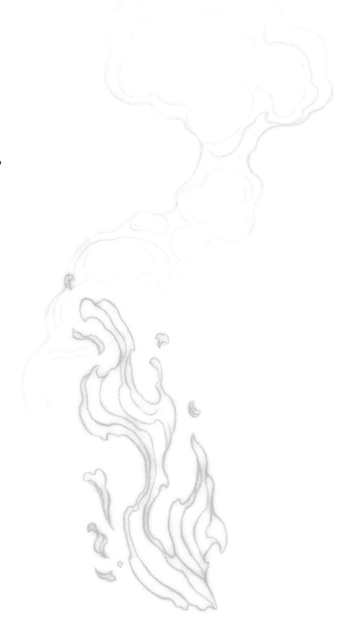

But still, the scientific aspect of elemental magic is utterly
fascinating and informative, and it can and should be
an integral part of our research process along with the
organic study of the elements. Having a well-rounded
knowledge of every possible aspect of any given effect
is a great idea, and will inevitably help us create more
convincing special effects animation.

As I emphasize throughout my first book and in all my workshops, working rough is of the utmost importance if you want your work to have structural integrity and dynamic movement. One of the greatest secrets to drawing elements that appear to have a lot of movement in them is to draw with dynamic movement—actually moving your hand and arm in a flowing sort of dance with your drawing surface. When you approach drawing with this energetic and dynamic technique, your drawings won't just *look like* they have dynamic energy in them, they literally will *have* that energy in them. The energy we project outwards is what manifests itself on our drawing surface.

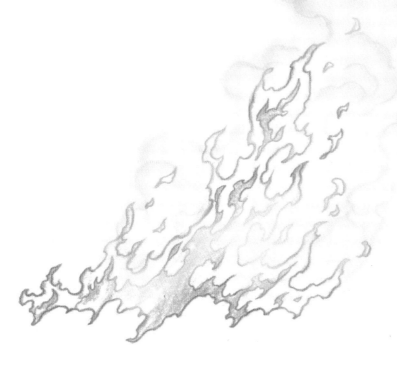

It's always helpful to go back to basics, and so here it is again: the waving flag exercise. I cannot overemphasize how important it is to incorporate this wave principle into almost every single effects element that you'll ever deal with. In water animation, fire and smoke animation, and of course anytime we are animating clothing or fabric of any kind interacting with a character, or the wind.

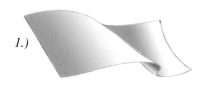

1.)

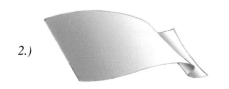

2.)

We even see the wave principle when solid objects break or shatter: as pieces bounce and scatter, there are wave patterns and movements everywhere. I have found it extremely important to understand wave movement when animating fire. It is also absolutely essential knowledge to have if you are working with CGI effects.

3.)

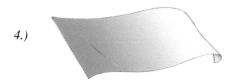

4.)

5.)

6.)

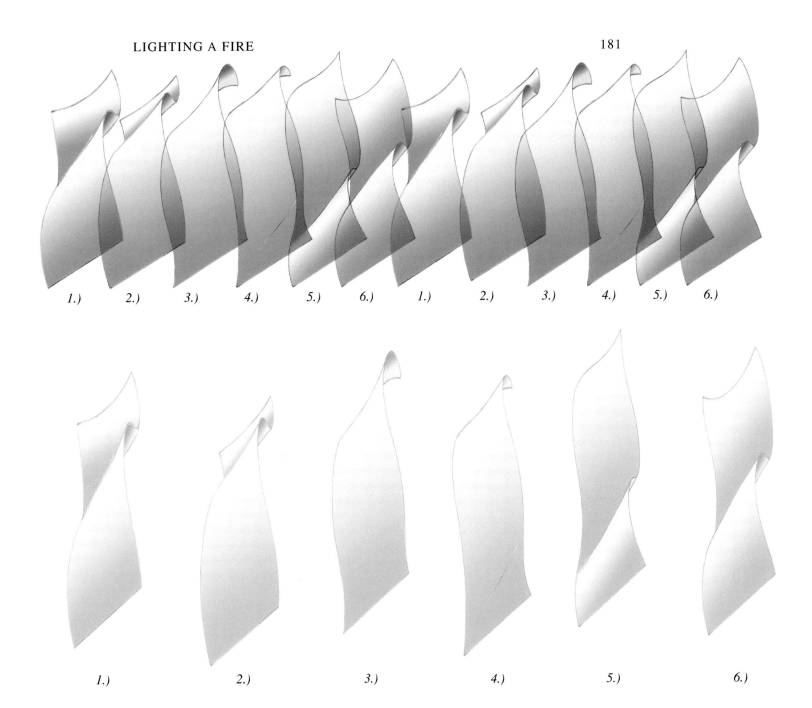

1.) 2.) 3.) 4.) 5.) 6.) 1.) 2.) 3.) 4.) 5.) 6.)

1.) 2.) 3.) 4.) 5.) 6.)

The Art of Scribbling, Part 2

A great way to practice drawing
with energy is to work on very large
surfaces, as is often recommended in
life drawing classes. Working while
standing up can be extremely beneficial
as well, as it frees up your entire
body to move with the energy of
the effect you are creating. Again,
this is almost a kind of a dance
with your drawing surface and
your artwork. The elements we
are trying to draw and animate,
after all, are incredibly graceful,
poetic, and hypnotic in the way they
move. Can we really expect to recreate
these elements convincingly if we are all
tightened up and hunched over our drawing
tables or computers, squeezing our pencil or our
stylus with white-knuckled intensity?

The drawings on this and the following pages illustrate some very effective techniques and principles to keep in mind when animating a fire. First of all, I illustrate how we can think of a fire as moving very much like a flag in the wind. The very same wave principles that we apply to animating a flag work extremely well when animating a fire!

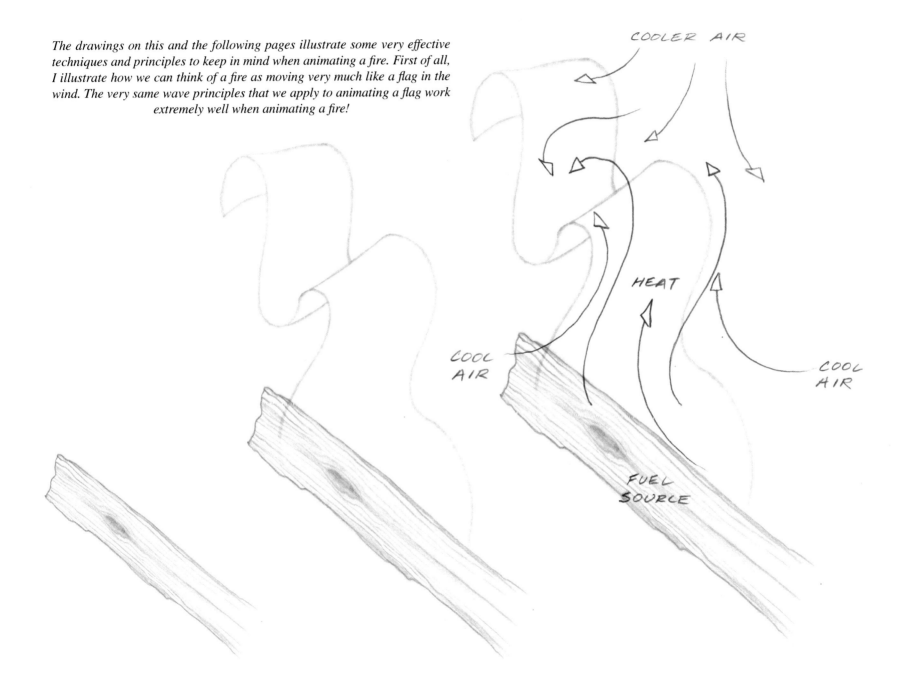

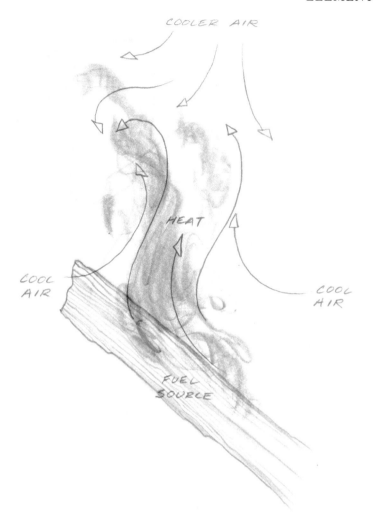

In this illustration we see how my first drawings of the fire are extremely rough, sketchy drawings. Very little attention is given to specific details, but rather, going with the flow of my waving flag, I sketch very flowing shaded areas with the side of my pencil, drawing fast, with the energy that I can see would be moving the flag. In this earlier drawn version I did not follow the flag shape as literally but just followed the roll of the flag beneath the drawing.

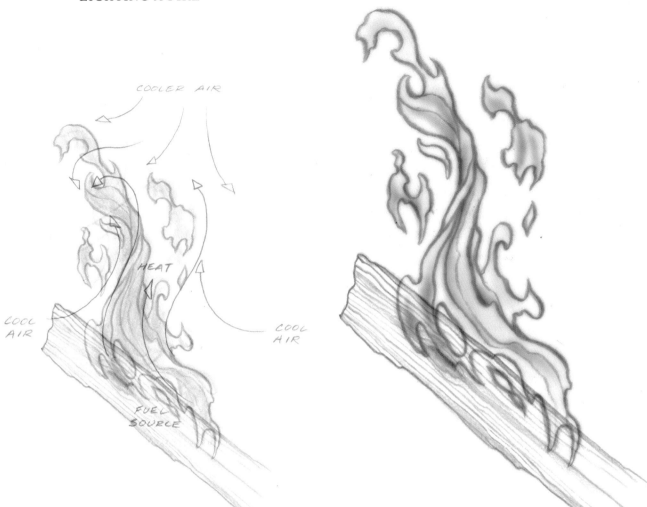

After I have done my rough, energetic drawings, I apply a clean outline. I find that if I follow the outside of the shapes in the rough sketch, and squint my eyes a little to almost put the sketch out of focus, elegant fire shapes can sort of be pulled out of the rough sketch. These shapes are in there because of the energy that I put into the rough drawings. This is an almost magical process that I have developed over many years of drawing special effects. I believe this to be the very best way to draw beautiful effects designs! With practice, you will see what I mean.

There is a principle of letting go and loosening
up that is a very important element of learning to
play a musical instrument with grace and finesse.
I am going to propose here that we examine
that principle, in order to apply it to the way we
approach our drawing. Any percussionist who
plays with some sort of sticks can tell you, if
you grip your sticks tightly, your playing will
always sound and feel tight and restrained. Barely
holding on to the sticks at all, and really just
guiding them, allowing them to strike, recoil,
and vibrate freely, gives your playing a much
more natural, full, and flowing sound.

The same is said of the proper technique
of holding and moving a violin bow.
If it is clutched tightly and pushed
and pulled, it will sound painful,
tight, and forced. It is only when we
let go and simply guide the bow to
interact with the violin strings on its
own terms, that we begin to hear clear,
sweet-sounding notes.

This is precisely the same technique
that I use when I am sketching out a
rough effects drawing, and it is safe to
say *especially* when I am drawing fire,
because in some ways fire is the fastest
moving and most wildly dancing
element. My pencil is supported lightly
sideways across my fingers, with the
broad side of the lead facing the paper
rather than the point. As I sketch rapid
strokes across the pages in a staccato,
shaky fashion, barely guiding it and
allowing it to overshoot and rebound
from my quick movements freely, it
can sometimes look to an observer
like I am doing nothing more than
scribbling a mess of chicken scratch
across the page.

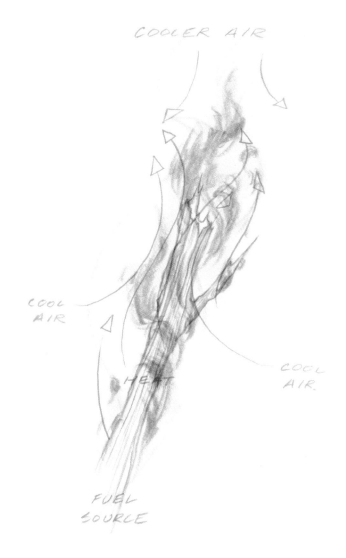

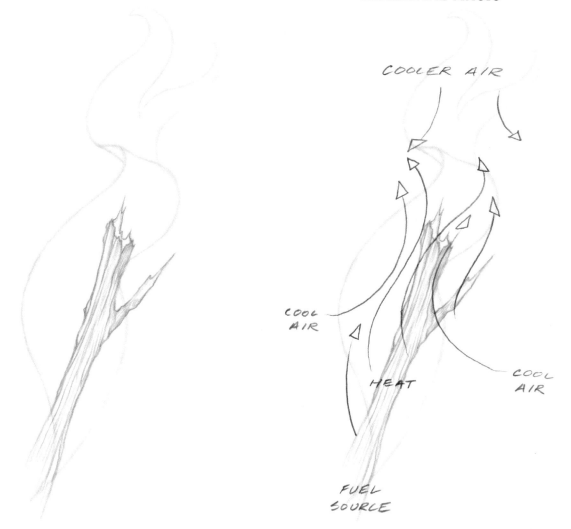

When I try to imagine what a fire will look like, I always begin by thinking of the energy that is creating the fire. This is a mostly intuitive process for me now, and I rarely if ever actually draw a literal flag shape before roughing in my effects animation. But early on in my career when I was learning how to animate fire, I found it immensely helpful to start with a flag shape. So give it a try. Once you have a working flag in place, the rest falls into place easily!

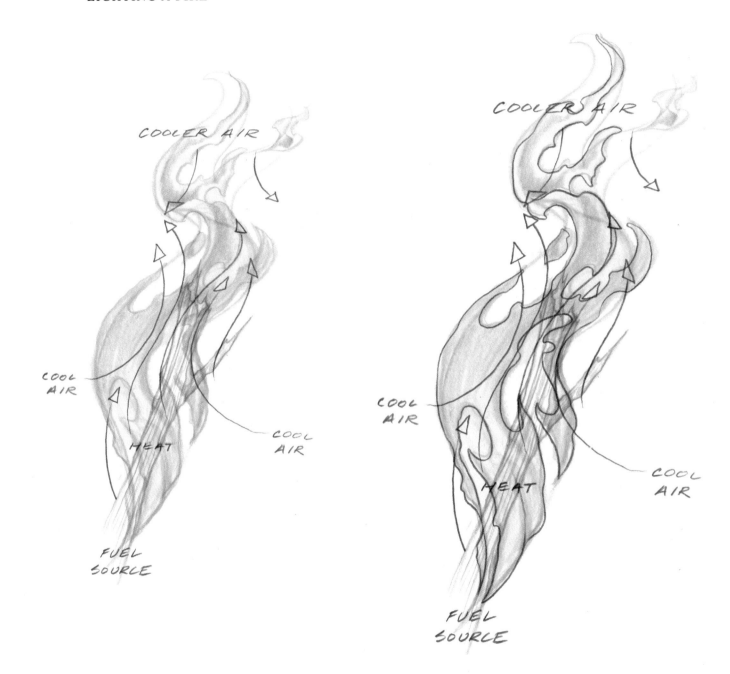

COOLER AIR

COOL
AIR

COOL
AIR

HEAT

FUEL
SOURCE

COOLER AIR

COOL
AIR

COOL
AIR

HEAT

FUEL
SOURCE

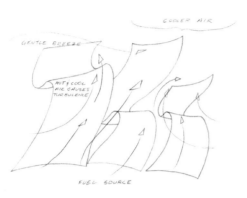

Animating fire using the waving flag as the basis for our movement is extremely liberating, because once we have the movement working well, we are free to sketch and animate our fire with a greater level of abandonment, which lends itself to achieving a more organic feel with our animation. The beauty of animating fire, as opposed to an actual object such as a flag, is that with fire one is no longer constrained to the limits of volume.

When animating a flag it is very important to ensure that the length of the flag remains consistent, but a fire changes volume constantly and unpredictably as it dances and fluctuates with great irregularity. So we can break pieces off whenever we want to, and we can stretch and squash our fire animation freely. In fact, the more irregularity we animate into our fire animation the better. As long as we are following the underlying flag movement, our fire will animate elegantly, regardless of how erratic or unpredictable its shape and volume is.

One of the most difficult things to teach a person about animating fire is in fact just how inconsistent fire really is. We have a tendency to be too careful when we animate fire, following through with every single shape and piece of flame. But in reality, pieces of flame can and will appear and disappear very randomly. The problem we can see with a lot of fire effects animation, is precisely that it is too predictable, and there is not enough of that crazy, chaotic energy going on.

So always remember that as long as the basis for the fire animation, the waving, rolling flag that is driving it, is animating smoothly, the fire will animate nicely. So we are free to play with the volumes and shapes of the fire, and it can be wildly erratic but still animate well. Spend some time watching a real fire, and these principles are easy to observe. Look for them!

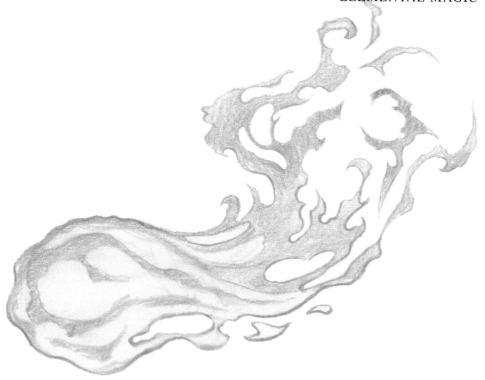

Another way to exploit the way fire effects work in a really fluid way is
to imagine that the hot air or fire that you are animating is bubbles of hot
air underneath the water, because it is, in a way. When a fire is burning
it is actually creating bubbles of heated air, and the cooler atmosphere
around this hot air acts much like water around the pockets, or bubbles,
of hot air. These bubbling, fluid, hot and cold air currents are visible
using exotic photographic techniques, and I included a couple in the
first *Elemental Magic*. For me it is a really key effects skill to be able to
envision the physics working around an element like this fire. When we
start to see the fire and treat it as if it's a bubble of hot air being spewed
into the air, our fire animation takes a leap!

The more I look at this sort of example of the physics going on in the air around a fire, the more I wonder how I used to animate fire without envisioning it in this way. It is in fact more accurate to see fire as a fluid bubble of warm air moving through a cooler and fluid surrounding atmosphere. Read through these fluid fire pages a few times if it doesn't stick at first. This is really important stuff!

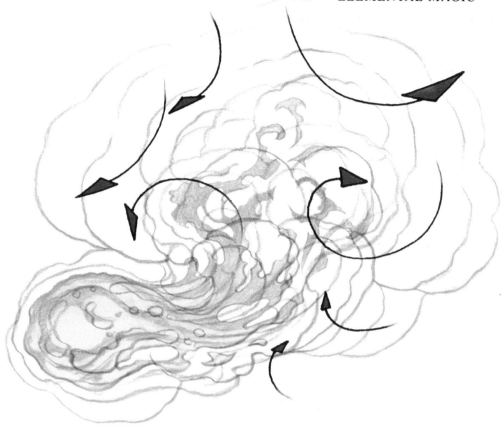

Using this knowledge of how the surrounding cool air drives the behavior of the fire's super-heated air has led me to approach my fire effects drawings much differently than I used to. Now I will usually rough in a lot of detail describing the mushrooming hot and cold air surrounding the central fire, and these are shapes that my fire designs will ride on and use as their structural base. This introduces a whole new level of dynamic range to your effects work!

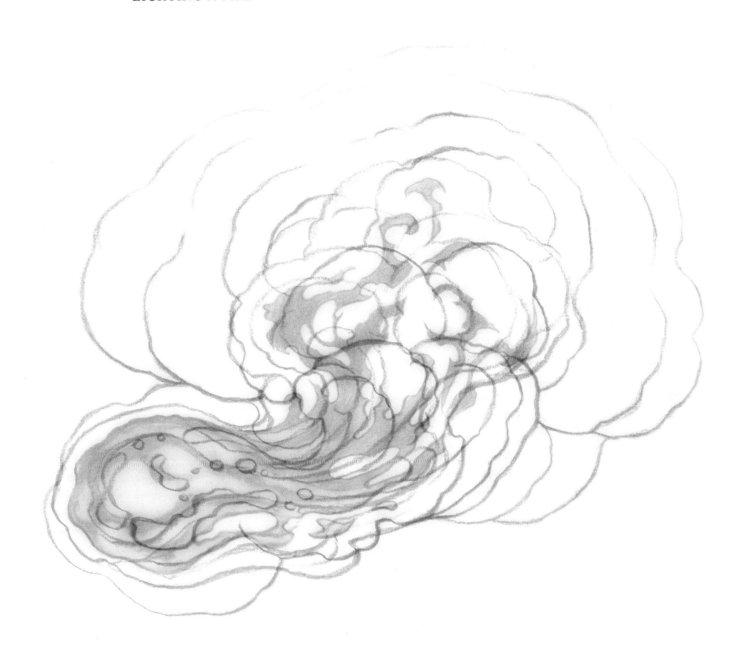

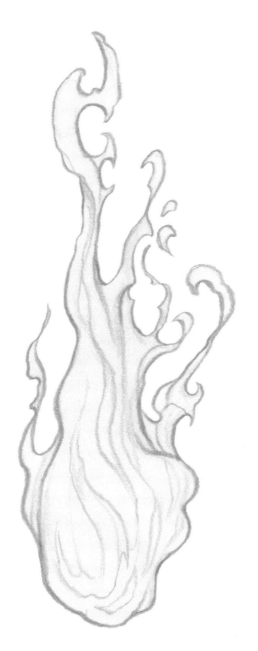

In these next few drawings, I demonstrate again some of the hidden shapes that work behind the scenes in an effects element like a fire. This is really a breakdown of the patterns of energy actually creating the shape of a fire. I have never seen this broken down in a way that makes this concept easy to teach. I think many people have animated fire or water or whatever effects element and never even imagined that these powerful shapes, based on profoundly complex fractal mathematics, are constantly going on under the hood of a complex event like a fire.

As you watch the sinuous dance of a fire now, after reading this, look for the structural shapes underneath the details. Imagine the cold air around the fire, pressuring the fire to look for an escape route up and away from where it is. As the fire shapes expand up and away from their point of combustion, they follow invisible guidelines of beautiful flowing geometry. Just like every other atom in the entire universe, as far as we know.

When I look for the patterns of energy behind
a specific movement or action, I allow my
imagination to take some liberties, and some
crazy flights of fancy as well. I think it is
healthy to keep our visual vocabulary fresh and
dynamic, to push ourselves to see beyond the
veil.

I have long seen patterns in splashes and fires
that made me think of branches, trees, flowers,
shells, coral reef formations, a deer's antlers,
you name it. There are visual correlations all
over the place if you look for them. When I let
my imagination run away with me, I come up
with shapes I find inside a fire design that are
reminiscent of surrealist painter and set designer
H. R. Giger's biomechanical imaginings. These
shapes are easily found and always radiate
outward from the point of combustion, or in
the case of a water splash, the point of impact.
Same thing. Find the source of the energy,
and you will find fractal energy flowing out of
it, expanding as it generates fantastic shapes
emanating in every direction at once.

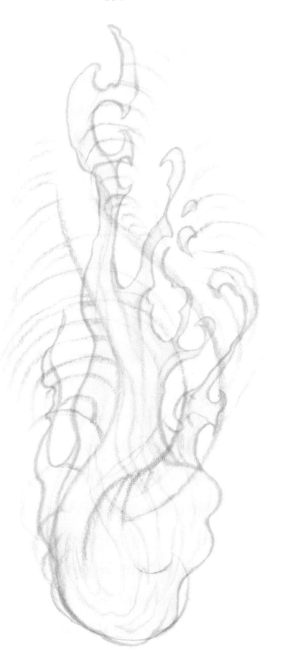

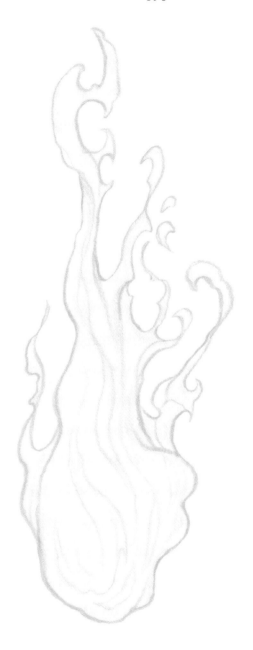

Not many people would imagine a fire and a splash as having very much in common, but I find it helpful to see them as having a great deal in common. If nothing else, it is important just to remember the important design principles that go into a nice fire design as much as a splash design: that is, a good silhouette, and the avoidance of too much symmetry or repetition.

But deeper than those design principles are nature's real quantum building blocks, and those differ very little in their divine design between fire and water.

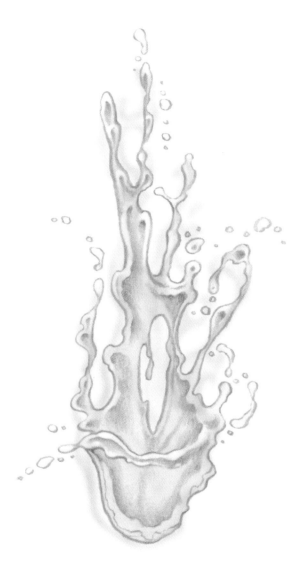

I also enjoy just pushing the envelope sometimes, beyond what is even remotely logical, and I think that this playful tendency is a great way to push and broaden the limits of your special effects designs.

Look for creatures or plants in your effects designs and turn them into actual characters, writhing on your page. It's not only a good break from the toils of animating, it's truly a helpful way to look at our creations with a more open mind.

Seeing these absurd patterns in our effects will help us to create effects designs that truly stand out and resonate with a natural energy that is very familiar to most people. Because all things in nature are tied together in wonderful ways, so should our effects elements be rooted in this way.

Trees are a great source of inspiration for me. Each species of tree has a special way of extending its branches, reaching sinuously skyward. I see a lot of fantastic smoke and fire shapes in the way a tree's branches grow.

Of course, sketching in nature is the greatest practice and inspiration you could ever ask for. Any walk in any forest, anywhere, will serve up one incredible natural element after another.

I do not want to overuse the term *fractal,* but nature is entirely fractal. The deeper you go into familiar repeating shapes, the more connected repeating patterns you'll find: spiraling, branching, unfolding, pouring, burning, and radiating.

All nature imbues its subjects with powerful natural design. Roots, branches, and the bark of trees are a natural source of inspiration for smoke and fire design cues.

This delicate art nouveau border was the end result of a squiggly sketch I was doing of some incense smoke, not intending at first to create a decorative element but rather a natural one. Thus I discovered firsthand how the art nouveau movement was in fact drawing on the very forces of nature to drive their designs. In these designs, as well as many of the tighter more geometric art deco, we see repeated fractal geometry, ascending and descending in the design's hierarchy.

I have found throughout my career as a sometime-illustrator, that my special effects work lends a very natural feeling to my more design-oriented pieces.

When I say that you can see the design in
nature or vice versa it is not a metaphor. It
is as plain as the noses on our faces when
we begin to see the overlapping repeated
patterns of energy that occur all around
us, all the time. Life is like a never-ending
dream of visual effects treats occurring as
a part of our daily routine, and the very
fabric of what we do as human beings is
threaded with a design that is derivative
of that natural magic of real-time effects
phenomenon. It is an integral part of our
reality.

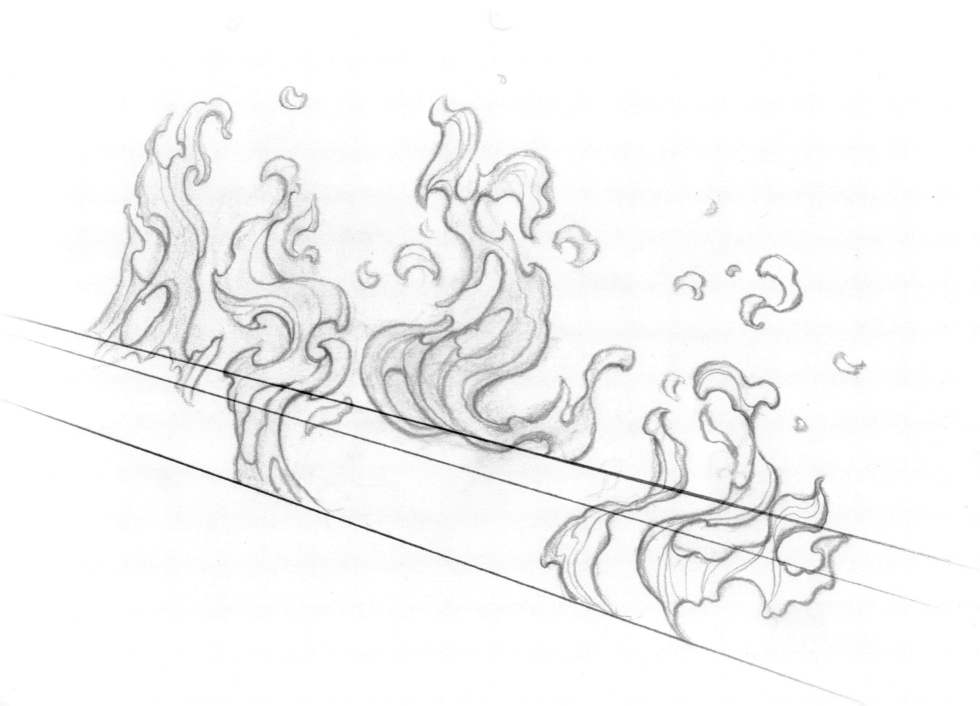

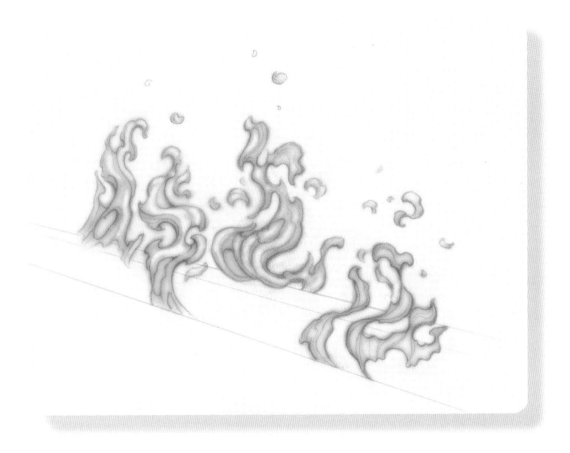

Fire has a wonderful way of wrapping around the object it is burning. It all has to do with air currents and the way that the fire feeds on the spontaneously combusting material. The super-heated particles in the fire leap into a much colder world that restricts their movement, flattening the flames to their host, seeking a way for their pure energy to escape. All of fire's twists and turns, its unexpected licks and pops, are a result of the heated gases simply trying to expand into the cooler air around them.

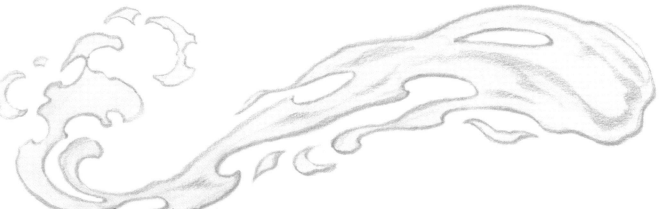

Once again we find ourselves well into a chapter with only hand-drawn effects examples directly from my imagination, without looking at or referencing photographs in any way.

There is something extremely beautiful about drawing fire. It is like trying to capture the purest essence of the true natural design of pure energy. The style you portray your fire with is like your own language of fire. You can leave out or add whatever dynamic component you choose, tweaking your own personal physics experiment incrementally from an exercise in physics to an expression in design.

Fire is an incredibly playful element to draw and design with, as it is lyrical and poetic, swirling and curly, swooping and flowing. As when it burns and clings to surfaces, as a design element it clings to borders and frames pages and compositions of all kinds beautifully.

In the next few pages I will be looking at a lot more photographs for fire reference. Since I've been compiling and reviewing fire photos to put this chapter together, I've been really pleased to see that a great many of the shapes and design principles that I use when drawing fire from my imagination are right there in the photos I have taken as well. I have found perfect examples of design hooks and flourishes that I use when I am drawing fire, leaping out from these fire photos like familiar old friends. My nephew, Ben Duperron, has also helped out as he did with my splash photo session, taking hundreds of pictures with his beautiful SLR camera while I played with fire.

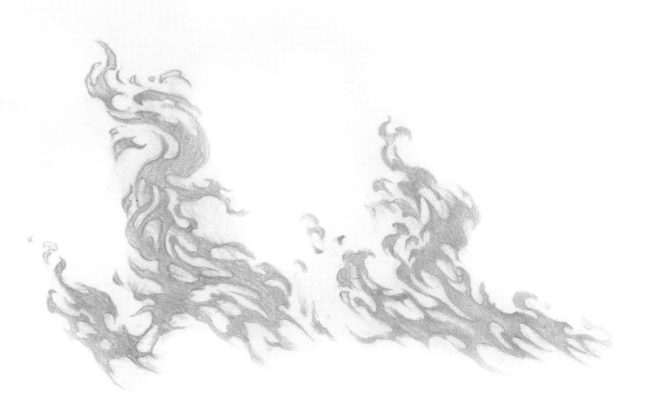

It was a deeply gratifying experience to
draw dozens of fire drawings right from my
imagination, and then see in real photos of fire
the same structural physics of my fire drawings
playing out. I wasn't even sure that it would
be the case, as I know I have been drawing
fire for a long time, and one has a tendency to
fall back on a formula and a heavily stylized
approach to drawing fire. But the foundation of
my designs is built upon the knowledge of how
the underlying energies of a fire are actually
unfolding. So no matter how stylized my
drawings become, they always possess within
them a strong connection with the real energy of
fire.

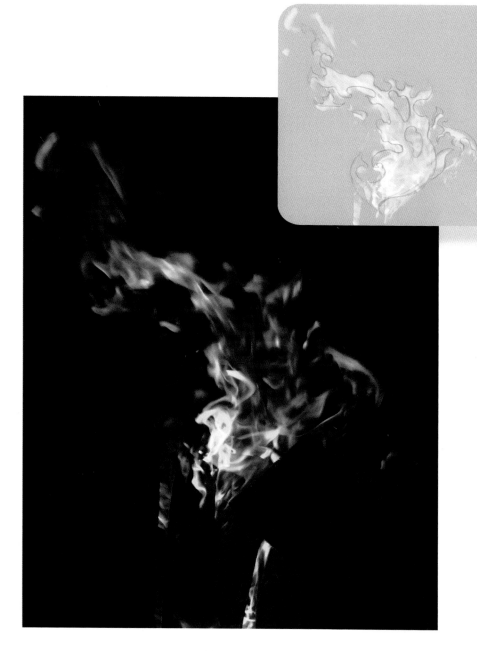

This photo really stood out as looking almost like one of my fire drawing designs. The key to getting photos of fire that look like exciting fire shapes is the shutter speed. When the shutter speed is extremely fast, we see the strange shapes of a leaping fire but we don't see the movement, or the motion blur that is created by the movement. It is the natural motion blur that we perceive with the naked eye that gives fire its distinctive shapes. That translates into a fairly slow shutter speed with a camera, to get photos that look more like what we observe naturally.

It is a lot harder to create a really good-looking drawing from a photograph than one might think. If you try to follow a photo too closely, it is easy to get caught up in an absolutely incredible amount of detail. Look closely and you will see the jumbled mess of twisted shapes making up this fire photo. The most important thing to get from a great fire photo is its essence, and that can be captured by looking into the underlying design yet again.

This is very much like the art of looking at a human figure and being able to catch the particular geometry, weight, and attitude of a character. This is the art of understanding the physics, geometry, and attitude of your fire.

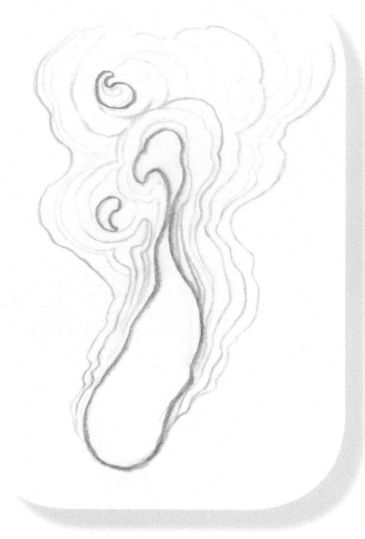

I mentioned earlier that one of the biggest changes in my work with fire effects came when I was able to start looking at the actual air currents moving the fire, and shape them. Before I had understood that when you animate smoke you are really drawing tiny particles traveling on air currents. But that knowledge hadn't immediately translated to my fire animation, and I would still get caught up in animating shapes without a real natural energy pushing them. It was very helpful to realize that the glowing, super-heated particles that we see in a fire are also moving on those same air currents. If you try sketching outlines around fire shapes, you may be able to start visualizing what these air currents look like.

Thinking of fire as a fluid does not make
a whole lot of sense at first. We have it
locked into our brains that fire and water are
diametrically opposed elements that don't
share any characteristics. But when we look at
fluid dynamics, the parallels are undeniable,
and we see air currents behaving almost
exactly like water currents.

The blue photograph on this page is a fire
photograph, with a direct inversion done on
the color so it is a negative image. If one did
not know what it is, one could study it and
declare that it must be water. In the next few
pages we will see many clear examples of the
fluidity of fire.

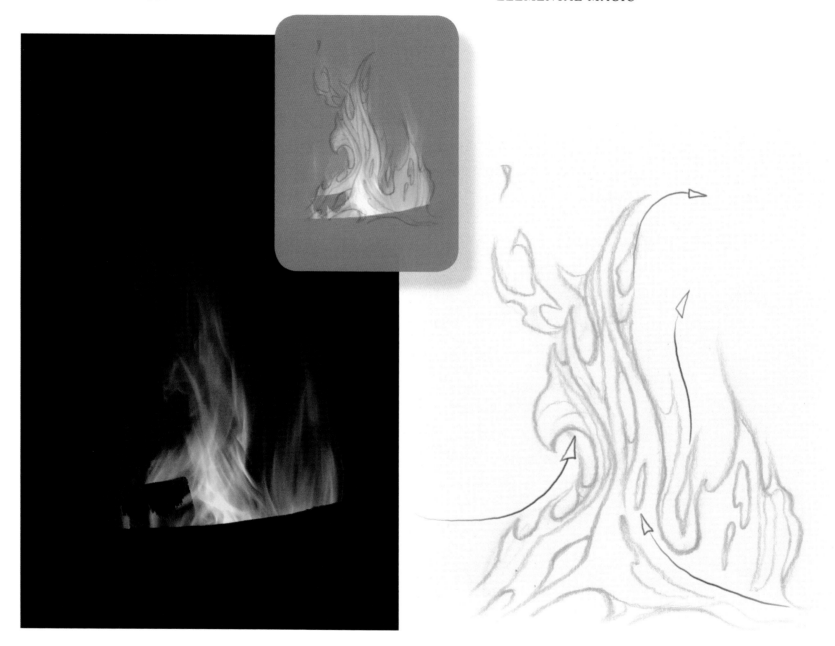

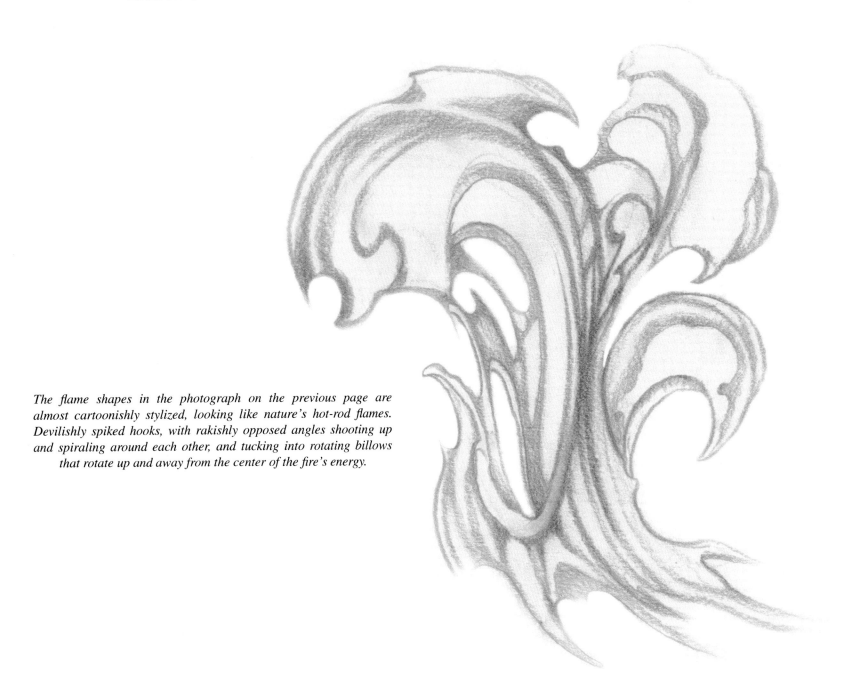

The flame shapes in the photograph on the previous page are almost cartoonishly stylized, looking like nature's hot-rod flames. Devilishly spiked hooks, with rakishly opposed angles shooting up and spiraling around each other, and tucking into rotating billows that rotate up and away from the center of the fire's energy.

"I am left speechless by the beauty of a crackling, leaping fire in the fresh country night air."

The shapes that we see in spiraling embers and swirling smoke are magnificent studies in elegant design, and lend themselves to many design elements in popular culture. The designs I present here are somewhat more hand-drawn in their style, but the swirling decorative clichés of the 2000's decade are everywhere in our tattoo-art-ridden culture, and that has in turn leaked into mainstream media.

Much of the design I see in the fire is reminiscent of the art nouveau work of Alphonse Mucha and Aubrey Beardsley. These designs also echo the decorative folk art of many diverse cultures around the world. As I mentioned in the previous chapter, the design of classical Persian rugs and Victorian lace also contain many of these visual hooks.

The beauty of this study is to find the root of these classical designs, passed on down through human history over centuries, living and dancing in real time, in a display of brilliant, pure, fluid light energy. Fire is a deeply visceral expression of "in your face" designs, designs that can leap out at you and grab you by the throat.

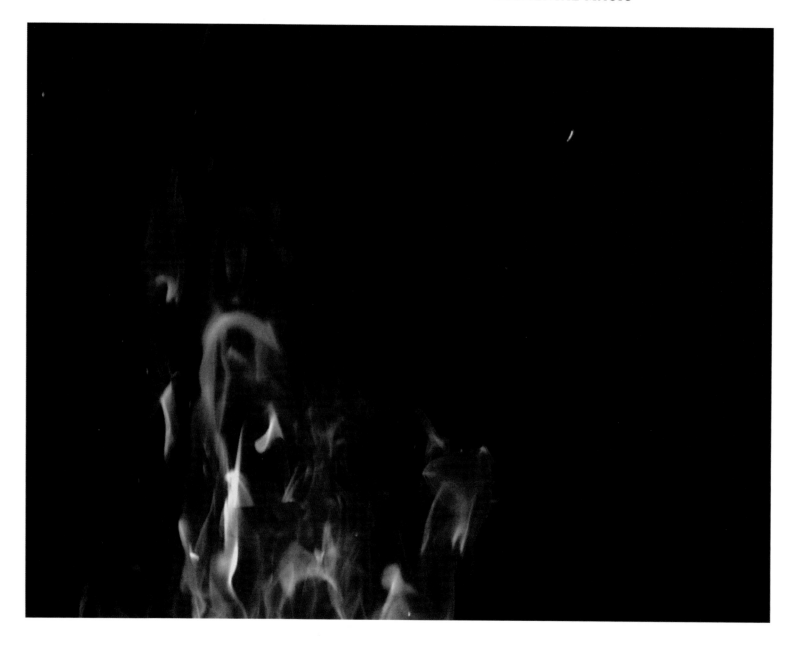

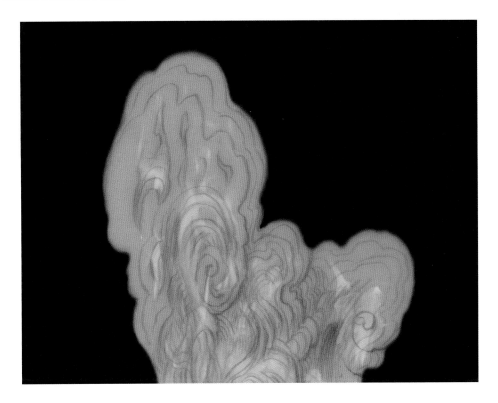

In these drawings that you see layered over the photograph, I am trying to catch an "essence" of the energy informing the fire in the photo. In some of the following drawings, I will show some examples of copying the photos just by looking at them, and not tracing, which can often reward one with a much more interesting and dynamic drawing.

Tracing can teach you a great deal, though. When you find out how hard it is to capture many of the highly complex shapes of even the simplest fire, you quickly gain a new respect for the element of fire itself. It is incredibly detailed and intricate, and the deeper you look into it, the more you see.

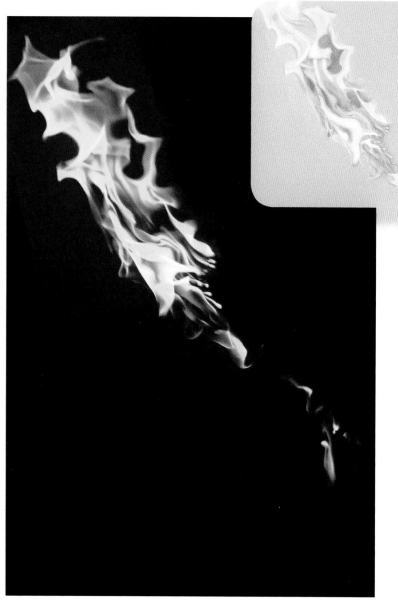

If you really try to pick up all the detail in a fire photo, you are quickly overwhelmed with details. Even the simplest-looking fire is deeply complex.

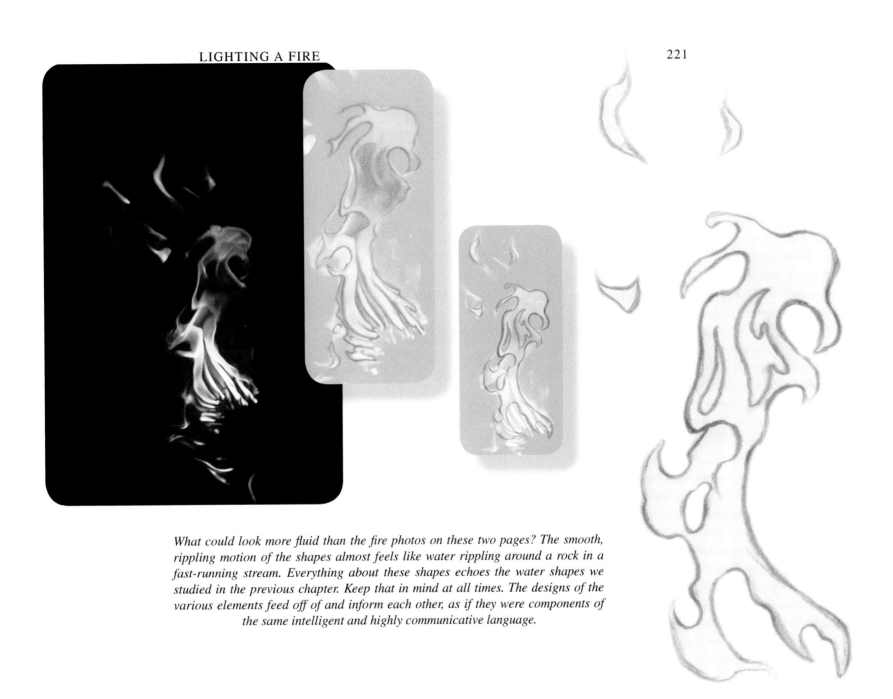

What could look more fluid than the fire photos on these two pages? The smooth, rippling motion of the shapes almost feels like water rippling around a rock in a fast-running stream. Everything about these shapes echoes the water shapes we studied in the previous chapter. Keep that in mind at all times. The designs of the various elements feed off of and inform each other, as if they were components of the same intelligent and highly communicative language.

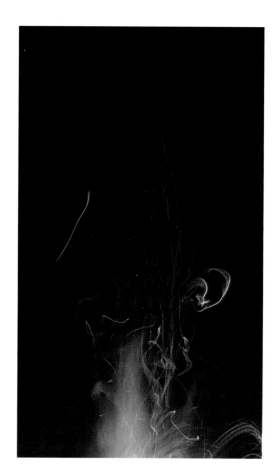

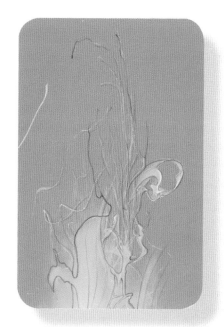

These swirling embers are utterly stunning in their complex beauty. When I first looked at these photos my jaw hung open at the whimsical and lyrical beauty of these images. Longer exposures capture the shapes that the ember's glow cuts through time and reveal amazing exploding flowers of flame, which look a lot like elegant exotic flower arrangements.

In this photo my nephew Ben was stretched out on his back next to the burn barrel taking photographs as I shook off big fir branches crackling with millions of red, glowing embers. Big, thick clouds of embers shot up in brilliant waves of natural fireworks.

In only a couple of hours maximum of playing around with a fire barrel and a couple of cameras, we put together an incredible collection of fire effects photos, which are still mesmerizing me as I write this, and I continue to find new gems whenever I look at our collection of fire photography.

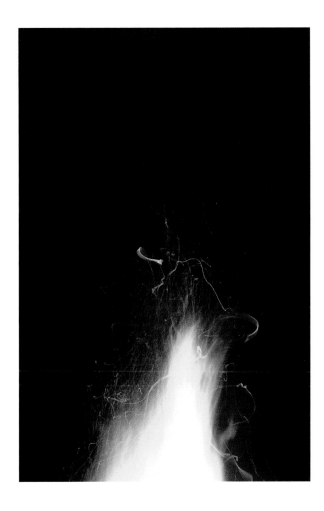

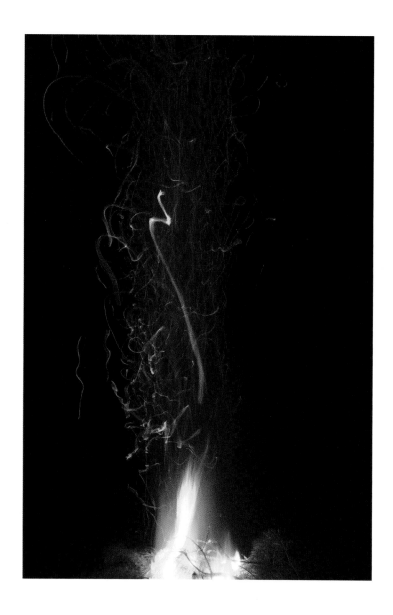

These delightful fire ember photos, are an incredible cacophony of swirling strands of light interweaving delicately with each other. Although highly abstract, there is a great deal of form and design in fires that looks so perfect sometimes as to almost seem like something premeditated. If you had paint brushes that painted glowing lines with pure light, this could be a study you might do with intense floral energies.

If you ever have to design something like this from scratch, remember to really play with the shapes and strokes of your lines. This may be a high point in the history of scribbling!

These are fairly long exposures, and
we are able to see much longer streaks
than you ever could with the naked eye.
It is interesting how all together this
collection of embers on their travels
shooting out of the top of a fire creates
an overall design that is very strong.

But interestingly, many of these embers
do not follow the same energy path
that the majority of them do. Some of
these embers are like self-propelled
little rockets: as they quickly heat up,
tiny pockets of air trapped in these tiny
propellants are forced out, shooting
them through the air erratically. Many of
them will shoot off sideways or spiral off
wildly in a totally random direction.

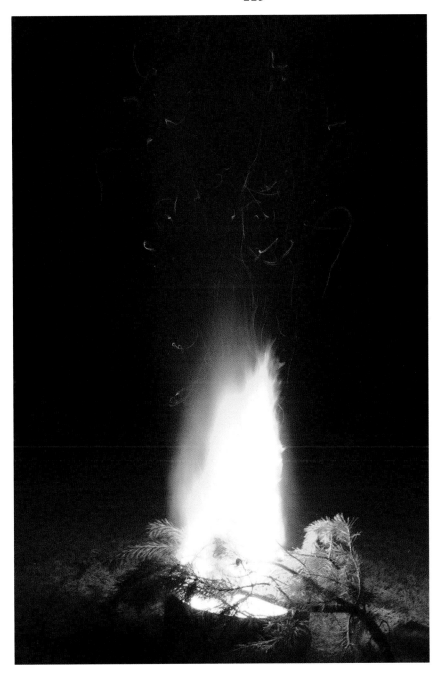

"Fire is like water made of of pure burning light, that instinctively claws its way upward to escape at the speed of light into the darkness of the night..."

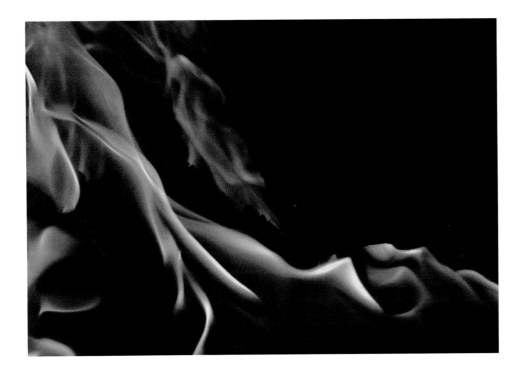

Did I mention the fact that every time I do a simple little effects photo or film shoot, I have an absolute blast and always learn something completely new and unexpected? I repeat the point because it really is just awe inspiring to get busy experimenting with special effects, and the amount of real-time information about physics that you can absorb is infinite. Of all the advice I can give, the encouragement to actually play with the real effect is just absolutely number one. Just be careful and reasonably diligent about the real danger involved when you are 'playing with fire'!

"If you really want to learn about smoke, you've got to get some in your eyes!"

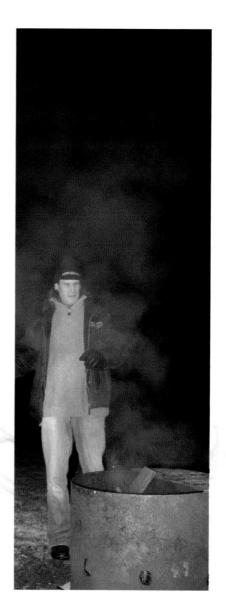

You're not really doing fire research until you get your hands dirty—and get some smoke in your eyes. The outdoors aspect of doing great effects research is of enormous benefit for your health as well; besides getting the occasional bit of smoke in your lungs, it's mostly fresh air! So much of an animator's life can be spent working indoors for years. Any excuse to get out and stretch our legs is a good one!

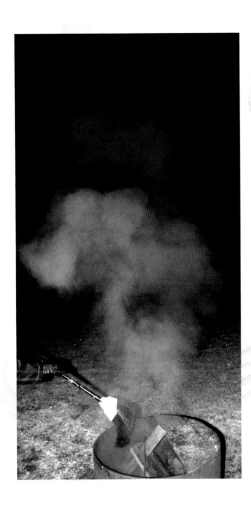

Even though I've been drawing and experimenting with special effects for over 30 years, I can still honestly say that I learn something new, or see something that influences my subsequent work, every time I play around with smoke, either when conducting "serious" effects research, or just hanging around a campfire poking around. Watching hypnotic writhing waves of unfolding mushrooms of smoke evokes something deep inside me every time. And the residue of that experience is that I have a fresh sense of the very essence of how smoke moves at my fingertips.

Please excuse the next few pages looking a little bit like a Christmas card. It was the holiday season when I took these smoke photographs, and my set was already decorated. I was lighting a little bundle of sage on fire and then blowing it out to produce thick white smoke. In this first photo, I was amazed to see such a perfectly flat sheet of smoke rising up and then folding over on itself, creating perfect little folds in the smoke.

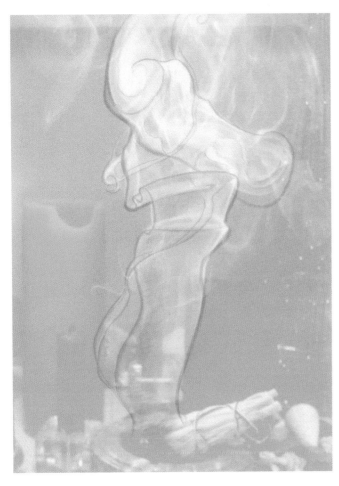

Studying photographs of smoke is a great way to learn. Otherwise we can only base our knowledge on what we see with our naked eye. Much of what smoke does is very fast and so abstract that it is impossible to observe and sometimes defies description. But when paying careful attention to its behavior, one begins to see a solid underlying structure beneath it all.

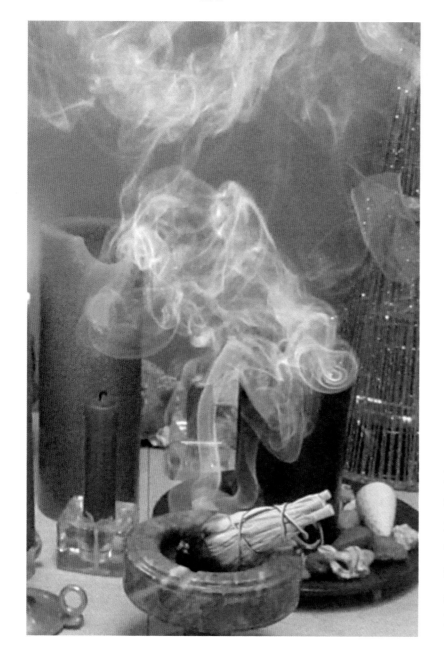

In this photo I found a strange spherical bubble of careful rolled up layers of smoke that absolutely fascinates me. Looking at it carefully I had to realize that the air currents the smoke is riding on had to have taken on those precise shapes. Incredibly intricate, delicate little structures, in such a small and ordinary little puff of smoke.

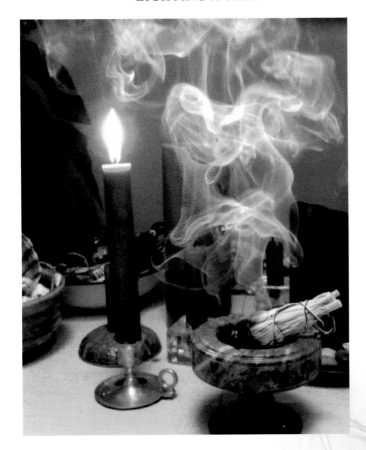

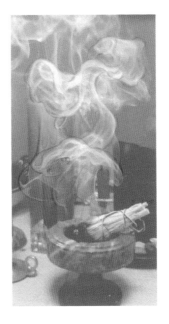

The warmer air carrying the smoke particles ripples upward and outward in fluid, bubblelike pockets of air that twist, roll, and tangle through each other like graceful dancers.

The smoke in this photo is a superb example of a classically unfolding strand of sinuous, linear-style smoke. It folds back over itself elegantly as it pushes its way up through cooler air currents that try to flatten it out.

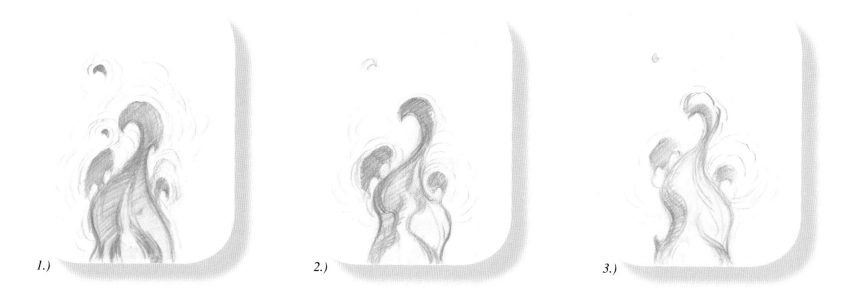

1.)　　　　　　　2.)　　　　　　　3.)

This image sequence is a lovely example of a medium-sized fire, stylized and animated in a very fluid manner.

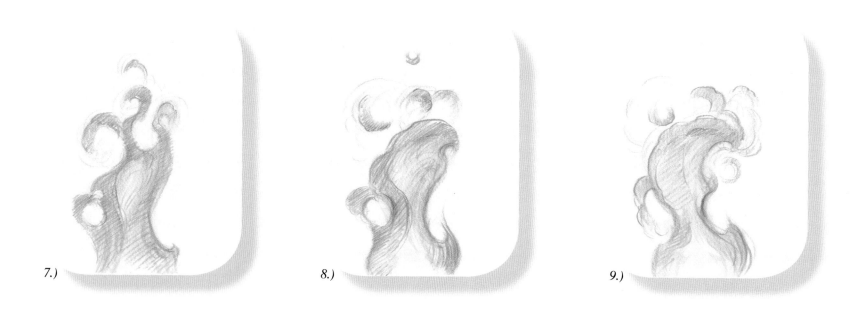

7.)　　　　　　　8.)　　　　　　　9.)

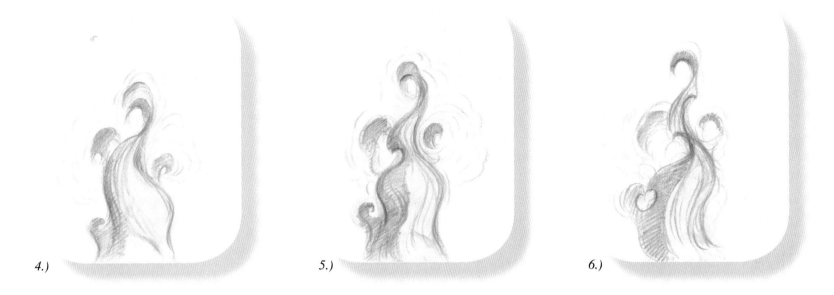

4.)

5.)

6.)

I have left many of the rough flowing lines that I sketched in while animating this fire.

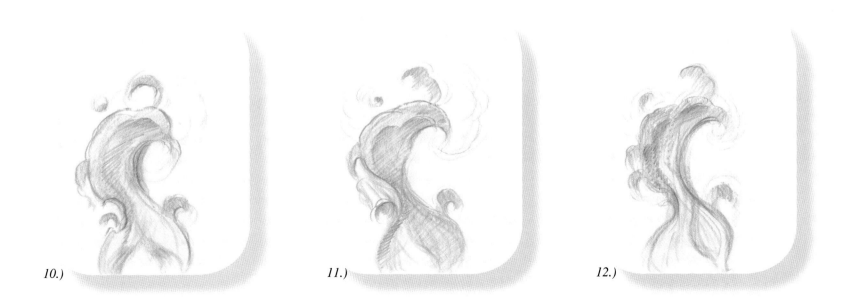

10.)

11.)

12.)

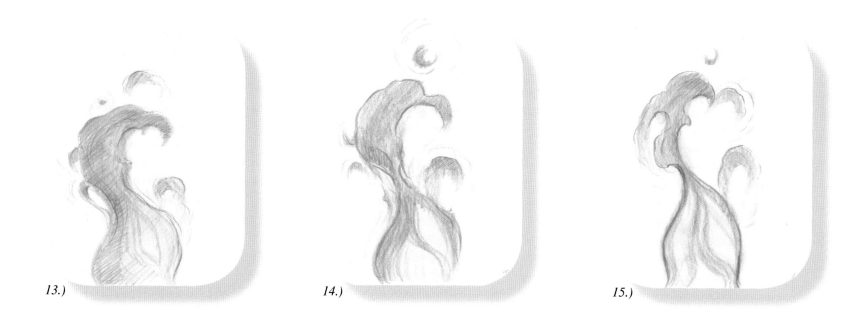

13.) 14.) 15.)

If you analyze this sequence carefully, it is easy to see the fluid, flapping flag motion.

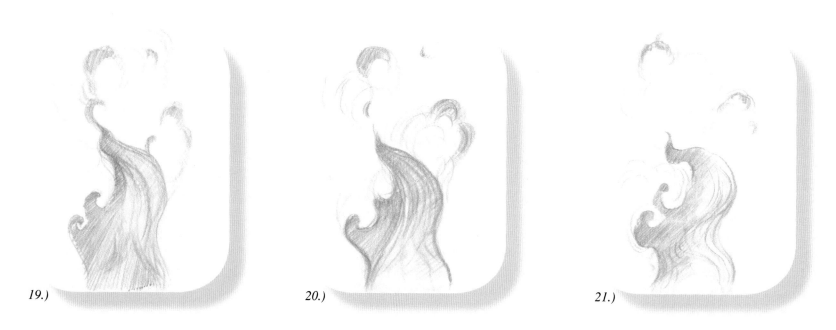

19.) 20.) 21.)

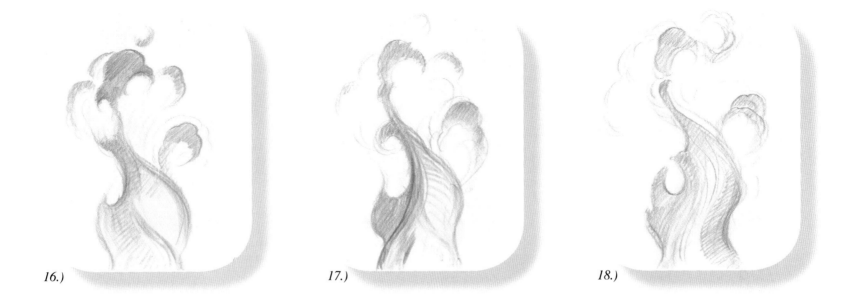

16.) 17.) 18.)

As the "flag" flaps, the pieces on the end break off and disappear in two or three frames.

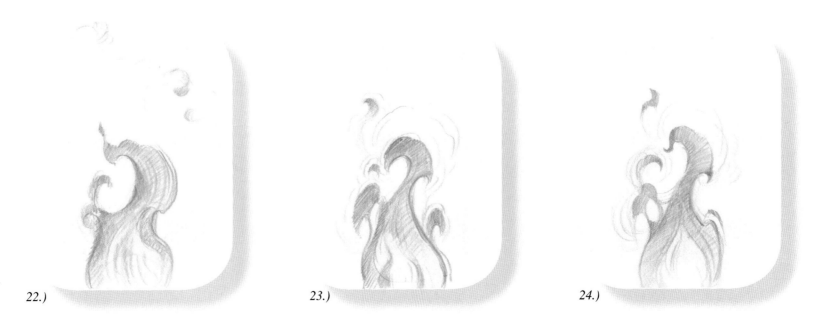

22.) 23.) 24.)

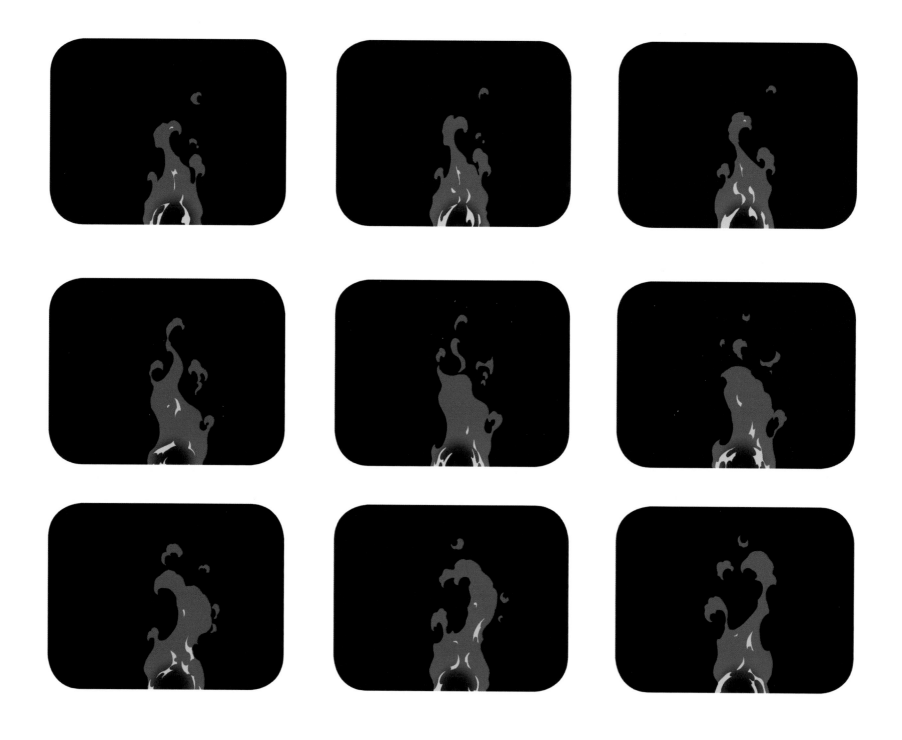

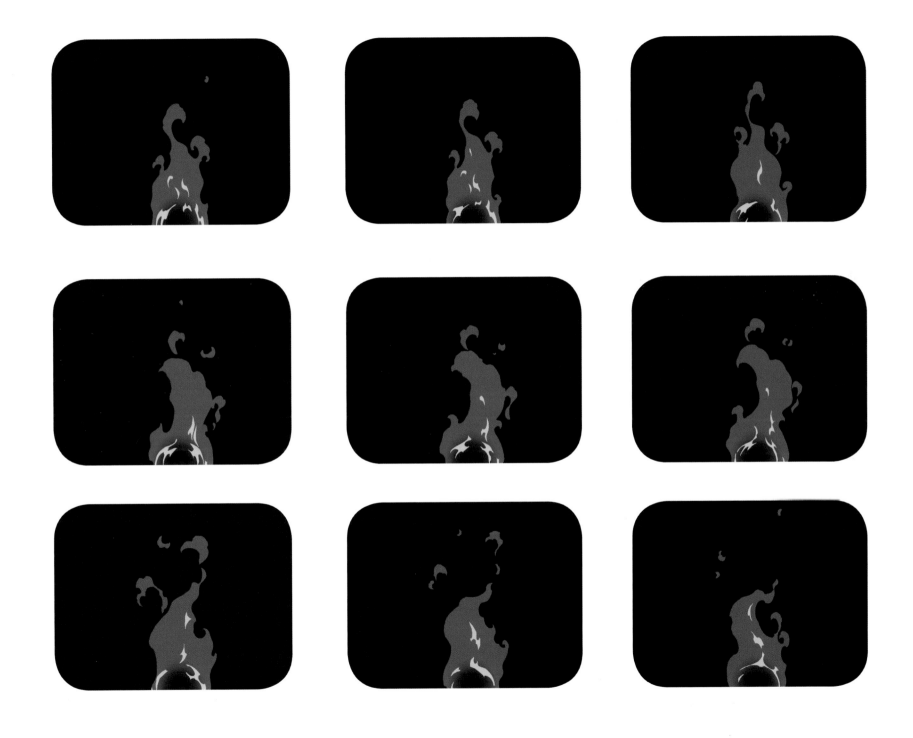

In this image sequence I have used the basic flag animation and actually laid my fire animation directly over it, illustrating just how literally you can use the flapping flag approach when animating a fire. If these images are cycled in an animated movie sequence, you will see how smoothly something as simple as a six-frame flag cycle can animate as a fire.

This is a great example of how, even if you are working with a very limited budget, there is no reason for fire animation to look stiff and unnatural. It does not necessarily take more drawings, time, or money to make a simple fire animate in a pleasing, fluid manner. All that is required is the knowledge of wave and fluid dynamics, and the creative application of that knowledge.

Chapter 5

Blowing It Up

When we think of explosions, the first thing that generally comes to mind is a big, violent, cataclysmic, and usually fiery event like a bomb exploding. But explosions truly come in all shapes and sizes, and it often surprised people what constituted an explosion in my first book. And it may surprise them in this book too, for that matter. So first, let's look at what I consider to be a real explosion, and then we'll take it from there.

A description of an explosion is simply a rapid and abrupt outward expansion of energy. Another definition from a dictionary is as follows: "A violent expansion in which energy is transmitted outward as a shock wave." In both cases, at the heart of the description is a rapid and violent outward expansion of energy. It docs not spccify the material, or indicate that there needs to be any heat or combustive materials involved. Thus an explosion, it would appear, does not need to be an incendiary event.

I was very happy to read this realistic definition of an explosion, because I have maintained throughout my special effects career that explosions come in a great many sizes and shapes, and that a raindrop landing in a puddle constitutes an explosion. I arrived at this deduction because I realized that when I was animating small splashes, the very first drawings of a splash are always very explosive and would not look a whole lot different than the first drawings of any other explosion, except maybe in scale. In fact, I realized quite early in my career that a great many small special effects events in our day-to-day lives that we don't think of as explosions are in fact explosions.

A ceramic coffee cup falls out of our hand and lands on the floor, shattering. A match is struck to light a candle. A car drives through a puddle of dirty water. A child bites on a fresh grape. An acetylene torch is lit. An axe is used to split wood into smaller pieces for the fireplace. The dry wood in the fireplace crackles and pops as it burns up. A champagne bottle is opened. A revolver is fired. A speeding car crashes into a telephone pole.

All of these events contain explosions within them; however, very few of these events are generally thought of as explosions. But according to the dictionary description of what an explosion really is, these phenomenon all qualify perfectly as explosions, because they all contain within them "a rapid and violent expansion of energy."

When my ceramic coffee mug hits the hardwood floor there can actually be quite a substantial little explosion. Depending on just how a ceramic object collides with an unyielding surface, it will sometimes explode quite violently, sending broken shards shooting outward at an extremely high speed. In lighting an ordinary match, when a sulphur match head reaches its flash point temperature of combustion, there is a sudden violent expansion of energy, however small and subtle, as the match actually lights. A car driving through a mud puddle at an adequate speed shoots water violently outward from the point of impact of the muddy water with the car's tires. A child biting down on a fresh grape is surprised when the grape actually pops in a wonderful explosion of flavor!

Every event I have just described contains within it that rapid expansion
of energy that qualifies it as an explosion. And if we think about it,
it is easy to add to that list of explosive events. Small explosions are
all around us. When we walk in the rain, each raindrop that lands on
us explodes on impact. When we turn on the tap to brush our teeth,
even the water coming out of the tap and hitting the sink is creating an
explosion. Pay close attention to the description of an explosion, and
then look around you in your day-to-day life, and you will find many
commonplace explosions that most of us witness on a daily basis.

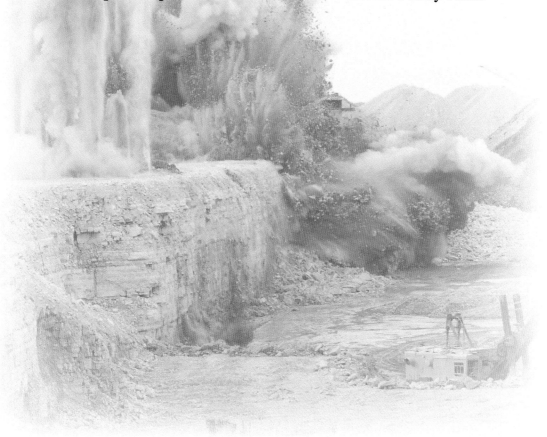

One of the most important lessons in this book is my simple illustration showing how many different special effects events start out looking like an explosion, but soon afterwards the materials involved return to their natural state. It shows us that all matter, in the grip of an explosive event, takes on the same shapes. And that is the shape of an explosion, that is to say, energy and matter expanding outward at an extremely high rate of speed. Because the speed of this phase of an effects event is so quick, the naked human eye does not necessarily see the shape as it occurs. But it is absolutely essential to be aware of these explosive shapes and to use them when animating any explosion.

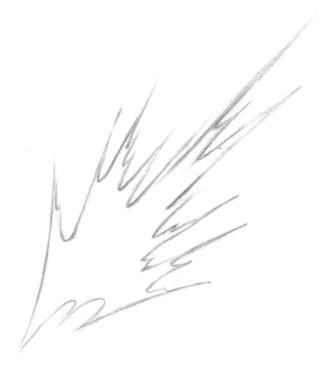

The first frame of an explosion looks exactly the same, regardless of the element that is involved. In this first frame, at the point of the explosion's most energetic expansion, all we can see is the speed and force of the energy. But as the energy decreases, the molecular make-up of the element in question becomes more apparent, as we see in the drawings on the following page. Smoke, water, or fire all start off with the same explosive design. This is also true of a great many other elements. The initial force of an explosion always looks extremely similar, if not in fact the same.

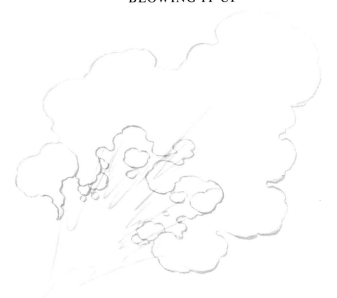

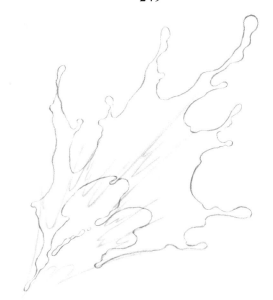

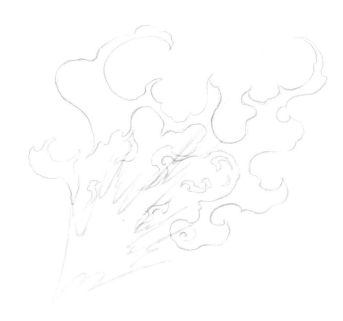

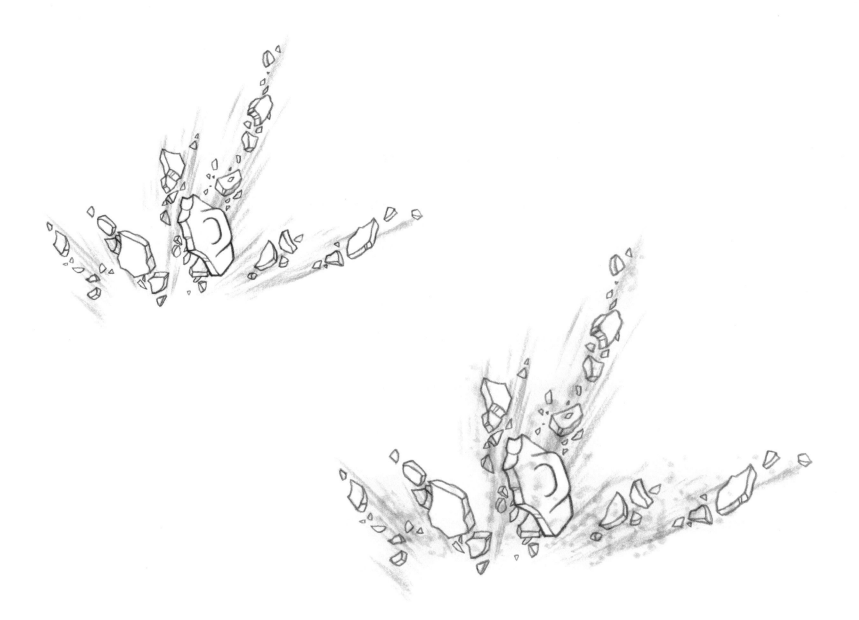

A very good example is that of an animated water splash, and I always
emphasize the importance of the first few frames of a splash looking
as explosive as possible. If we very carefully analyze a rock colliding
with a water surface in a slow-motion clip, we will inevitably see that
in the very first frames when the rock actually hits the water, the water
shoots out so rapidly that it does not have typical fluid characteristics.
The water is moving much too fast to display its normal H_2O water
molecular behaviors and shapes. In the moment of that "rapid expansion
of energy," the water simply looks like an explosion. It is shooting
outward so quickly that our eye can only catch the directional energy
of the movement and not the subtle characteristics of the exploding
material.

But this explosive energy is of course relatively short lived, and as soon
as the energy of the initial explosion has subsided, within the blink
of an eye, in a fraction of a second, the water, in the case of a splash
explosion, will quickly return to its fluid state and take on the shapes
that we generally recognize as "water." The farther the water molecules
get from the point of impact, and the initial explosive energy, the more
they return to their fluid state.

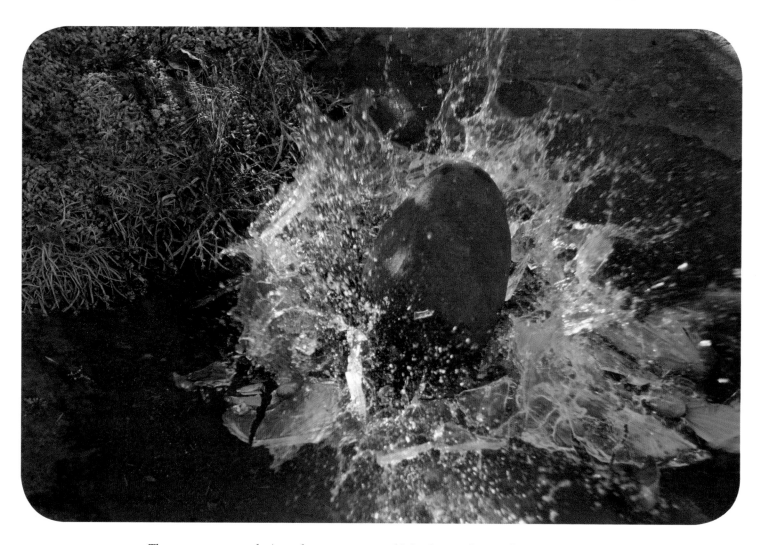

There are many explosions that we may not think of as such initially, until we really stop and think about what constitutes such an event. Often these phenomena are much easier to observe and film than large-scale explosions, which tend to be dangerous and difficult to be around!

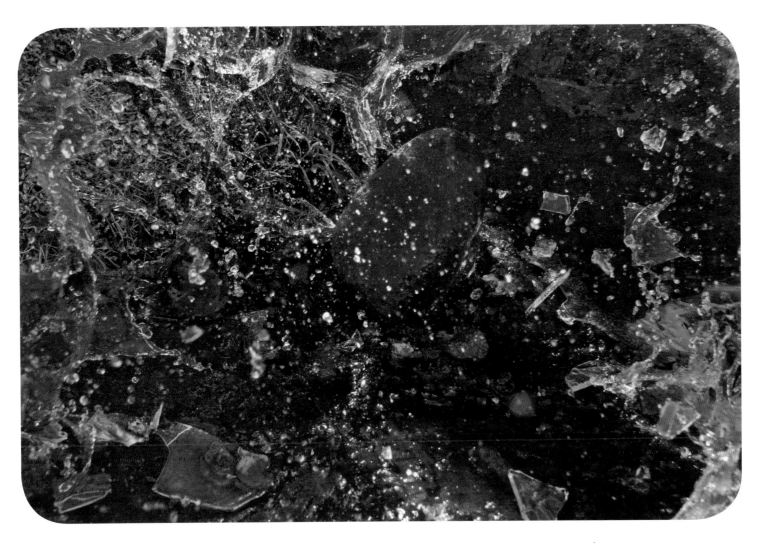

Getting out in nature and playing around with the natural elements around us, we can come up with a multitude of ways to stage small-scale explosions, which can be filmed and analyzed. Use your imagination, and you will find endless ways to create explosions—and in the process, become an expert!

Dropping a sheet of ice is a great way to create a small explosion, and much safer and less expensive than breaking china bowls or glass dishes. Of course, it helps if you live in a frosty climate as I do, but if you think about it, you can create almost any shape you want in your own freezer at home, regardless of climate!

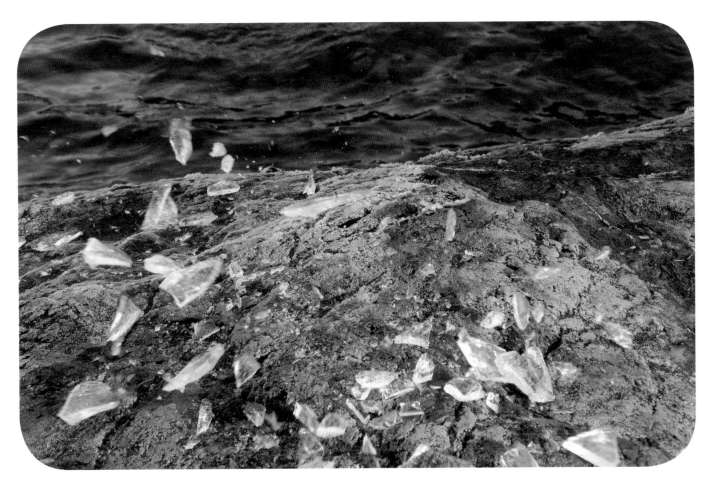

One of the things you will see when you try these kinds of experiments on your own is that there are always some pieces that fly away much farther than all the rest—what I call "the ones that got away." I learned about this from observing real-life explosions of things like broken cups and glasses in the kitchen. No matter how well you sweep up, you will always find some stray pieces far, far away from the actual impact point!

And the very same can be said for our exploding coffee mug, a match being lit, a grape exploding between a child's teeth, or a seriously explosive and dangerous incendiary event. The matter that is propelled outward at sometimes supersonic speeds, returns to its natural state, even if it has been broken up into very tiny pieces by the initial explosion. In the case of material that is burned up, as is often the case with incendiary devices, the burnt particles that create the quickly expanding smoke will at first have the same highly directional and explosive-looking shapes of any other explosion. But then as the outward energy subsides, the smoke will begin to take on the billowing, mushrooming bubblelike shapes of the air currents surrounding the explosion.

Okay, so we have looked at my "real" definition of an explosion, but
let's face it, explosions are explosions, and we all know what we're
talking about here. What would modern-day filmmaking be without
explosions? People seem to love a good blast, be it a car bomb in a
Mafioso film, or a house blowing up in an animated film. Animated and
live-action films are full of explosions. They are a great way to catch
an audience's attention, and they can be a great deal of fun to create
as well. Explosions are, of course, extremely exciting, abrupt, and
energetic phenomena, without the kind of flowing and sinuous energy
that we see in fluid and fire movements.

An explosion is initially detonated by an extremely rapid increase in chemical activity that causes whatever fuel is available, usually an extremely flammable or unstable substance, to reach its *flash point* or point of ignition. The resulting powerful and extremely fast release of energy is generally moving straight outward from the center of the highly combustible matter. This forms the classic explosion shapes that we so often observe in blockbuster special effects films and a wide variety of cartoons (some violent), which are frequently filled with explosions.

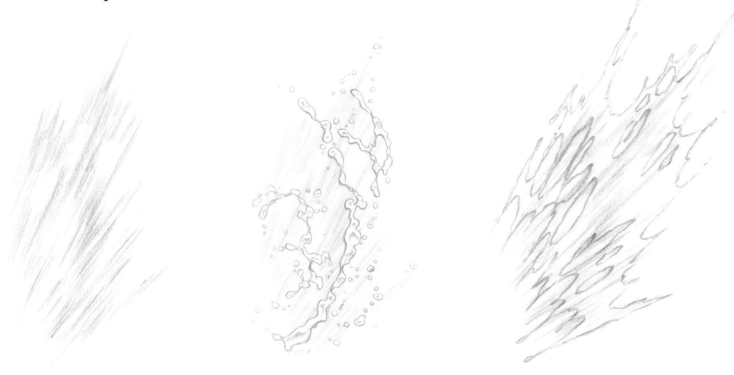

It is only well after the initial powerful outward blast of an explosion
that we begin to see more flowing and graceful actions occur. As
the spent fuel in the form of smoke, and whatever debris or dust the
explosion has kicked up, loses its initial directional energy and begins to
slow, it begins to be more and more affected by other outside forces, like
gravity, air pressure, wind, temperature, etc. And larger pieces of flying
debris may still be bouncing, rolling, tumbling, or settling after their
initial reaction to the explosion. I will look at each one of these events
that takes place during and after an explosion, and we'll look at how our
classical animation principles can help us to create *better* explosions
when we are creating them using our animation toolbox.

Explosions are dynamic and visceral, and many a special effects artist will spend much of his or her career blowing things up. In the world of live-action filmmaking, "action" films often call for real-life explosions, and special-effects explosives experts are called upon to create incredible scenarios using real-live fuels and bombs. Great care must be taken to ensure the safety of film crews and actors. This is a seriously dangerous and demanding line of work, requiring extreme professionalism and perfectionism to avoid unfortunate accidents! Interestingly, throughout my career, when I tell people I am a special effects animator, they often ask me if I actually blow stuff up. It seems to capture people's imaginations, to imagine that some people get paid to create explosions for the movies.

In this age of CGI special effects, incredibly convincing and effective explosions and fireballs can also be created virtually using a variety of particle and fluid dynamic computer animation programs. This gives directors a great deal more freedom in staging explosions and a wide variety of cataclysmic events, without the fear of injuring anybody, although live characters must sometimes still be filmed to look as though they are reacting to real-life explosions, and this can be challenging. More and more often, the characters, the object exploding, and the explosion effects will be handled using CGI, so that no one and nothing is put at any risk whatsoever. At the end of the day, though, an old-school, real-life explosion really hits home. Even though very few people have experienced actual large-scale explosions in person, subconsciously I think we can tell whether we are looking at a real explosion or an artificially created CGI explosion. There is no substitute for the real thing!

However, when we are animating an explosion, whether as a 2D hand-drawn element or a 3D CGI element, there are techniques we can use to actually increase the dynamic impact of an explosion greatly, using the principles we learn as animators, such as anticipation, exaggeration, overlapping action, and eloquent follow-through. This is where we can have a great advantage over a special effects expert who deals with actual, real-time, live explosions. While great care and attention can be put into ensuring that an explosion goes off with optimum dramatic effect, and devices can be put into place to direct energy in specific directions and so on, when a bomb explodes it is to a large degree going to do whatever it does, and there's no way to control it. Live-action effects experts must be willing to settle with what they get. Of course, sometimes there are pleasant surprises, and when serious professionals do this sort of work they usually get pretty impressive results.

But when we as animators create an explosion from scratch, we can control each frame, each 24th or 30th of a second. We can control every aspect of an explosion's character, design, speed, and overall dynamics. We can make it do things an explosion *would never do,* in order to make it fit into a given situation better. We have complete control if we want it, and therein lies the beauty of animation—and in our case, special effects animation. As always, in my *Elemental Magic* approach to creating visual effects animation, I emphasize the dynamic power that we can wield as effects artists, and I heartily discourage animators using digital tools such as "canned" effects to create phenomena like explosions. Even if we do use prepackaged CGI effects, or superimpose live-action special effects into a scene, we can and should still always use our magical animation toolbox to emphasize and increase the dynamic impact of our work.

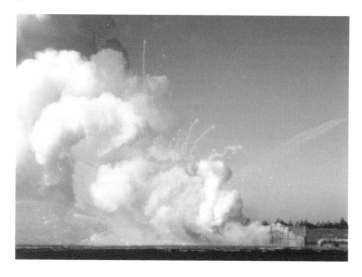

And so, when we are animating an explosion, the first place where we can add dynamic energy is of course in its initial detonation. The ancient, tried-and-true simple animation principles of anticipation and exaggerated timing can subtly, or not so subtly, make any explosion feel far more exciting and fun to watch, right from the get go.

If we break down a real live-action explosion, we will see that generally speaking, from the initial moment of detonation, an explosion expands outward in a smooth, incremental fashion. We will see it grow very quickly, yes, but if we look at it frame by frame, we will see each step of its growth, from very small to very large, over a number of frames, anywhere from 3 to 30, depending on the size and scope of the explosion.

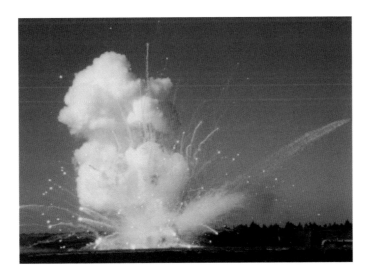

Now, if we animate an explosion that way, we will end up with
something that somehow feels somewhat lifeless and lacks impact.
I believe that is because with a real, live explosion, we have a lot of
supporting data, information telling us that it is indeed a real explosion,
and that helps to make it *feel* good and right. With an artificially created
explosion, we are suggesting to the viewer's eye that what he or she is
observing is an explosion. And so we must use the tools we have to up
the ante, so to speak, to push the envelope of what is possible.

How do we do that? To begin with, a little bit of subtle anticipation can
go a long way toward increasing an explosion's dynamic effect. So, in
the first frame of an explosion, it can appear to be expanding outward,
but in the second frame or two, we can actually implode the image
slightly, actually shrink it into itself, thus giving it additional energy
when it unleashes its full fury.

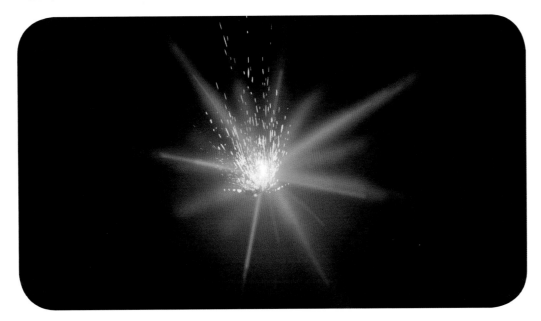

On the following pages is an explosion sequence that I animated. Imagining that the frame before frame 1 is entirely black, note the anticipation in frame 2, where the explosion actually shrinks for one frame before exploding with force. Then in frames 3 to 6 we see the initial violent outward force of the explosion. Following that in frames 7 and 8, there is a negative frame followed by a black white frame that add a visual "punch" to the animation, by subliminally hitting our eyes with a blast of light. In the final frames of the sequence, we see the resulting cloud expanding slowly as it fades off. At the same time, we see the bits of particles that were shot out in the initial blast, reaching their highest trajectory point, and then slowly falling as they fade out as well. This sequence is actually over 80 frames long, so I edited out many of the resolving frames near the end to fit the entire sequence here in 24 frames.

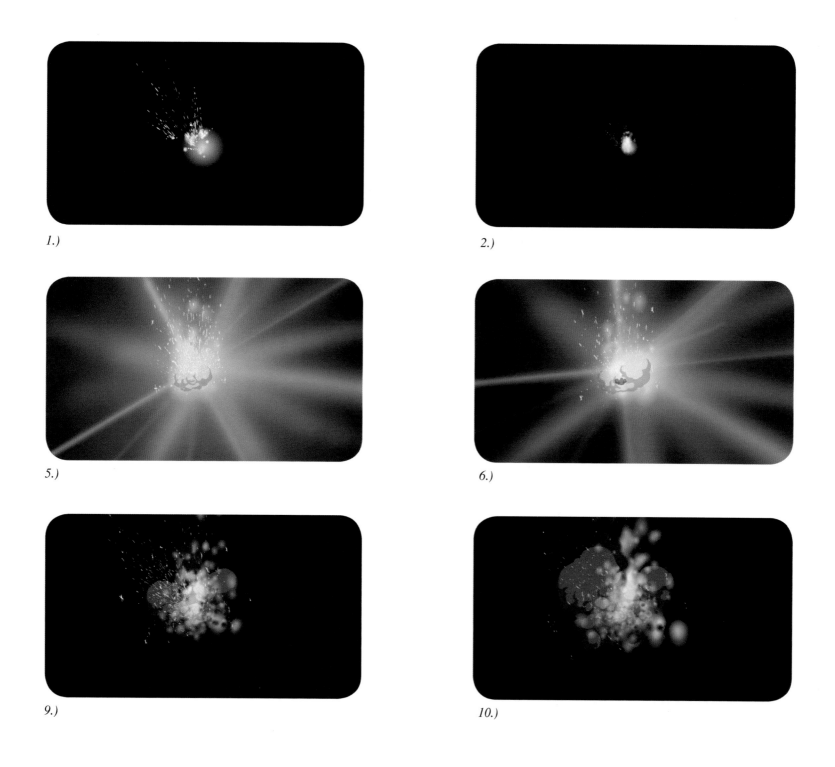

1.)

2.)

5.)

6.)

9.)

10.)

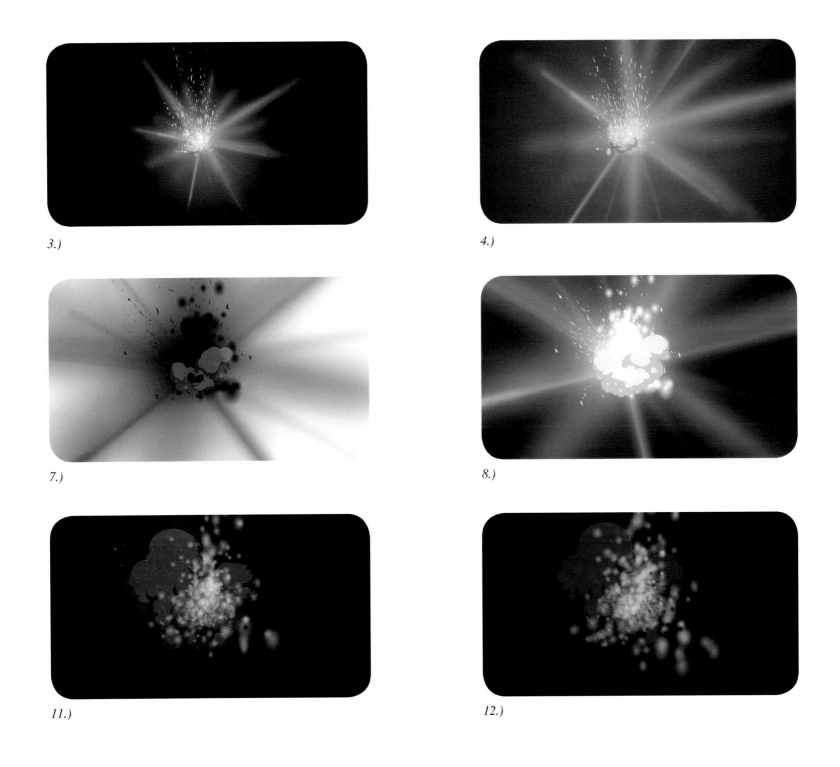

3.)

4.)

7.)

8.)

11.)

12.)

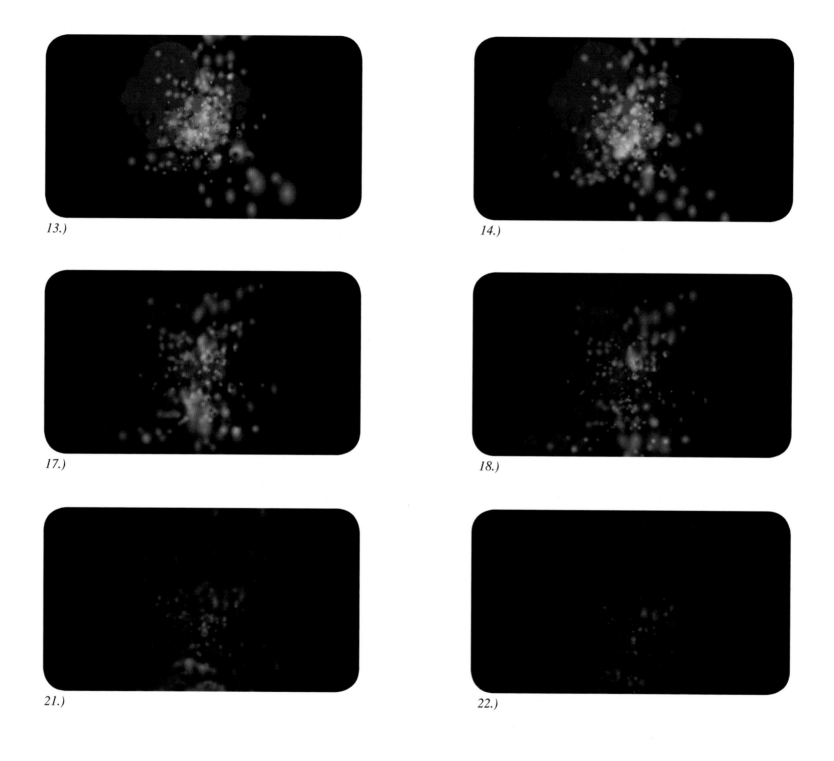

13.)

14.)

17.)

18.)

21.)

22.)

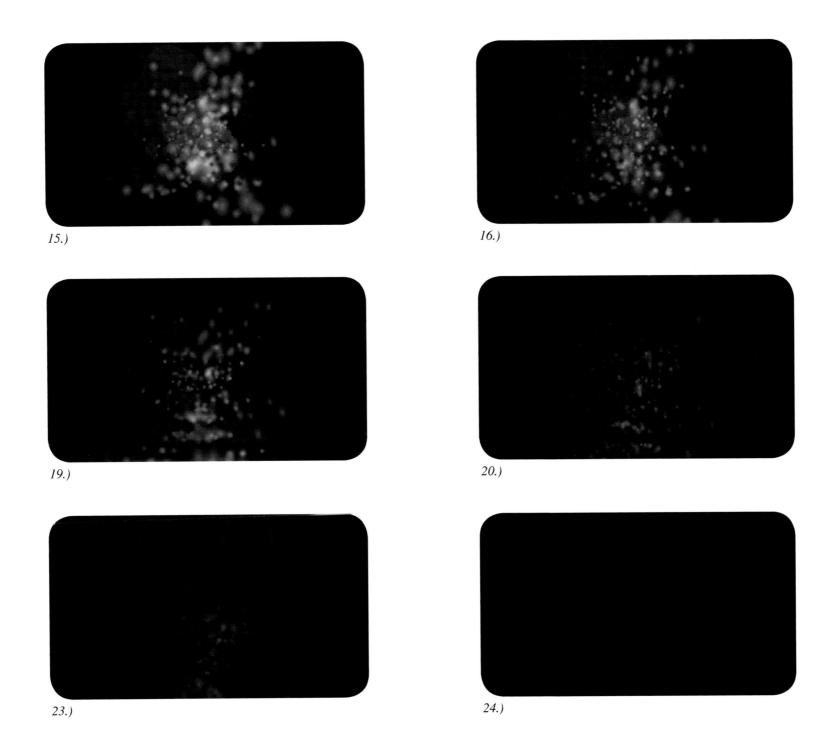

15.)

16.)

19.)

20.)

23.)

24.)

The basic dynamics of an explosion are very simple. It is an extremely rapid outward expansion, followed by an acute slowing down of the outward action. Nothing could be more straightforward. But this simple formula can be greatly exaggerated to give us a more dynamic explosion. Once we have added the aforementioned anticipatory frames, we can then exaggerate the speed at which the explosion expands, and push it very quickly into the slower final phase of the explosion. When this simple formula is greatly exaggerated, explosions can take on an extremely elastic and animated nature, cartoony and fun, dynamic and exciting to look at!

Another great way to add a lot of dynamic energy to an explosion is to overlap the timing of more than one explosion, having a secondary explosion occur that shoots out quickly while the initial explosion is slowing down. This introduces overlapping action, a key principle of all quality classical animation. And with the digital tools at our disposal today, simply cloning an explosion and reusing it can save us lots of time and energy, with outstanding results.

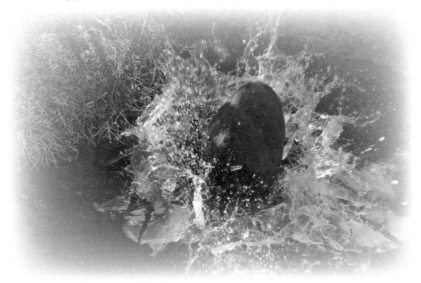

So remember, explosions are one of the most simple elements in the world to understand as far as the basic physics are concerned, but it's important to apply the principles of classical animation: stretch, squash, and exaggeration. Whether you are animating by hand or using a computer, you will be able to produce vastly more dynamic and enjoyable effects explosions!

In the following sequence by master effects animator Michel Gagné, we see just how exaggerated an explosion can be, especially in a cartoony environment. The initial blast of the explosion happens after a character is zapped by electrical energy, which builds up to and anticipates the actual explosion very nicely.

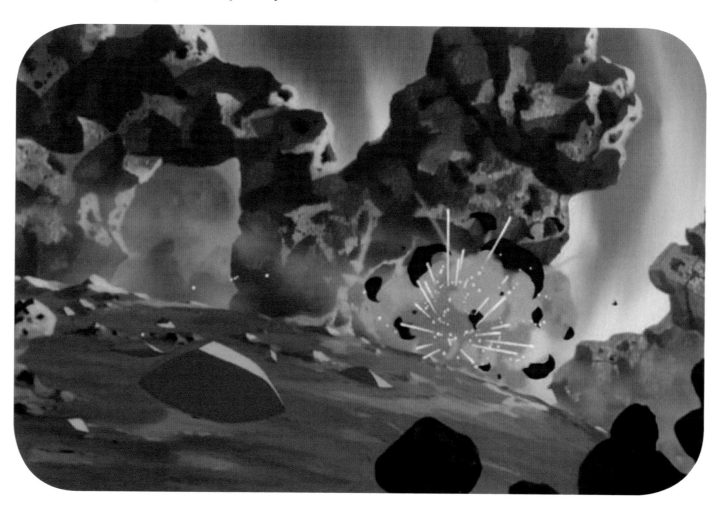

There is actually only one frame of the initial explosion, which then forms a classic mushroom cloud in the second frame. The mushroom cloud then continues to mushroom, rolling upwards and then in on itself very slowly. Viewed at full speed, this is a beautiful explosion that looks extremely dynamic. Always exaggerate as much as possible!

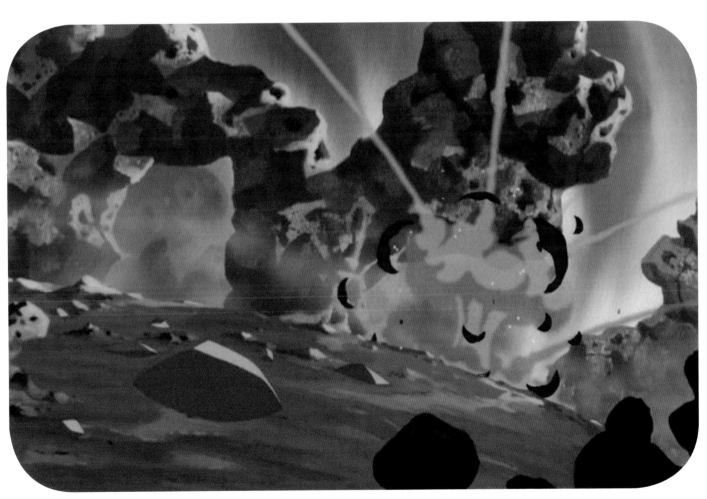

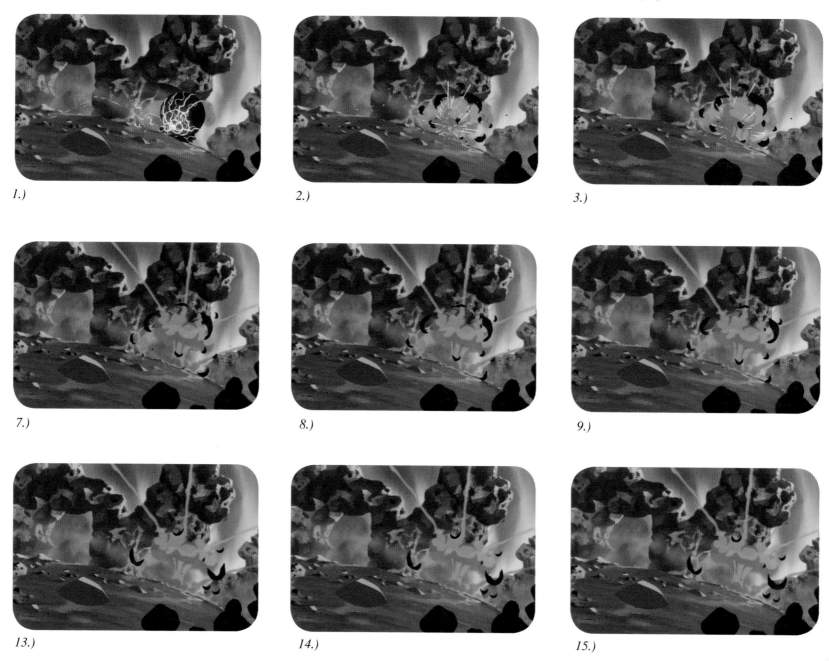

1.)

2.)

3.)

7.)

8.)

9.)

13.)

14.)

15.)

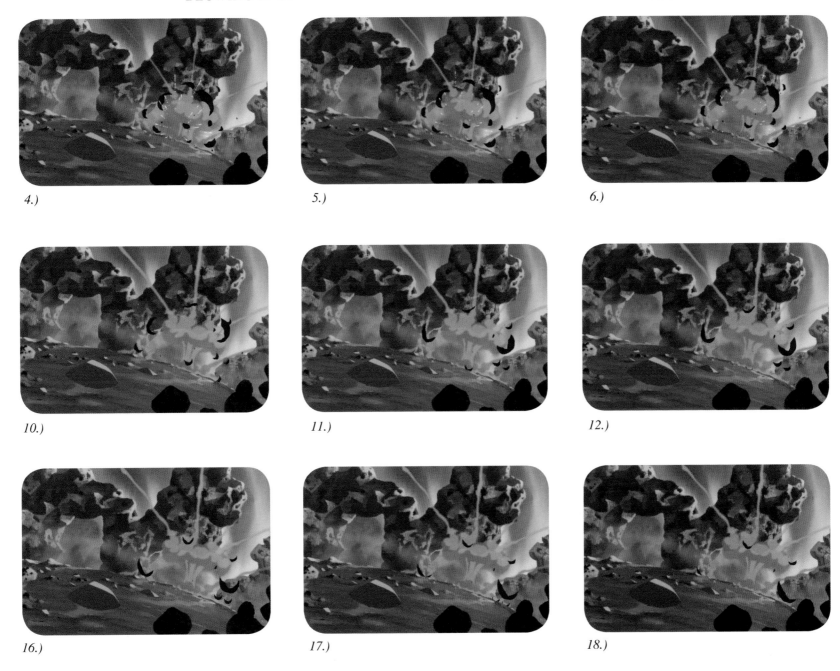

4.)

5.)

6.)

10.)

11.)

12.)

16.)

17.)

18.)

Chapter 6

Magic

The Art of Animating Pixie Dust

Ah, magic! Just uttering the word seems to have some kind of an effect. And whether or not we actually believe in magic one way or another, we cannot deny its existence—at the very least in the form of storytelling and entertainment. From the very beginning of the history of filmmaking, magic has been portrayed abundantly in films of all kinds. In fact, when first witnessed by humans, moving pictures projected onto a wall were seen as a kind of magic. Many present at the time of the first demonstrations of film projections cried out in disbelief that a living, breathing, moving being could possibly be up there on a wall or a screen.

This brings to mind a famous statement made by Leigh Brackett in his story "The Sorcerer of Rhiannon," in *Astounding Science-Fiction Magazine* published in February, 1942: "Witchcraft to the ignorant . . . Simple science to the learned." And then there is Arthur C. Clarke's even more famous line of 1973, the third of "Clarke's Three Laws" as outlined in his collection of essays *Profiles of the Future:* "Any sufficiently advanced technology is indistinguishable from magic."

Arthur C. Clarke: "Any sufficiently advanced technology is indistinguishable from magic."

Indeed this is true, and as special effects artists and filmmakers, we have been in the unique position to create magic for the masses since the beginning of the history of animation filmmaking. Since the early Disney films of the 1930s, audiences have been shocked and amazed again and again to see impossible things brought to life on the silver screen. In the 1970s and 1980s, we began to get a handle on how to really push our visual effects to the next level, and the technology eventually began to catch up to our ideas.

Science fiction classics like Stanley Kubrick's *2001: A Space Odyssey* (1968) raised the bar of what was possible in cinematography, and in 1977 *Star Wars* was born. Audience's tastes became more and more sophisticated, and watching characters walk upside down and talk to computers or play with light sabers began to be considered a normal movie-going experience. Although the average viewer still had no idea how the illusions they were watching on the screen were created, moviegoers just love to be tricked into believing the unbelievable.

Now, in the last several years, the bar has been raised higher and higher. Cinematographic masterpieces like *Avatar* have completely blurred the lines between what is "real" and what is "animated," and what constitutes an actor as opposed to an animated character. Using motion-capture technology and extremely powerful new tools to build artificial environments and create mind-boggling visual effects, today's filmmakers are unfettered by any limitations, except maybe what they can afford to do, depending on their budget. But the sky is definitely the limit. The only limit to what we can do with visual effects today is our knowledge and imaginations.

However, what I am covering in this chapter has absolutely nothing to do with the sophisticated digital wizardry seen in our modern-day animation filmmaking industry. In this chapter I will delve into the art of creating beautiful pixie dust animation, similar to the magic effects in Disney's *Cinderella* (1950) or *Peter Pan* (1953). This magic has been thoroughly rooted in my imagination since childhood, and it has much to do with the fact that I always wanted to be an animator, for as long as I can remember. Although the stories in the early Disney films certainly captivated me, and the characters had their wonderful appeal, it was when I saw actual *magic* on the screen that my jaw dropped opened, and I felt my imagination swirling with the idea that absolutely anything is possible.

Suddenly, a pumpkin being transformed into a garish gilded carriage was not a long stretch of the imagination, and children flying out of their bedroom window and out into the starry night sky made perfect sense. And it was the appearance of the magic sparkling fairy dust that carried me into that state of complete suspension of disbelief.

The "classic" pixie dust that first comes to mind for most people is probably Tinker Bell's trail of magic dust that she leaves behind wherever she flies. And this is reinforced by the fact that even if you haven't seen Disney's original *Peter Pan* in decades, Tinker Bell continues to grace countless Disney television shows and commercials. Although much of the Tinker Bell pixie dust we see these days is a cold computer-generated version that is a far cry from the whimsical, light, and playful pixie dust of days gone by.

Some readers may remember that in my first volume of *Elemental Magic,* I touched on the fact that in my early days at Disney I was saddled with the job of attempting to recreate perfect Tinker Bell pixie dust with CGI technology, using Disney's own proprietary particle software. It was an arduous task, far more difficult than it sounded at the time. And it still is to this day, which is why the CGI pixie dust that we frequently see in films and on television today somehow lacks that special *something* that makes the old hand-drawn stuff look so darned magical. This is really a damned shame, because it is still feasible and could actually be substantially cheaper for an animated production to create pixie dust the old-fashioned, hand-drawn way.

But our 21st century obsession with all things digital has narrowed people's creative toolboxes, and at this point the mere suggestion that something could possibly be done better *and* cheaper by hand would be summarily dismissed by most folks in the animation industry. Be that as it may, I have found in my travels around the globe conducting my *Elemental Magic* workshops, that students and professionals from all arenas of the animation world are still very interested in how these magical effects are (or were) done, back in the day.

I can't help but look back on my computer-generated pixie dust work at Disney in the early 1990s, and I'll never forget telling my boss at the time, "You know, I've been working on this digital pixie dust for weeks, and I could easily have animated it all by hand by now, and it would look spot-on perfect!"

And I contend that learning just how it was once done will benefit any animation artist immensely if he or she intends to attempt to create pixie dust of any kind, regardless of the technique being used. Animating magical pixie dust by hand, one gets to see it unfold frame by frame on a piece of paper in front of one's eyes, and subtleties become apparent that are sadly missed when digital tools are used to splash pixie dust recklessly across the silver screen. When animating pixie dust by hand, each sparkle, every tumbling twinkle, can be infused with character and a mischievous magic all its own. The level of control one actually has over the general "feel" of the pixie dust is far and above what one has using digital tools.

When I am animating pixie dust, I take full advantage of the fact that each individual particle can be tweaked in its own special way. Some sparkles will glimmer, starting from a small, barely perceivable dot, and then expanding and contracting in size. Others will twirl and whirl, also growing and shrinking in size as they do. Still others will twinkle randomly, with no rhyme or reason, creating a fluttering kind of chaotic energy in the pixie dust. Many particles can be allowed to appear randomly out of nowhere and then disappear, winking in and out of existence and creating a shimmering effect to the overall look of the pixie dust.

1.) 2.) 3.) 4.) 5.) 6.)

1.) *2.)* *3.)* *4.)* *5.)* *6.)*

1.) *2.)* *3.)* *4.)* *5.)* *6.)* *7.)*

1.) 2.) 3.) 4.) 5.) 6.)

Another consideration is the lifespan of each individual particle; the lifespan being the amount of time any given particle of pixie dust actually appears on the screen. When we are creating particle pixie dust using CGI software, one must control each particle's lifespan using fairly broad tools that affect all of the particles in the same way, with only a modicum of control over the randomness of the particles' lifespans. This can be pushed farther using mathematical expressions, and some software allows the artist to introduce additional chaos to the lifespan of the particles in a number of different ways. But it is still a far cry from being able to tweak each individual particle, on the fly, making decisions intuitively and immediately as we animate straightforward in time.

When animating pixie dust by hand, an effects artist can add or subtract
the number of particles at will, customizing the final design of each 24th
of a second, and playing with the lifespan of the particles to suit the
needs of each individual frame. The decisions being made can be purely
esthetic and utterly random in nature, and this kind of frame-by-frame
creative freedom gives hand-drawn pixie dust a personality that is nigh
impossible to match when software is being relied upon to generate this
effect.

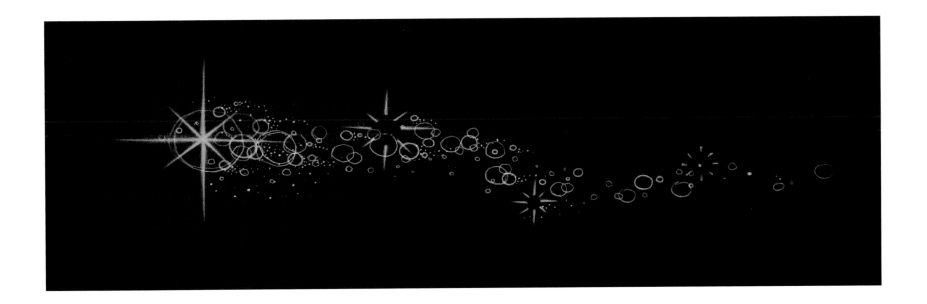

Another fascinating thing about animating pixie dust by hand is the effects artist's ability to change up the overall design and/or physics of his or her pixie dust at any time. Let's say a "fairy" flies into screen left, leaving behind a string of sparking magic dust that falls elegantly in dripping curtains of twinkling particles, in the classical style of Disney pixie dust. But then, when the fairy does a series of loops or sharp turns, the trailing magic powder can suddenly spray out and away from its source, much like a beautiful wake of water spray from behind a water skier. Or it can billow out elegantly in turbulent smokelike waves, or perhaps it can animate upwards away from its source like air bubbles trapped underwater.

The possible variations and combinations are infinite and can occur at whatever point in the sequence that an effects artist chooses, and the physics can return to the classical "dripping" variety covered on pages 296 through 305, at any given moment as well. To introduce this kind of truly random variation to a computer-generated pixie dust simulation is a highly complex proposition, and rather than doing it intuitively frame by frame, on the fly, a CGI artist would have to break the sequence down into separate overlapping chunks of time and tweak dozens of complex parameters, write mathematical expressions, and then make everything fit together through a painstakingly technical process. The process is far less intuitive and flowing than the classical hand-drawn technique, and radical changes cannot be made randomly without telling the computer exactly what to do using a very rigid set of predetermined parameters.

For an effects animator using CGI tools to match the extremely chaotic, random, and sometimes absurdly imaginative changes that a traditional effects animator can bring into play at whim is, in my estimation, absolutely impossible. And I welcome a healthy debate on this topic, as I know there are a great many 3D artists who will probably vehemently disagree with me. But before anyone out there gets too upset with these ideas, at least try animating some pixie dust by hand before forming an opinion, and read on, as I do honor all the great things that CGI technology *is* capable of.

I will concede that yes, of course it is possible to create some utterly amazing looking pixie dust with CGI tools, and that yes, of course there is a place for it in the industry as well. In some cases, if a director is looking for a very dense, or large-scale kind of magical pixie dust effect, I would be the first to recommend creating the effect digitally. In addition, when working in a fully 3D CGI environment, with complex 3D camera moves and sets, sticking with CGI tools is probably the best bet to ensure that everything is working together well and integrating into the 3D space seamlessly.

Please, keep in mind that the pixie dust I am referring to here is the
classical and much simpler *Peter Pan* or *Cinderella* style of magic, that
to this day has never been matched by an animation artist using CGI
software, at least not to my knowledge.

So now I'll look at how I might go about animating a pixie dust scene,
from scratch. In most cases, an effects animator working in a studio will
get a scene that has already been finished by the layout department, and
if there is any character animation, it will usually have been completed
before the scene gets to the effects department. So chances are, in the
case of a pixie dust scene, there will already be a clearly defined path of
action for the effects animator to follow.

For the sake of this exercise, let's imagine that the character that is generating the pixie dust is a tiny fairy, who only appears as a shining, sparkling light as she flies into and around the screen. This would be considered an "effects only" scene (a scene in which there is no actual character animation, only effects), but the path of action would still be previously defined by the layout department, and then the character animation department would probably animate the point of light, at least roughly, for the effects department to follow.

Before starting to animate, I will usually do a few sketches, and maybe a couple of clean, finished drawings, to get an idea of the look I am trying to achieve. At this stage, I would be working closely with the director, to make absolutely sure I get a clear idea of what he or she is thinking of, both design- and animation-wise. There are a lot of different ways to approach a magic scene of this nature, and it is important to make sure that you are on the same page as the director, art director, and others, before getting too far into the work at hand. This stage is one of my favourite parts of the creative animation process, for it gives me a chance to come up with fresh ideas and techniques, and possibly to pitch a unique way of animating pixie dust to the director.

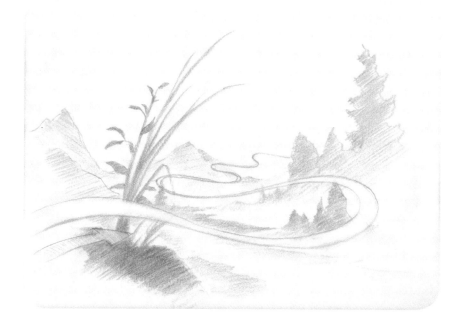

Even if the design and look of the animation have already been predetermined, this is still a fun, creative part of the process, and thumb-nailing the way the pixie dust will unfold is a good way to get started. This is also when an effects artist can think about the physics of the magic he or she is going to create. As the trail of magic particles is created, they can behave in an infinite variety of ways, as mentioned earlier in the chapter. I like to *invent* a new set of physics, particular for the film I am working on. Even if the director is looking for typical, traditionally animated pixie dust, there is always room for a little variation or customization of the magic effect, which will give it some originality and set it apart, if only slightly, from the the rest. Adding that special *something* to your special effects animation should always be your goal, if you wish to excel in this field.

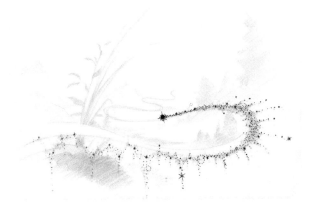

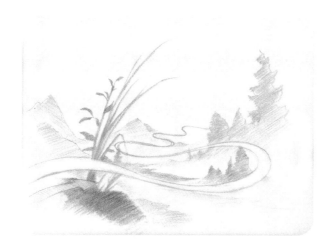

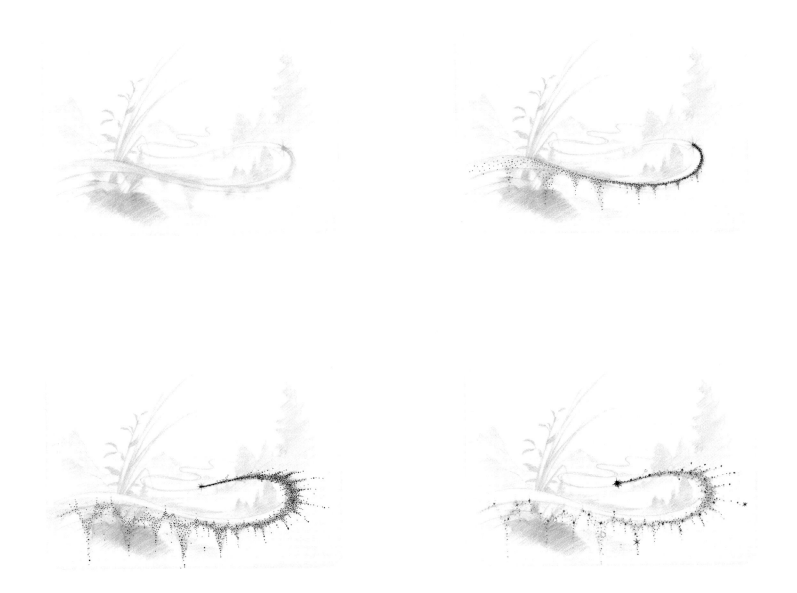

It is important at this point, to determine the complexity of the pixie dust. One of the most common mistakes that I see effects animators make is making pixie dust overly dense. A really elegant pixie dust design does not necessarily need to have millions of densely packed particles to look good. In fact, far fewer particles can look far better in many cases. A much cleaner and more subtle design overall is also far easier to manage timewise, so I always try to economize as much as possible, although I am as guilty as anyone for getting carried away and going over the top from time to time.

As a general rule for either a novice or experienced professional animator, pixie dust, like most fluid special effects elements, is usually animated straight ahead. That is, without many key frames or poses, but rather just animating one drawing after another, forward through time. As always, I start the animation out with very rough drawings, just to get a feel for the scene. Flipping pages is important at this phase of the scene's development, to see how the flow of the animation is working.

So what does this rough animation actually look like? Well, it can be
as messy as can be, mere scribbles on the page initially. What is most
important is that we create a series of drawings that flow into each other
elegantly. As the path of action meanders and the pixie dust magic turns
corners and moves through space in perspective, we must take great
care to assure that there are no abrupt changes of trajectory or direction
in our animation, if we are to create a flowing piece of animation. The
smallest awkward bump in our animation will kill the magical feeling
that we are attempting to portray.

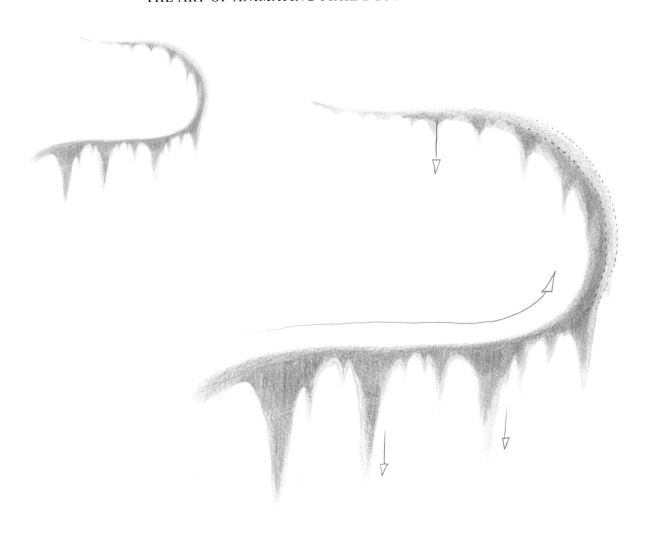

As pixie dust flows around a corner, it is of utmost importance to keep the directional flow moving smoothly and following through elegantly in its path of action. Failure to do so will result in a stiff performance, so flip your pages often and make sure you "go with the flow!"

This brings to a close this small chapter on animating pixie dust. I invite you to take a look at the examples of me animating pixie dust in real time on the *Elemental Magic II* website, as well as many other clips of well-executed magic effects animation. This is where the true value of this volume will spring to life, giving you moving examples in real time rather than relying entirely on a series of images in a book. While I am sure this book will be helpful, I am excited to be introducing an interactive website as well, and I welcome your input and comments wholeheartedly! And if there is anything I have missed in this volume (I know there are tons of things!) that you would like to see, drop me a line and I will do my best to get it up on the website www.elementalmagicbook.com as it progresses!

Happy animating!

Index

A

Aquarian symbols, 47–48, 47f
Art deco, 217
Art nouveau, 202
Avalanche, 10
Avatar, 282

B

Bambi, 165, 166
Beardsley, Aubrey, 217
Bluth, Don, 167
Boil, 110, 111f, 113f, 114f
Bowl-shaped splashes
 boil, 113f
 characteristics, 88–90
 digital tablet sequence, 158
 example, 87f, 90f
 as flower, 143f
 tearing and stretching, 96
Brackett, Leigh, 280
Bubbles
 bursting, 114f
 diver, 125f
 fire as, 192–194, 193f
Buoyancy effect, splashes, 84–85,
 85f, 86

C

Canemaker, John, 2
CGI effects
 explosions, 262, 264
 "flag waving" basics, 180
 pixie dust, 285, 290, 293, 294,
 295
 splash design, 131, 134f
Chaos, wave animation, 43
Chinese paintbrush style, 146
Cinderella, 283, 296
Cinematography, magic effects, 281,
 282
Clarke, Arthur C., 280
Cloudbreak (Roberts), 33f
Cold air, fire dynamics, 193f, 194f

Combustion, fire, 175

Compositing

with digital tools, 129–130

splashes, 122

Conflagration, fire, 176

D

Digital tablet, splash sequence, 156, 158

Digital tools, *see also* CGI effects

vs. by hand, 287

"canned" effects, 264

cloning, 273

compositing, 129–130

design simplification, 133f

drawing capture, 3

drawing techniques, 51

for element overlap, 121, 130f

Disney effects

design integration, 146

fire, 165

large splash, 111f

magic effects, 281

pixie dust, 9, 283, 285, 286, 292

splash as flower, 144–145

splash drawings, 156

Displacement principle, 35–36, 36f

Droplets

movement energy, 151

secondary splashes, 106f

splash design, 132, 134f

Dumbo, 111f

Duperron, Ben, 62, 69f, 208, 223

Dust

basic effect, 12f

post-explosion, 259

vs. smoke and steam, 9f

Dynamic wave, 52, 53f, 54f

E

Embers, fire, 222f, 223, 224, 225

Energy

explosions, 248f, 251, 265

fire, 173f, 196, 209–211, 219

fluid movement, 151

splashes, 143f

swells, 25, 30f

water in wooden trough, 163f

Exaggeration, explosions, 272, 273–275, 274f

Explosions, *see also* Fire; Smoke

appeal of, 257

building anticipation, 266

CGI effects, 262

debris, 259

definition, 243

detonation, 265

dynamic energy, 261

everyday examples, 244, 246

exaggeration, 272, 274f

example sequence, 267

first frames, 248f

flash point, 258

post-explosion, 256

shapes, 247–248

small-scale staging, 252f, 253f, 254f

splashes as, 99f, 251, 252f

timing, 273

F

Fantasia, 9, 144, 166

Fire, *see also* Explosions; Smoke

air currents, 205, 212

art deco design, 217

Bambi, 166

basics, 8, 13–14

as bubbles, 192–194, 193f

combustion, 175

conflagration, 176

Disney effects, 165, 167

effects research, 228

embers, 222f, 223, 224, 225

energy, 173f, 196, 209–211, 219

explosive design, 248f

as flag, 180, 183f, 184f, 188f, 190f, 240–241f

flame shapes, 215f

flash point, 176

as fluid, 169–173, 170–172f, 213

hot-cold air dynamics, 194f

inconsistency, 191f

medium-sized example, 234–237f

from photo, 211f

pulling out shapes, 185f

ripples, 221f

scientific aspects, 174

shutter speed, 210f

splash similarities, 198

tracing photos, 219–222, 220f

Flag shape

fire as, 180, 183f, 184f, 188f, 190f, 234–237f, 240–241f

wave motion, 23

Flame, *see* Fire

Flash point

 explosions, 258

 fire, 176

Fluids, *see also* Splashes; Water

 vs. character animation, 152

 fire as, 166, 169–173, 170–172f,

 192–194, 193f, 213

 free drawing, 153

 morphological tendencies, 150

 movement energy, 151

Fractal, as inspiration, 200, 202

G

Gagné, Michel, 274f

Geyser secondary splashes, 108–

 109, 109f

Giger, H. R., 197

Global tidal pull, 41

Gray, Milt, 136

Great Wave of Kanagan, Katsushika

 Hokusai (1831), 31f

H

Hercules, 146

Hot air, fire dynamics, 192–194,

 194f

I

Iconic representation, waves, 46,

 47f

Inkblots, splash design, 148

J

Jets, *see also* Secondary splashes

 characteristics, 102–103

 example, 103f

K

Kubrick, Stanley, 281

L

Lake waves, 40

Layering

 splashes, 122f

 water in wooden trough, 164

Linear-style smoke, 233

Liquids, *see* Fluids; Splashes; Water;

 Waves

Live-action effects, explosions, 257,

 261, 263, 264, 265

Lundy, Chris, 16f

M

Magic effects

cinematography, 281, 282

historical background, 279

pixie dust, *see* Pixie dust

Mid-ocean breaker waves, 29f

Mucha, Alphonse, 217

Mulan, 146

Mushroom cloud, explosion, 275f

O

Oahu's North Shore surf break, 32f

Oxidation, fire, 175

P

Particles

pixie dust, 288, 290, 292, 299

smoke, 212

Persian rug design, 149, 217

Peter Pan, 9, 111f, 283, 284, 296

Pinocchio, 165

Pixie dust

animation flow, 303, 304–305, 305f

complexity, 302

customization, 291, 299

design and physics, 292, 293

early movies, 283

by hand, 287

hand *vs.* digital, 286, 294, 295

inspiration, 9

particles, 288, 290

preset design, 296, 297

sketching stage, 298

Tinker Bell, 284, 285

Plunging waves, 27–34, 28f

Pool waves, 35–41

Primary splashes

air pocket, 111f, 112f

bowl-shaped, 87f, 88–90, 90f

"cannonball" jump, 80

"can opener" jump, 81–83

definition, 70–71

dolphin landing, 77

example, 70f

head-first dive, 82f

and jet, 103f

object shape effects, 87

pebble drop, 76

raindrop, 78

rock drop, 75

rock skipping photo, 69f

rock throw, 74

vs. secondary, 72, 73–74

shape variety, 95

Primary splashes (*Continued*)
 sheet-shaped, 93, 94
 smooth rock throw, 79
 soccer ball, 83f
 spray, 101
 tearing and stretching, 96, 97f
 waterlogged wood, 85f
Profiles of the Future (Clarke), 280

R

Raindrops
 as explosion, 244, 246
 secondary splash, 106
 splashes, 78f, 116, 128
Reef break waves, 28f
Reflection, water, 127
Refractions, water, 127
Repetition, wave animation, 44
Ripples
 bursting bubbles, 114f
 characteristics, 23
 example, 61f
 fire, 221f
 light bounce, 152
 pool, 39
 scribbling example, 138f
 shapes, 59

smoke, 233
sources, 116
splash design, 128, 129–130, 130f
Roberts, Phil, 33f
Rockslide effect, 10

S

Secondary splashes
 boil/surfacing bubble, 110, 111f, 113f, 114f
 bowl-shaped, 90f
 "cannonball" jump, 80
 "can opener" jump, 81
 definition, 70–71
 dolphin landing, 77
 droplets, 106f
 example, 71f
 head-first dive, 82f
 jet, 102–103, 103f
 pebble drop, 76
 vs. primary, 72, 73–74
 raindrop, 78
 rock drop, 75
 rock skipping, 69f
 rock throw, 74, 79
 shallow pool, 107f

soccer ball, 83f

surge/geyser, 108–109, 109f

waterlogged wood, 85f

Shamu: The Beginning, 136

Sheet-shaped splashes, 93, 94, 96, 97f

Shoreline waves, 24, 30f, 40, 44, 116, 120

Shutter speed, fire, 210f

Smoke, *see also* Explosions; Fire

Bambi, 166

basic approach, 8

basic effect, 11f

effects research, 228, 229

elegant design, 217

explosive design, 248f

linear-style, 233

post-explosion, 256, 259

ripples, 233

vs. steam and dust, 9f

studying photos, 230, 231

as tiny particles, 212

"The Sorcerer of Rhiannon", 280

Spilling waves, 27–34, 29f

Splashes, *see also* Primary splashes; Secondary splashes

basics, 7, 127–135

buoyancy effect, 84–85, 85f, 86

detail impressions, 131

digital tablet sequence, 156, 158

diver bubbles, 125f

droplets, 132

energy effect, 143f

everyday sources, 118f

experience as research, 60–61

as explosions, 251, 252f

familiar shapes, 147

fire similarities, 198

as flower, 141f, 142f, 143f, 144

hole tearing, 98–100, 98f, 99f, 100f

inkblots, 148

as jug, 146

layering, 122f

leading edge, 155

live demo benefits, 3

movement energy, 151

object rotation effects, 67f

object shape/angle effects, 68f

object shape effects, 66f

photo example, 60f

powerboat wake, 123

ripples, 129–130, 130f

rock drop photo, 61f

Splashes (*Continued*)
 scribbling example, 138f
 shapes, 59
 simplification, 133f, 134f
 skeleton, 139f
 sources, 116
 swimmer, 126f
 trajectory effects, 62, 64f, 65f
 uniqueness, 57
 as vase, 145f
 water complexity, 128
 waterlogged wood, 84–85, 85f
 water ski, 124–126
 wave crashes, 120, 121
 waves from, 23
Spray-shaped splashes, 101
Squash, explosions, 273–275
Star Wars, 281
Steam, 9f, 12f
Stretch, explosions, 273–275
Surfacing bubble, 110
Surf breaks, 32f, 33f, 34f
Surge secondary splashes, 108–109,
 109f
Surging waves, 27–34, 28f
Swells, 25, 26, 29f, 30f

Symbols, waves, 46, 47f

T

Tavarua, Fiji surf break, 33f
Teahupoo, Tahiti surf break, 34f
Tidgewell, Dave, 167, 168
Tinker Bell, 284, 285
Tracing, fire, 219–222, 220f
Trees, as inspiration, 200
Tube-shaped waves, 30f, 32f
2001: A Space Odyssey, 281

U

Undertow, wave mechanics, 30f

V

Vanishing point, 46
Victorian lace design, 149, 217
Volcanic lava flow effect, 10

W

"Wagging dog tail", 23
Wakes, 23, 123
Water, *see also* Fluids; Splashes;
 Waves
 Aquarian symbols, 47–48
 basic effect, 15–19, 16f

design inspiration, 149

displacement, 35–36, 36f

example, 16f

explosive design, 248f, 251

global tidal pull, 41

leading edge, 155

pencil sketch, 140f

reflections and refractions, 127, 128

sketch examples, 140f

wooden trough/bucket exercise,
 160, 162f, 163f, 164f

Water fountains, 105

Water hose, 105

Waves

Aquarian symbols, 47f

basics, 7, 43–54

chaos, 43

characteristics, 21

crashing animation, 121

displaccment, 35–36, 36f

dynamic wave example, 52, 53f,
 54f

"flag waving", 180

global tidal pull, 41

Great Wave of Kanagan,
 Katsushika Hokusai (1831), 31f

iconography, 46

initial design, 49–50

in lake, 40

natural world examples, 51

Oahu's North Shore pipeline surf
 break, 32f

ocean, 41

plunging and surging, 28f

in pool, 35–41

powerboat wake, 123

repetition, 44

at shoreline, 30f

size/shape variation, 45

spilling, 29f

splashes, 116, 120

swells, 25

Tavarua, Fiji surf break, 33f

Teahupoo, Tahiti surf break, 34f

travel mechanics, 30f

wake, 23

from wind, 24

Wells, 41

Wind, 10, 24

Wooden trough-water exercise, 160,
 162f, 163f, 164f